Eyes by Hand

Eyes by Hand

Prosthetics of Art and Healing

Dan Roche

The MIT Press
Cambridge, Massachusetts
London, England

The MIT Press
Massachusetts Institute of Technology
77 Massachusetts Avenue, Cambridge, MA 02139
mitpress.mit.edu

The MIT Press would like to thank the anonymous peer reviewers who provided comments on drafts of this book. The generous work of academic experts is essential for establishing the authority and quality of our publications. We acknowledge with gratitude the contributions of these otherwise uncredited readers.

This book was set in Times New Roman by New Best-set Typesetters Ltd. Printed and bound in the United States of America.

Library of Congress Cataloging-in-Publication Data

Names: Roche, Dan.
Title: Eyes by hand : prosthetics of art and healing / Dan Roche.
Description: Cambridge, Massachusetts : The MIT Press, [2025] | Includes bibliographical references and index.
Identifiers: LCCN 2024060068 (print) | LCCN 2024060069 (ebook) | ISBN 9780262049832 (paperback) | ISBN 9780262383844 (epub) | ISBN 9780262383851 (pdf)
Subjects: MESH: Eye, Artificial | Orbital Implants | Prosthesis Design | Patient Satisfaction | Quality of Life | Professional-Patient Relations | Personal Narrative
Classification: LCC RE51 (print) | LCC RE51 (ebook) | NLM WW 358 | DDC 617.7—dc23/eng/20250317
LC record available at https://lccn.loc.gov/2024060068
LC ebook record available at https://lccn.loc.gov/2024060069

10 9 8 7 6 5 4 3 2 1

EU Authorised Representative: Easy Access System Europe, Mustamäe tee 50, 10621 Tallinn, Estonia | Email: gpsr.requests@easproject.com

For the wearers and the makers

Contents

Preface

Four thousand years ago a woman had a very fancy artificial eye she probably wore while she was alive. It was possibly made of natural tar and animal fat or maybe bitumen paste; it had a gilded surface and a central circle where the iris would be, with lines radiating outward, sunlike. Gold wires inside the eye imitated capillaries. Archaeologists discovered this item in 2006 during an excavation of Shahr-e Sukhteh, otherwise known as the Burnt City, in what is now southeastern Iran. The woman had been six feet tall and around thirty years old when she died. The prosthetic was in her left eye socket.

An even older eye was found in a skeleton in Spain. This one was estimated to be 7,000 years old. However, it could not have been worn comfortably and was placed backward in the socket, probably after the man's death.

Eye makers for millennia, then, have been trying to re-create the expressionist power of the human body's most complex and emotionally meaningful visible organ. Efforts continue today.

I learned about the ancient artificial eyes during a gathering of contemporary eye makers in 2023 in Las Vegas. A woman named Emily Brunson, who was in the middle of her five-year apprenticeship to become a professional eye maker, gave a presentation. The room was filled with eye makers who seemed to appreciate the deeply historical roots of their work.

Today, we call professional eye makers *ocularists*. They work in a field called *ocularistry*. They are not doctors. They have a variety of backgrounds: sometimes sculpture or painting, sometimes medical illustration, sometimes special-effects makeup artistry, sometimes something completely unrelated to eye making. Most often, they are self-employed, owners of their own small businesses, or work for a self-employed ocularist. Almost always, you'll find their offices in medical parks next to those of orthodontists, veterinarians, optometrists, urologists, allergists, dermatologists. Sometimes they'll be in brick buildings by themselves on thoroughfares near shopping malls and fast-food restaurants or on the sixth floor of a building downtown. Many times, an

ocularist will belong to a family with generations of ocularists, the older teaching the younger, the business passed on like an heirloom. You can find third-generation and even fifth-generation ocularists.

And yet ocularists are nearly as rare as astronauts. Fewer than 200 certified ocularists scatter themselves across the United States. The most populous states (California, New York, Texas) might have a dozen each, and more rural states (Utah, Kansas, Vermont) might have one, maybe two, sometimes none. Around the world, their numbers are equally small—even often much smaller. In India, for instance, for a population of 1.4 billion there are only about three dozen ocularists.

The eyes ocularists make now are not like the one belonging to the woman from the Burnt City, and they're certainly not like those in some common popular-culture representations. For instance, they don't, as in some cartoons and movies, fall out of sockets and roll across floors, horrifying those whose feet they rumble past, because they are not round. Nor are they clear plastic, filled with circuitry, simultaneously space-agey and gumbally, like the "bionic visual cortex terminal" from the 1970s TV show *The Six Million Dollar Man*. That device, we learn from the show's intro when Steve Austin is being rebuilt after barely surviving a crash of his test plane, connects by some cord directly backward into his occipital lobe. No.

Nor is a "glass eye," most of the time, even glass. The dominant material these days is acrylic, although glass eyes are still being made.

Most importantly, maybe, the eyes that ocularists make do not yet restore vision, especially not with a zoom ratio of 20.2 to 1, like Austin's bionic eye. They might do so someday, and scientists have made small steps in that direction. For now, though, the function of a prosthetic eye is much less physiological than it is artistic. It is meant not to create vision but to create illusion, not to see but to shape how its wearer is seen.

This is a book about the art and craft of making eyes. And it is about the frequently life-changing and sometimes life-saving experience of receiving and wearing an artificial eye: the physical, psychological, and emotional healing that an artificial eye can help facilitate for someone who has undergone the trauma of losing an eye or lived with the shame and embarrassment of having a disfigured eye that is difficult to hide. It explores ocularistry in a way that no other book—no other movie, magazine article, or documentary, for that matter—has.

There are a couple of reasons most people know little about prosthetic eyes or where they come from. First, there is that small number of eye makers. Second, if a prosthetic eye is made to be as realistic as is possible and to fit well, no one will know it exists. Ocularists' goal is *not* to call attention to their

work. (There are exceptions for people who want "fun" eyes—ones decorated with sports logos or a heart or pretty much anything else that can be painted on a small space.)

Soon after I got my own prosthetic eye in 2009, a cashier at the grocery store said, "You have the most beautiful blue eyes," and I thanked her and asked if she could tell which one was real. I was still in the initial euphoria of having the gift of the eye, and I couldn't help bragging, though she had no idea what I was talking about, and she seemed only a little less confused when I tapped my fingernail against my eye so she could hear the click.

My experience with getting an eye—a common one, according to many of the people I interviewed for this book—was one of intimacy and gratitude. Visits to my ocularist from the time of my eye's creation—which took two days—through every annual polishing have been long stretches of personal attention and care that seem increasingly rare in a medical world of high volume, crazy insurance regulations, and systemic stress. Maybe the extended eye contact required is a big reason for that. Maybe it's the fact that handcrafting and hand painting an eye takes hours. Maybe it's that the profession asks its practitioners to employ not only their technical and artistic skills but also their skills of listening and empathy. My ocularist has told me that his business is "probably 75 percent psychology and 25 percent an actual product that I make." The healing to which an artificial eye contributes is never merely aesthetic.

The expressive power of real eyes can be frustratingly elusive in the making of an artificial eye. Damage to an eye socket—from an accident, a fire, cancer—is sometimes so extensive that an ocularist cannot achieve full harmony and symmetry and what seems in the best cases like magic.

Still, magic does often happen.

What I try to show in this book is how it happens, why people have been trying to replicate lost eyes for thousands of years, and why for someone missing an eye or burdened by a disfigured one an artfully crafted and generously given artificial eye can help heal not by bringing a body back to perfect function but by easing trauma to that person's very sense of self.

1

Repulse

"Nothing is more offensive to look upon than a sightless closed eye, and the loss is indeed a misfortune, as it disfigures the face, distorts the features, and renders the patient unfit to mingle in society," claimed a newspaper advertisement by Dr. John Scudder, a New York City eye maker in 1829.[1] A few decades later, another New York eye maker, T. J. Davis, was just as brutally insistent: "The loss of an eye," he wrote, "is a deformity—in many cases it amounts to a perfect repulsiveness in the unfortunate person who has experienced the loss."[2]

When soon thereafter Dr. Emile Debout, the president of the Medical Society of Paris, published a survey of ocularistry up to the mid-1860s, he didn't call out Scudder or Davis explicitly, but he did push back against the dismissive assumptions they had articulated. His article "On the Mechanical Restoration on the Apparatus of Vision" was meant primarily to show and praise the many times ocularists had used their artistic skills to salvage the social and professional standings of people unlucky enough to need an artificial eye. First, though, he expressed dismay that such salvaging was even necessary, that irrational prejudices toward the one-eyed even existed.

"Now, in our state of civilization," he wrote, "individuals who present any deformity offensive to the eye are debarred from many employments, even the humblest. How many persons would object, solely because she had lost an eye, to take into their service a servant? Look at that young soldier: a brilliant action has entitled him to be promoted with honour; but he has lost an eye in the fight—without the benefit of a prothesis how could he pursue a career so well begun?"

Debout tells the story of Madame X, a piano teacher who'd lost her right eye when she was five. Her parents got her an artificial eye, but they were careless in helping her with it. They let her leave it in too long, so the socket became irritated and scarred. By the time she was nineteen, she had to quit wearing the eye because it popped out of the socket "whenever she made any

sudden movement." She wore a bandage "to hide her deformity," but she could not teach music looking as she did. She would get no students.

After several eye makers had failed to solve Madame X's dilemma, she was referred to a preeminent French oculist. He spent six months trying to make an eye that would fit the difficult interior of Madame X's socket. The back of the prosthetic had to hook over a ligament of scar tissue that was in the way and to correspond with the rest of the disheveled contour. It took him more than thirty tries. Finally, he crafted an eye that not only would stay put but do so "without inconvenience or fatigue." The story had a happy ending: Madame X was "able to resume her teaching, and to go into society without her deformity being suspected by anyone. She married very suitably some years ago."[3]

Scudder and Davis weren't disinterested commentators on the poor fate of anyone who had lost an eye in the early and mid–nineteenth century. Both of them were eye makers, so they had a stake in whatever cultural attitudes existed toward that particular physical deformity. Specifically, they could ride to the rescue, present themselves as able to provide their own happy endings. In his advertisement, Scudder followed his "nothing is more offensive" line with this one: "The fitting of Artificial Eyes so near as to resemble Life, and deceive the most sceptical is perhaps one of the most extraordinary of all operations tending to remedy the deficiencies of the human frame." If you hired him, he promised, "the real Eye will be correctly imitated." If you were one of those who had had "the misfortune to lose one of these valuable organs of sight," he said confidently, you could "be made whole in appearance if not in reality."[4]

Likewise, Auguste-Pierre Boissonneau, the oculist son of the Parisian oculist who had accomplished the magic work for Madame X, employed a similar salesperson's slyness in giving bad news (the one-eyed are unbearably ugly) and then following it with good (I can help!). He began his short book *General Observations on Artificial Eyes: Their Adaptation, Employment and the Means of Procuring Them* (1862) with this dispiriting assertion: "Of all the bodily misfortunes to which Man is subject, resulting from diseases or accidents to which he is daily exposed, there is perhaps none that occurs more frequently than the loss of an eye: at the same time, there is no deformity more painful to be borne with, both on account of the physical suffering and functional derangement by which it is often accompanied, and also on account of the moral torture occasioned by the humiliations or self-imposed idea of repulsiveness to which the unfortunate person who has experienced such a loss is exposed." But he switched tone and direction quickly, asserting immediately afterward that "science possesses a means by the aid of which it is

always possible—we might even say easy—to re-establish the harmony of the visage, to restore to the physiognomy its wonted expression, and, finally, to remedy all the inconveniences resulting from the disorganization [*sic*], the deformation, and even the absence of the ocular globe."[5]

Negative judgments about how the one-eyed looked (or how they thought they looked) and how little they might be welcome in public may have captured a dominant and mostly unquestioned appraisal in societies such as the one that would not let Madame X teach piano in her condition. It's equally possible that though *repulsive* certainly sounds heartless, it wasn't intended to be, completely. The word's meaning and connotations at the times those ocularists used it were in flux. It was synonymous, as it most commonly is now, with *disgusting*, though the first written use of it that way didn't occur until 1791. Still prominent was the more objective, scientific meaning of "able to repel," which is how Isaac Newton employed it in his *Opticks* (1718) when he wrote of "a repulsive Force by which [two objects] fly from one another."[6] (Scientists today still use the word this way. At the nanolevel, for instance, light is described as having both attractive and repulsive forces.[7]) In addition, *repulsive* in the 1800s could mean an intentionally chosen defensiveness or protectiveness, a coldness of manner. "Mary was not so repulsive and unsisterly as Elizabeth," wrote Jane Austen in *Persuasion* (1815).[8]

Perhaps, then, those nineteenth-century ocularists did mean to say that the one-eyed were too hideous to look at, that visceral reactions of disgust toward them were warranted. Or perhaps they meant more that even if this description were true, it wasn't the one-eyed's fault, and that an impersonal cultural force would inevitably push them from polite society. The distinction was likely immaterial, however, to the "unfortunate person who has experienced such a loss."

What is true, as the medical historian Katherine Ott has pointed out, is that conceptions of repulsiveness and belonging are never universal. In writing about who acquired prosthetic eyes in the nineteenth century and why, Ott explains that even within classes and demographics, various groups of "people embraced different aesthetic standards."

Bodily difference was taken for granted—everyone had scars, bad teeth, a unique gait, or some other mark of physical diversity. How the individual presented his or her own diversity in public indicated both their social and economic background and their aspirations. A farmer, expecting no deviation from his lifetime's labor, might carve an eye from a piece of wood or quartz to use for special occasions and wear a patch the rest of the time. He need only please himself, his family, and his cows. But young persons with big ideas and any of the thousands of newly apprenticed lawyers and doctors responded to other social pressures. They were cognizant of prejudice against the wearing of crudely made eyes. . . . These sentiments addressed bourgeois

conventions of propriety and gentility and appreciation of others who behaved accordingly. One's artificial eye may not have passed for a natural one, but the gesture of wearing one, as well-made as possible, was what middle-class members and aspirants approved of and found significant.[9]

Nonetheless, for the many who undoubtedly did yearn for a "harmony of the visage" that they'd lost along with an eye, the obstacles to artistic replication were real and substantial. It was difficult to make a lifelike artificial eye in the nineteenth century, especially in the first half of it. It had been difficult or impossible for millennia. Histories of artificial eyes tend to start with the ancient Egyptians and recount how they were pretty good at making eyes for people to be mummified—they "removed the eyes of the dead, poured wax or plaster into the orbits, and then inserted precious stones to simulate the iris"— but not all that sophisticated in their techniques for the living: an eye-sized piece of clay painted to look like an eye and then secured over the socket with a piece of flesh-colored cloth.[10] Those histories usually jump over centuries and centuries—to the mid-1500s—before describing any real progress, particularly in the design of an ocular prosthetic meant to fit into the socket rather in front of it. The French military surgeon Ambroise Paré is often noted as the first to describe replacement eyes in use at the time, though he made no claim to have invented them. One was a metal prosthetic—perhaps gold—meant to fit under the eyelids to cover a shrunken globe. Paré called this type of eye a "Hyplepharon." For someone whose bad eye wasn't shrunken and so didn't allow room for anything else in the socket, there was an "Ekblepheron": a steel spring that wrapped around the head and widened into an oval surface at the front end. The oval was covered in leather and painted with the image of an eye and eyelids. Not surprisingly, both types were clumsy and uncomfortable—and neither created much or any illusion of reality. Few people wore either.[11]

Later in the fifteenth century, the Murano glassmakers of Venice introduced glass eyes: thin and fragile shells not much more comfortable, by any accounts, than the metal ones. Nonetheless, Venetian eyes were the best a one-eyed person could get for more than a century. Even when Paris became the dominant source of prosthetic eyes in the early nineteenth century—eyes there were porcelain—the product was frequently disappointing.

"Very inferior articles," an article in 1856 about new developments in eye design called those earlier eyes. They consisted of "an oval shell, exactly like half of a bird's egg." They "varied only in size and colour, the same piece being used for both the left and right side." Such a primitive and simplistic design "gave the wearers much pain, produced a staring effect, and imparted to the face a repulsive aspect."[12]

A bad or missing eye—or an imperfect glass eye—was a useful trope for, say, a nineteenth-century fiction writer who wanted to signify the moral failings of a character. (A character with an eyepatch, in contrast, was often a badass.) In his novel *Nicholas Nickleby* (1838), Charles Dickens gives his sadistic schoolmaster Mr. Squeers "but one eye" when "the popular prejudice runs in favour of two."[13] And in *The Bertrams* (1859), Anthony Trollope has a character named Miss Ruff, a wearer of one of those "inferior articles" that does not move with its companion eye but stares disconcertingly straight ahead. Other characters describe her as "dreadful" and "horrible." In a scene where she is playing whist, she's impatient and without mercy. She's a pain. She claims that her opponent, Lady Ruth Revoke, "hardly knows one card from another." Lady Ruth deals much too slowly for Miss Ruff's satisfaction. "Lady Ruth, do you ever mean to have done dealing those cards?" Miss Ruff asks while "emitting fire out of her one eye." Lady Ruth, who is known for having paralytic fits, plays on, stiffly ignoring Miss Ruff's exclamations. "Well, I declare—what! the ten of spades—ha! ha! ha!" says Miss Ruff. But tension builds. "Miss Ruff's tongue [goes] faster and faster, and her words [become] sharper and sharper." And, as one woman in the room observes, "she has a way of looking with that fixed eye of hers that's almost worse than her voice." Miss Ruff's partner urges her to put a lid on her commentary. People at other tables start paying attention. There's a general fear that Lady Ruth is inching toward one of her fits. She has begun to sit perfectly still, but with her head bobbing "up and down in a strange unearthly manner" and her eyes "fixed in one continued stare directly on the face of her foe." Her lower jaw has fallen "so as to give a monstrous extension to her cadaverous face." She's had it. She doesn't announce her abandonment of the game, but she allows two people who have rushed to her side to help her stand. They lead her to the door. But before she goes through and on to a bedroom where she can compose herself, she shakes loose from one supporter's arm and turns to those left sitting with cards in their hands. She has one thing to say, slowly and with finality, about Miss Ruff: "I wish she had a glass tongue as well, because perhaps then she'd break it."[14]

Miss Ruff's unmoving eye looks decidedly unnatural, but it is not as obviously *not a real eye* as was, say, Paré's Ekblepheron. And while some people in the room with Miss Ruff, including Lady Ruth, know it's fake, others seem less than 100 percent certain. The eye seems to awaken what Sigmund Freud, well after Trollope placed Miss Ruff in the midst of a tense card game, called an "uncanny sensation"—the result, Freud would say in the case of Miss Ruff, of an object appearing both alive and dead, of being both familiar and unfamiliar. The woman who speaks up—"She has a way of looking with that fixed

eye of hers"—implies, intentionally or not, that Miss Ruff's fixed eye can see and hence is alive. She doesn't say that it *looks* as if Miss Ruff's eye is looking, as one would say about, for instance, the eyes in a freakishly lifelike portrait following you around the room. Miss Ruff's eye, though it stares straight ahead and refuses to move in concert with its nimble partner, *is* looking. Any eye that *looks* does so only because there is something to be gained from the looking.

The room seems bursting with deceptions. The eye deceives the woman through its disconcerting uncanniness. The woman deceives herself by assigning a power to the eye it doesn't have. She deceives others in the room by stating aloud her assumption about the eye's aliveness.

We don't know why Miss Ruff doesn't have a better eye, one that would make her whole in appearance if not in reality. Maybe she got hers when designs were crude, the "half of a bird's egg" days. Perhaps she never upgraded and instead has worn that one eye for years and years, handling it like a jewel each time she removes it, hoping it will not break, utterly loyal to it and dependent on it as it defines her self-image more and more deeply. Perhaps that self-image became based through the years on the fixedness of that eye and the pain it causes as it cups without congruence or art over her shrunken and blind real eye, and perhaps the knowledge that the fake eye she treasures enough to wear every day imparts to her face a repulsive aspect she does not completely dislike. Perhaps the dreadfulness of her personality is tied up in her insistence upon wearing that fixed eye, making people think she is looking at them with it, and taking whatever power and pleasure she can from their not knowing what to think about her or it at all.

There is a photograph that shows an eye that was part of the collection of Peter the Great, who ruled Russia as czar and then as emperor from 1682 to 1725. It wasn't a real eye, any more than Miss Ruff's was. It was, in fact, made of glass, antler bone, and metal. Peter the Great was thirsty for wide-ranging knowledge, curious and passionate particularly about science and the practical arts. He amassed a gigantic collection into what was called a *Kunstkammer*, or chamber of curiosities. The eye was part of that collection—as were real teeth, pulled by Peter himself, from members of his own entourage and from random people who passed by at the wrong moment.

The photograph is by Rosamond Wolff Purcell, and I know of it because my daughter's college class went to their school's art museum to look at an original print. They had been reading Freud's "The Uncanny." The photograph shows the eye against a background of russet velvet. The eyeball itself is

enclosed within lids that have the patina of old ivory and curve just across the top and bottom of the large brown iris. The tear duct has a mottle of red that seems to have partly worn away.

It was not immediately obvious the eye was not real, my daughter said. As she and her classmates studied the print, they experienced the uncertainty Freud described. Couldn't the background, taken in quickly, they wondered, be part of the face of a horse or some other large animal—and the photo then a detail of animal anatomy? What about the windows reflected in the brown iris? Something is in the eye's line of sight, and hence the eye exists not in empty space but in physical relation to something that can be viewed. (I am, with her permission, stealing phrases here from a paper my daughter wrote in response to the photo.) Who wouldn't conclude—as Trollope's character might have—that the eye is doing that viewing because that's what eyes do? Yet hints of the eye's inanimateness gradually arose—intensifying the students' uncertainty and hence their sensations of Freudian uncanniness. The eye's pupil, which is hard to see within the iris, is actually looking away from the windows. Also, there's a small crack in the iris, visible in the original print but harder to see in reproductions. And the shadows in the photo, especially the deep ones in the velvet background, make the eye seem to be floating in a void. The expected context is missing. That, too, Freud said, can create the experience of uncanniness. He gave some examples of objects removed from their natural contexts and existing in the ambiguity between aliveness and nonaliveness: "Dismembered limbs, a severed head, a hand cut off at the wrist . . . feet which dance with themselves."[15]

Dr. Debout pitied the woman who could not get hired as a servant and the soldier who might not have a career after his honorable military service cost him his eye. Such discriminations might seem of Debout's time, an era when the one-eyed may very well have given off repulsive forces. But employment discrimination against the one-eyed is by no means limited to those long-past days. The one-eyed were passed over for jobs well into the twentieth century, perhaps based in part on their appearance but more explicitly on the assumption that they simply weren't as capable as the two-eyed. This was surprising because, as one history of physical disability reports, "through at least the early 1920s—and longer in dangerous industries—disabling injuries were an expected, if feared, aspect of working life and, in particular, of poverty. During the mid- to late-nineteenth century, for instance, railroaders' missing and crushed fingers signified experience, along with the good judgment and competence necessary to survive a train wreck."[16]

On the subject of eyes, though, that history provides the contrasting story of a Philadelphia man named Walter Pratt, who had lost an eye to a flying piece of steel.

Despite wearing a natural-looking glass eye, he could not convince an employer to hire him for even the most menial job. In 1928, he complained to an investigator from the Consumers' League of Eastern Pennsylvania: "You know nowadays you have to pass a physical examination and I would get along fine until they would test my eyes, one at a time, and then it was all off." After being rejected for yet another janitorial position, he exclaimed, "Well, the fact that I have only one eye doesn't affect my hands and feet, I can do this work as well as a man with both his eyes." But the employer told him, "Why should we bother with a one-eyed man when we can find plenty with two good eyes?"[17]

So the one-eyed have often been limited socially because of their disfigurement. Like Walter Pratt, they have been unintended victims of the increasing centrality of mechanized labor to the economy as "employers in nearly all sectors began to demand workers who, unlike Pratt, had intact, interchangeable bodies."[18] These two factors have risen and fallen in consequence with changing cultural attitudes toward appearance and with changes in workplace regulations. A third factor in the common response to those with a missing or disfigured eye may be more eternal and universal because this response involves the very human experience of squeamishness so many of us feel when presented with evidence of an eye's vulnerability.

Perhaps no other body part is the catalyst of as wide a range of consideration and response as is an eye. When the organ is healthy and cuddled within tissue and bone, it is exquisite, worthy of reverence, metaphor, poetry, philosophy. That reverence, like all reverence, exists in conjunction with mystery, with an unknown more expansive than the known. Normally we see of an eye only its flashiest snippet. The wash of the iris. The cave opening of the pupil. A nimbus, maybe, of cream or alabaster. When an eye moves, we see a wave from depths cloaked behind the hood of the brow, the folds and stretches of the upper and lower lids, the sweeps of the lashes.

When that harmony is broken, we cringe.

A semipro basketball player in New Zealand, struggling for a rebound, took a finger to his left eye. He fell to the floor, head buried in his muscular arms. In the grainy video footage of the moment, when he does raise his head, it looks almost as if something external has landed on his face: a spider sac, fungi from a tree trunk. The announcers speak in troubled voices.

"His eyeball has popped out of its socket."

"Oh my god."

"That is horrific."

Other players nearby turn away, and it's possible to read in their movements visceral anxiety and disgust. The exposed eye seems to physically push them a step or two backward, to repulse them.

The episode got the kind of media coverage that gross events do—the parasites popping out of people's skulls, the unwrapped condom in the fast-food sandwich. On a medical TV talk show, even the doctors on the panel squirmed in viewing this video. The audience groaned.

One panelist said: "The report was that the players and coaches were more upset than he was."

Another replied: "He didn't see it!"[19]

The basketball player was fine. His eye returned to its home, his vision intact. A happy ending. But still present was that primitive urge when an eye's vulnerability is exposed to turn away, to raise one's hands in front of one's face as protection against a threat that feels close and immediate, even if the feeling of that threat is generated by a story about someone else or an image on a screen. There's too much frailty that cannot be lessened. Take any other vulnerable body part—the stomach, the knee, the neck, the nuts—and it's possible to increase its protection. More crunches and planks. More stretching and weight lifting. More practice at turning sideways and closing the thighs. Other fragile body parts—the brain, the kidneys—are already wrapped in some fortification, though imperfectly. An open eye has no real security and cannot be made less delicate. *Go for the eyes*, teachers of self-defense say.

This vulnerability is a big reason people get queasy at the sight—sometimes even the thought—of an eye that is damaged or exposed, even if it's not a real eye. Think of the peeled grapes in a bowl that you stick your hand into in a darkened haunted house.

I know a woman who had a car with a stick shift topped by a plastic eyeball in place of the normal knob with the small map of gear positions on it. She told me that her brother, a grown man, refused to drive that car, refused to touch the eye.

And though I had, for most of my life, a blind and troublesome eye that many doctors touched and cut into, and though one doctor to whom I'd been referred a few decades ago ascribed to me "quite an interesting past ocular history" in his report even back then, I avoid movies that would subject me to the visceral horror of eye trauma. I flinch and feel light-headed when I open a book or website to an image of an eye that is hemorrhaging or has been impaled by a metal shard or has been cut in a chain-saw accident. More than once while doing research for this book, I had to get up from my desk and walk to the kitchen to eat a cookie to settle momentary faintness. I don't even like remembering what

my taciturn grandfather used to say when asked how he enjoyed a meal or a walk or almost anything else: "Better than a stick in the eye."

American popular culture, at least, has opened to wider representations of physical diversity: characters on TV shows with facial differences, a line of Barbie dolls with a prosthetic leg. And even prominent displays of eye disfigurements have begun to appear, as in an ad by Google for a phone designed to help people with low vision identify aspects of their surroundings, featuring an actor with one eye that is clouded and pointing conspicuously off to the right. The asymmetry of his eyes is pronounced, and yet he looks directly into the camera for relatively long stretches. In contrast, more common still is a fear of wooziness and an involuntary repulsiveness at the chemical level that seems to have been in the minds of the editors of a feature article on a popular news website in 2019. The story was about a British woman on vacation in Turkey who got out of the shower one morning and was patting her face dry when "she felt her eye 'pop' before experiencing blurry vision and a sudden rush of immense pain—so much so that she feared her eye had fallen out of her socket." She had perforated her cornea, and by the time she got back to England, the eye was infected. It couldn't be saved. The article was accompanied by photos of the woman after an operation, her eye gone. A banner at the top of the article announced: "WARNING: GRAPHIC IMAGES BELOW."[20]

In my high school English class, we read Edgar Allan Poe's "The Tell-Tale Heart" (1843). The narrator is repulsed by the disfigured eye of an old and helpless man: "He had the eye of a vulture—a pale blue eye, with a film over it. Whenever it fell upon me, my blood ran cold." We were supposed to condemn that narrator for killing the old man, for rushing into his bedroom one night and smothering him under his heavy bed. But my empathy was completely with the murderer. His goal—"rid myself of the eye forever"—was my own goal.[21] I dreamed often of crushing my damaged eye under something as heavy as a bed.

In truth, though, I have known for a long time—and probably knew then—that my eye was not horribly disfigured, not an object of repulsion for others, as it was for me. I could barely look at it. I wanted to hook it out with my fingernail or the pocketknife I kept in my dresser drawer. The knife's blade wasn't especially sharp, but it was pointed and thin like a surgical instrument. I'd also often evaluate the efficiency of the filet knife my grandfather used to clean the bluegill he and I caught while floating in his rowboat. I fortunately didn't have the Oedipus-level despair to use either of those knives or any other, but I cannot now begin to count the hours I spent imagining doing so.

I was born with a cataract on my right eye—an old person's condition right out of the gate and with no good reasons for it being there that I've ever

discovered, except maybe that my mother had the German measles when she was pregnant with me, which is a story I swear I heard as a kid, though she now claims she hadn't. The hospital where I was born had long ago destroyed its medical records from that time. I not only don't know exactly why the cataract appeared but also why doctors did not immediately remove it, though it covered the pupil like a midwinter Arctic ice cap. "I guess they just decided to leave it on," my mom has said every time I've asked her. My dad, when he was alive, had no better information. Cataract removal in the late 1950s was more involved than today's ambulatory procedure. Still, people had been treating cataracts since the fifth century BCE. Advancements had been made. The best clue I've found is in a hefty book on cataract surgery from the time. In a section explaining the ways a congenital cataract could be removed or broken up and pushed back into the vitreous where it might be absorbed, the book concludes that sometimes no action is the best action. Operate only if the other eye is having its own troubles. "If the fellow eye is normal, or almost so, usually it is best judgment not to interfere with the cataract or anomalous development of the poorer eye." Don't risk more trouble. Also, the book said, babies are lousy patients for eye surgery. They rub their faces against their crib mattresses and "do all they can to vitiate the effects of the surgery."[22]

The eye was essentially blind—only enough peripheral vision to sense light and dark, to catch movement if the object moving were big enough and close enough.

And yet people told me I had lovely eyes. They liked the blue. "So deep-set," they said.

Which of us, I often wondered, was more blind?

My high school girlfriend had eyes brown with flecks of lemon and cinnamon. She was a theater kid and ran with a crowd I avoided because they were easy and emotive with their stares into each other's open faces. In a drama class, she was assigned to sing a saccharine love song, and a boy in the class was picked to let his face loom over hers. The only way she could give herself over to the words, she told me, was to imagine my face there instead. I was thankful for the stand-in. I could not have looked into even her eyes for three syrupy, unremitting minutes.

My eye was nothing my parents or I considered a physical disability. I played football, baseball, hockey, basketball. I bought my first car at sixteen and so chauffeured my friends, accident free, to school and deep into Friday and Saturday nights. No one besides me seemed to give my eye a second thought and maybe had no reason to if they didn't grasp how it hemmed me into shyness, kept me (my diagnosis) from maintaining eye contact for more than a glance, eroded social interactions into vexation for me and whoever wanted some connection with me. When I did address strangers or classmates,

they often assumed my wayward right eye was more of a message giver than the rest of my face or body. They glanced over their left shoulders to see who I must actually have been talking to.

"We just saw it as part of you," my sister says now of the eye, a reasonable and generous acceptance that I resented then and probably still do now on some lingering level because I got nowhere near the sympathy—by which I mean the care—I didn't know how to ask for.

There was, however, one moment of being seen in the imperfection of my own self-view. I was fifteen and on a baseball team called the Thunderbirds. I played first base and outfield and did so solidly, rarely misjudging fly balls, even without traditional depth perception, even in the dusk of evening. At the plate, I swung a heavy bat and sent the ball far when I connected. Eight or nine times out of ten, though, I trudged from the batter's box back to the dugout, head dropped over the mystery of another strikeout—one category in which I led the team (the other was home runs).

At batting practice halfway into the season, our coach leaned against the chain-link fence and watched me quietly for fifteen or twenty cuts. He was an understated coach, not one whose voice you would have heard throughout the neighborhood on summer evenings and Saturday mornings. He had a square but softly featured head, and when I glanced over at him between pitches, he'd make a tiny movement with his chin to tell me to pay attention to the pitcher, not to him. I hit a few.

He held up a languid hand to the pitcher and walked over to me.

"You're closing your right eye when you swing," he said.

I shrugged. "I can't see out of it."

"At all?"

I shook my head.

The fact seemed to surprise him a little, but he didn't judge it. We stood facing each other for a few seconds until he said, "Try hitting from the other side." I hesitantly moved into the box for lefties. My teammates playing the infield took it as a joke. They shuffled in closer. I startled them and myself by slapping the first pitch toward second base and then by hitting the next dozen, not powerfully but smack on. Each time, I *saw* the ball hit the bat, something I had not known could happen. Nor had I known that *keep your eye on the ball* was more than a figure of speech. Batting from my typical right side, the coach realized, I was swinging blindly, having lost sight of the ball several feet before it reached the plate.

He moved me back to the right side, then stood behind me, his square fingertips on my shoulders, gently repositioning. His left foot eased my left foot farther and farther across the dirt toward the outside of the batter's box. He

turned my shoulders so that I was nearly facing the pitcher and then my hips. "You'll pull it more this way," he said, "but you'll see it better." Initially, I did pull ball after ball foul. Then I adjusted more. My batting average began creeping up, so that by season's end it was not humiliating.

Another significant moment led to someone finally taking a knife to the cataract. I was nineteen and in a clinic, having gotten a shot for something. I was walking down the hallway toward the door when a young ophthalmologist stopped me. He couldn't believe the inexplicable failings of his colleagues. *"Why is that cataract still there?"* he wanted to know. He led me to his office, sat me down, and explained a surgery he could do—actually two surgeries: one to rid me of the cataract and a second to straighten the gaze of the eye by tinkering with the eye muscles. He drew diagrams. He made sure I understood he wasn't offering me vision. The operation would be for looks. The vision ship had sailed long ago. Yet he was eager, whether more for my sake or his, I couldn't tell. He made me eager, too. It didn't take much. I felt only surprised and thankful for the coincidence that the two of us had been walking toward each other down the same hallway, that he had stopped me and spoken to the essence of my need. I wanted looks.

A month later, it was done. For the first time, my bad eye had a pupil that was dark and deep. It wasn't perfect. The iris immediately below the pupil was notched, as if the doctor had needed to chip out more than he'd planned. The pupil was a keyhole rather than a circle. But it was black. And four months later, I returned for what my medical records call "surgical correction of exotropia on the right eye due to amblyopia ex anopsia." The nursing notes from my admittance to the hospital say I was "alert, oriented pleasant and talkative." And why not? The doctor detached two rectus muscles, then reattached them, one six millimeters farther back and one five millimeters. The medical records end with the curious line "Problem #1 POST OP straightening of Rt. eye muscle, resolved."

That was optimistic. When the bandages came off, the right eye remained like a picture that refuses to hang straight. It and the good partner continued to ignore each other. I thought of them, when I was feeling at all kindly, as two dogs being walked together, one trained and trotting onward, the other tugged by its nose into the bushes. Other times I imagined the bad eye as a balloon floating next to my head, bouncing along on a short string, tugging darkly.

Then, fifteen years later, I took a finger to that eye while playing basketball. The eye did not pop out, though I felt it compress into itself then bounce back. The retina ripped loose. I didn't know for months because, with no vision, I

didn't see the tell-tale "grape cluster" sign of that condition. I went to the doctor at last only because the eye felt swollen, and I was imagining a tumor growing in there. So, another surgery, a duct-tape kind of effort at keeping a mostly useless body part from being even more trouble. But the components were too worn out. The retina refused to stick back in place, even after some follow-up laser blasts. My surgeon lectured me on the obvious: I was lucky not to have been poked in my good eye. He made two predictions about my future. The optimistic and unlikely one was that the eye would sit in relative stability forever, chastened into humbleness. The other was that the eye would gradually shrink in on itself like a neutron star and eventually hurt a lot. He estimated the latter would take twenty years. That prediction was almost exactly spot-on.

Over those two decades, the eye washed slowly from blue to gray green. Whitish scar tissue crept across the cornea like lichen. By the time I was in my late forties, the eye was a dull, cloudy marble, swirls of smoke and sandstorms, its internal pressure three times the normal. It throbbed, dragged my good eye into a lower endurance. I could read for half an hour if I were lucky, drive for only an hour or two.

By then I was living in a different place and seeing a different ophthalmologist. For four or five annual checkups in a row, I confessed I was done with the eye if he could help me be done with it. Each time, he explained it was not his approach to remove an otherwise healthy organ, which I supposed meant that I did not have ocular cancer. In his notes for one office visit, he wrote: "Use prosthesis as last resort if a lot of pain."

I called around, scheduled a check-up with a different ophthalmologist. And that led to a third moment of being seen in the way I craved by someone who could help. He walked into the long and dimmed exam room as his assistant was finishing her preliminary checks and a medical questionnaire. He was tall and thin, dressed in slacks and an open-necked shirt. He was still six or eight steps from me when we made eye contact. His first words were: "You know, we can take care of that."

They were the words I'd wanted to hear from every other eye doctor who had shined a flashlight into my eyes and written me a prescription for glasses with the right lens always labeled "balance," from every school nurse who had asked me to read a laminated eye chart worn around its edges from years on the wall of an office trafficked by streams of kids with stomach aches, even the nurses who made me put a Dixie cup over my good eye and try to read the chart with my bad eye, "just to make sure." Those were the words I'd wanted the eye doctors back in 1958 and 1959 to have said to my parents so that everything might have been different.

K. Potter, Eye Wearer

I had a really rare inflammation of the retina. That started in 1991, when I was going to be a student teacher. I did pretty well for a little bit. Then I had surgery for cataracts, and my eye just freaked out. I got glaucoma. I ended up having five surgeries on my left eye to try to get everything under control. Finally, my doctor said, "What's left is so beat up." I had a contact lens to make my eye look normal, but he said, "What's in there isn't even going to be able to hold that up eventually." So we just made a decision in 2018 to have the eye removed. And this is just part of it, so I have to say it: I actually could feel that I might have to get divorced, also. There was a sense in myself that things were going in a direction that was in conflict with my values and my life. And I had my vacations off as a teacher, and I had good health insurance. I did it in the winter. I thought, "Well, it's winter, you're not out much anyway, just get this done," and by spring break I was able to have the prosthetic put in. And then it ended up that I did get divorced in April, and I did have to take on another job. It would have been much more difficult to do it after that.

I guess I've had so many different eye surgeries that I wasn't even really scared. I should also say that I had the surgery in January, and in December I'd gone to San Diego for six days because one of my best friends was dying of cancer. I remember sitting with her husband in the living room after we'd been at the hospital, and I said, "It's kind of a strange year when getting your eye taken out is not the biggest thing on your mind." I knew I was getting divorced, my best friend was dying, and I'm like, "Yeah, whatever." So really I was just like: "I'll get it done, and I'll take care of myself so I heal."

I hadn't had vision in that eye since 1997, so I wasn't going from being able to see out of both eyes one day and then not. I was used to driving and living with one eye. Someone did give me a book about losing an eye when I went for the surgery, and I thought, "Oh, this would've been nice to get twenty years ago."

After being home for weeks after the surgery, I was really ready to get the prosthetic. I was so glad to be in the ocularist's office because she's such a positive, uplifting person, and I was just glad to move the process forward. You know, having no eyeball in your head, you can't exactly chitchat with people or do your life! So it was like, "Let's do this." I felt like she was really

an artist. I had heard really good things about her, that she was trained by the best. And I could feel that in her. And there were little touches, like a flower she painted on my eyeball up high where you can't see it. The process was very humane, and I didn't feel sad. I felt very grateful. I'd gone to a cataract clinic once in India, while I was traveling with Rotary Exchange, and all these people sitting there, in the brightest clothes ever, waiting to be seen for the follow-up to their cataract surgery by doctors who were volunteering their time. I remember thinking: "If I had this disease in India, my life would be very different."

This is not something I talk with anyone about, you know what I mean? People just don't talk about it. And I am really grateful for how my ocularist normalizes it and it's very, "Here's the steps, and here's what I'm doing."

I'm an instructional coach for teachers, and I also teach some at-risk-type courses. But I taught social studies for a long time, and then I taught stress reduction for ten years at the university and at the hospital. I trained with Jon Kabat-Zinn at the Center for Mindfulness, and I taught an eight-week class that the hospital offered. And then I taught a class we developed for university students: mindfulness-based stress reduction. I think the mindfulness that I do probably has saved my life or helped me in so many ways. We teach best what we need to learn.

Now I work at a junior high, and I coach teachers in the morning. I do individual coaching, and I coach the different departments in meeting their goals. I'm a teacher leader, basically, in the mornings, and then in the afternoon I have two sections of kids who struggle at school for some reason. We work on organizational skills, setting goals, having a connection at school so that they'll actually want to come to school. So that mindfulness helps me there, too, for sure. We do a little mindful moment every day.

There was a time when I had to take massive doses of steroids, when the doctors weren't getting my eye under control. They were trying a cocktail of things to get my eyes to stabilize. I got the "steroid moon face," and it was actually much more challenging to get up in front of new kids at the high school for that year or two than it was with my eye. With my eye, I haven't really felt that. Even by the time I got my eye removed, I went back to my mindfulness kids at the university for maybe one week before I got the prosthetic, and I just wore sunglasses. I had told them before I went why I was going, what was going to happen, and they were all just like, "Whatever." It wasn't a big deal. The nature of the class helps, and the relationship we had.

Everything's so much on computers now, and that has been hard on my eye. Trying to do my job with one eye, with so many screens, has been hard for me. It makes me more tired. My work contract is for 84 percent [of full-time]

because that's the max I can do without completely wiping myself out. And I have a daughter and a dog and a house, so I have to have boundaries. I can't just go go go like some people. During the pandemic, my boss at the university asked, "Do you want to teach a two-and-a-half-hour class online?" and I'm like, "No, I don't!" You're not just lecturing; you're trying to make sure you notice people's emotions, and you have to be completely on. And I couldn't stare at a screen. It made my eye hurt so much.

I never take my eyeball out, never. It's fallen out three or four times—when I was vigorously cleaning my lower lash—and I had to put it back in myself. My ocularist told me, "Don't take it out if you don't have to," and that's what I live by.

Once, when I first got it, it fell out and hit the ceramic tile, and I was so lucky it wasn't chipped. I'm religious about wiping toward the middle. Luckily, I'm not an eye rubber. They are sensitive, but I don't have the urge to rub them, knock wood.

Honestly, though, I don't think about "Oh, I only have one eye." Every once in a while, I don't see something in my blind spot. And I'm like, "Oh no, sorry, that's my blind spot!" I don't even know if any of the teachers I work with know. I just assume everyone has some vulnerability, I guess, so I just don't talk about it.

But when they take pictures, it's hard for me to get that eye open really wide. When you sit down on stupid photo day, it's just not a good time. They're like, "Open your eye more!" and I'm like, "Um, I'm doing my best! It's a prosthetic, thanks!"

2

Removal

I could have shown my reluctant ophthalmologist—the one who considered a prosthesis a last resort—an influential ophthalmology text from nearly a hundred years before he and I had our disagreement, particularly this line: "The usefulness of an eye is confined to two considerations, viz., vision and beauty, and when, through accident or disease, both of these attributes are lost, and in addition an element of danger is added, the eye should be removed."[1] To be fair, though, I would have had to concede two things. First, there was no element of danger added in my case, no imminent threat of my good eye going bad. There was just pain and ugliness. Second, criteria for whether to remove an eye have changed significantly from one era to another based on what's technically possible (without killing the patient) and understandings of eye physiology. Social prejudices have been factors, too. The historian Katherine Ott notes evidence of one physician from the late nineteenth century recommending "immediate enucleation for working-class patients but a wait-and-see strategy for members of the 'educated class,' whom he believed were capable of better vigilance about troublesome symptoms. Conversely," she added, "another physician suggested that poor people might be better served by leaving the 'shrunken and disfigured globe' rather than performing enucleation, because the procedure would entail the expense of an artificial eye."[2]

The first intentional eye removal for medical purposes that we know of is described in a report by the German physician Johannes Lange in 1555. He did not include details on his technique. For that kind of information, we need to look to George Bartisch, also a German physician and often called "the father of modern ophthalmology." In his treatise on eye disease and surgery, *Ophthalmodouleia: Das ist, Augendienst* (1583), Bartisch got very detailed about what was called "extirpation." It is, of course, gory reading.

One procedure was to use a strong, curved needle—something like you might use on leather today—to pull thick strands of thread in through the bottom of the eye and out through the top, leaving enough on each end to grasp

and pull the eye forward, while simultaneously working a sharp knife or spoon in behind the eye to cut away all the attachments: the muscles, the ciliary nerves, the optic nerve.[3] The procedure to remove a prolapsed eye, or one that is "brimming forward, severely and forcibly," so that it is "very large, repulsive, and abominable to look at," was similar, but without the needle and thread. You would have a strong person stand behind the patient and one on either side, then choose a knife that "must be sharpened all along its blade similar to a razor."

Press it up under the upper lid very fast yet being sure you get clear up on to the bone and skull and continue as far posterior as possible. Encompass the entire eye very fast and quickly, so that the eye is detached and made free on all sides with the greatest speed.

The cut is smooth and very close all the way around up against the skull and bone. That way the ruined material, evil humors, vessels, and nerves are removed to the fullest extent.[4]

Extirpation has been described as "'one of the most severe and repulsive operations in surgery,' 'so dreadful that many refused to perform it,' and 'inhuman except under the greatest and most urgent necessity.'"[5] In fact, until about 1850 "eyes were extirpated practically only in such cases as cancers, tumors, fungus hematodes, etc., and the method was rarely employed under any circumstances."[6] Even with those conditions, surgeons more often left patients "to die with malignancies that slowly overtook their faces, rather than inflict death from the consequences of enucleation."[7] Eye removal was made less horrible by the discovery of chloroform but remained very bad nonetheless.

A key improvement to the procedure, though, came as a result of a description in 1804 by the French surgeon Jacques-René Tenon of a part of eye anatomy that had not previously been detected or that had been recognized occasionally but not accorded the importance it would gain later. This part is a thin sheath that surrounds the eyeball like an amniotic sac, though with a hole over the cornea and another in the back for the optic nerve to pass through. (Previous dissections of eyeballs had often destroyed this subtle feature.) This sheath, which became known as "Tenon's capsule," has a smooth inner surface that allows the eye to move freely, like a ball bearing in a veneer of oil. Within the few decades after Tenon's description of this sheath, eye surgeons learned what was called "simple enucleation." It was all knife work. Descriptions make it sound like a delicate filleting or like dinner prep, as in 1842 when a surgeon named Stoeber shelled the eyeball from within Tenon's capsule—a pea released from its pod.[8]

The safer and tidier operation, however, did not immediately make people forget their dismay over what it had long meant to take out an eye. Even in

1868, when simple enucleation was well established, a Boston ophthalmologist named Benjamin Joy Jeffries, in a talk to the Massachusetts Medical Society, felt it necessary to bring his colleagues up to date, to draw them past the psychological obstacles created by the earlier and cruder eye removals. He began by acknowledging that extirpation *was* truly something to recoil from and that many doctors justifiably felt as queasy about it as did their vulnerable and suffering patients. Perhaps some of those doctors were in the room that evening. "I have found among my patients," Jeffries said,

a perhaps natural horror in reference to the removal of the eyeball, no matter how useless this organ may have become as respects sight, and even when it has been the seat of severe or lasting pain; and I have also found my medical brethren, when bringing their patients to the specialist, shrinking from advising them to submit to the removal of a sightless globe. There seems to be some sort of vague sensation among the laity, and I have found it also among physicians, that enucleation of the eyeball is a formidable and dangerous operation, only to be submitted to in malignant disease, and as a dernier resort. The laity also do not distinguish between the comparatively trifling operation of enucleation of the globe, and the, at present, rarely necessary and more formidable one of evacuation of the contents of the orbit.

What many people had already forgotten, Jeffries gently claimed, was the existence of Tenon's capsule, which, if recognized and employed properly, made it unnecessary, at least most of the time, to go overboard in digging out every last bit of stuff.

For the surgical purposes of our operation we may regard [the capsule] as a membranous sac on which the globe rolls, and which is pierced by the tendons of the muscles, the cutting of which tendons in front of the capsule at their insertion into the globe will leave this membranous sac as a basis or support for an artificial eye, and the muscles being still attached to this capsule will therefore move it and the glass eye lying on it in nearly as great degree as when an artificial eye lies against a stump of the globe left by disease or surgical interference.

This so simple operation . . . is in such contrast to the former one, really to be dreaded, of extirpating the whole contents of the orbit, muscles, nerves, fasciae, gland, &c., that it is a wonder that ophthalmic surgeons did not sooner practice it, but not more wonderful than that even to this day, perhaps, unfortunate patients are undergoing extirpation of their orbital contents, much as certain bivalves are their contents, and with not very dissimilar instruments.[9]

Jeffries's was far from the last word on the subject. The second half of the nineteenth century was a time of vigorous debate and experimentation within ophthalmology about how best to remove eyes that needed to be removed (and about how to know which eyes those were). There were certainly questions concerning cosmetics. "Every patient has the right to be deformed as little as possible," was one typical comment, though there were also criticisms of surgeons who chose certain procedures because they were quick and relatively

easy even though they might result in an appearance "mortifying to the patient and discreditable to the surgeon."[10] And there were questions of side effects—in particular meningitis, which could be caused by infections in the eye being transmitted into the brain, and sympathetic ophthalmia, an unpredictable condition in which an uninjured eye (called the *sympathizing eye*) mysteriously develops inflammation anywhere from days to decades after trauma to its injured partner (called the *exciting eye*). Sympathetic ophthalmia appears as "an insidious onset of blurry vision, pain, epiphora [excessive watering of the eye], and photophobia [abnormal sensitivity to light] in the sympathizing, non-injured eye."[11] It could manifest as minor irritation in the sympathizing eye, or it could lead to complete blindness.

There was vigorous debate, too, about whether eyes should be enucleated (removed completely) or eviscerated (emptied out), a debate that extended through the twentieth century and into the twenty-first.

The first definition of *eviscerate* given in *The New Shorter Oxford English Dictionary* (1993) is intensely physical, even violent: "to disembowel." The second is to "bring out the innermost secrets of," which seems applicable across all realms literal and metaphorical. The surgical definition is to "remove the contents of (an eyeball)."[12]

The first modern recorded evisceration of an eyeball—removing the contents of the globe but leaving the globe otherwise intact and in place—was an accident, an eye surgery gone very wrong. In 1817, "an expulsive hemorrhage" during an iridectomy for glaucoma left a doctor, James Beer, not much choice but to remove what was left inside the eye he did not originally intend to empty out.[13] Another sixty years passed before the Detroit ophthalmologist J. F. Noyes performed the first planned evisceration. By that time, enucleation had become well established as the eye-removal surgery of choice. Yet another surgical calamity, in 1881, would be especially important in the history of ocularistry because of its direct influence on a man who would employ evisceration specifically for the benefit of artificial eyes. In that case, the doctor "accidentally emptied the globe of all its contents in an endeavour to extract a foreign body, and leaving the denuded sclera to the unaided efforts of nature, was so delighted at the patient's recovery that he evolved the term 'excochleation,' or scooping out, but carried his researches no further."[14]

That description is from Philip Henry Mules, surgeon to the Royal Eye Hospital in Manchester, England, who only a few years later would become an enthusiastic early adopter of evisceration. (He apparently didn't know about Beer's accident because he labeled the evisceration event in 1881 as the first of its kind.) Mules hoped, first, that evisceration would allow for better preparation of the socket to accept an artificial eye and, second, that it would

prove just as effective as enucleation at preventing sympathetic ophthalmia. Enucleation's advantage was that it simply took out everything likely to cause a problem.

In the mid-1880s, no one had solid proof of what might cause an injured eye to seduce its healthy companion into blindness. In fact, there is still some uncertainty today. There are no lab tests to confirm a diagnosis of sympathetic ophthalmia. You can look for some common symptoms, such as the insidious ones described earlier, as well as inflammation, a thickened iris, an elevated intraocular pressure (or a lowered one). You can do some clinical tests to rule out other diseases that might have similar symptoms.

Mules went on the assumption that "infecting particles" from the injured eye begin to travel toward the healthy eye. This thesis was dominant for a while. Attempts to stop that traveling had previously been mechanical, with enucleation and a surgical procedure called "optico-ciliary neurotomy," which had been tried off and on since at least 1853. In that process, the eyeball was left in place and intact, and the surgeon reached behind it to sever the optic nerve as well as the ciliary nerves, which enter the back of the sclera and eventually control pupil dilation. The surgeon would also slice off a healthy section of the optic nerve. If that nerve and/or the ciliary ones (there were differing views on which were "the real offenders") provided the routes for infection, the solution was to remove those routes. (Surgeons did have to recognize, though, that if they were taking out an eye suffering from an all-encompassing infection called "panophthalmitis," removing part of the optic nerve could open "a pathway of infection from the eye to the brain."[15] Such cases led to fatal meningitis.)

Mules opted for a chemical approach. During evisceration, he suggested, thoroughly clean out the globe before any traveling could get underway. Use the proper antiseptic—plenty of it.

At a meeting in 1885 during which Mules read to his fellow doctors a paper about his new work with evisceration, he met with some conservative skepticism. One doctor suggested Mules might be a tad too confident about the exact cause of sympathetic ophthalmia (what this doctor would later call, in a paper of his own, "sympathetic mischief"). Wouldn't it be safer, he proposed, to continue removing injured eyes as ophthalmologists had been doing successfully for thirty years: Take everything?

That hesitation came from W. Adams Frost, assistant ophthalmic surgeon to St. George's Hospital in London. It wasn't his only question for Mules. He also "enquired as to whether the operation of evisceration was not much more tedious than enucleation." Mules admitted that evisceration *was* tedious—but nonetheless worth it for an operation that also appeared to be "less formidable

to the patient."[16] Though possibly with a grumble, Frost did seem open to what might come of Mules's further attempts at evisceration. Just be sure to clean out the globe thoroughly, Frost told him.

Mules and Frost remain tied together in the history of ocularistry. Mules is by far the more well known, as is often the case for originators, inventors whose names become attached to what they invent. Frost is secondary because he took Mules' ocularistry-centered invention and tweaked it in his own way. But the two of them together were at the forefront of issuing in a new era for artificial eyes, employing a relatively simple but new methodology that remains standard practice even after a century and half of further experimentation in materials and intricacies of design.

Here was Mules's idea: After emptying the globe of its natural contents, insert "a light hollow glass sphere."[17] This sphere would preserve the shape of the globe. Mules called the glass sphere an "artificial vitreous." Later medical literature referred to it as a "Mules sphere." Most often today it's called a "Mules implant." (The word *implant* refers to the object or material, usually spherical, that fills the volume of an emptied socket or globe. The word *prosthesis* refers to the convex shell that fits into the front of the socket and is visible, though it's also sometimes used casually to refer to the combination of implant and shell.)

For Mules, the key to the success of the implanted sphere was evisceration— because not only would evisceration (he hoped) reduce the risk of sympathetic ophthalmia, but it would also (he hoped), with the glass sphere inserted, "leave a firm healthy support, or stump, in every way superior to that normally seen after enucleation."[18] In other words, this method would leave a better-prepared site for an artificial eye.

More specifically, Mules wrote, there were half-a-dozen straightforward advantages to his method. Rather than in a sunken eye after enucleation, the Mules operation resulted in a "firm, round globe forming perfect support for artificial eye." Rather than an enucleation's "arrest of movement" through muscle removal, the patient would have "perfect harmony of muscular movements retained." There would be no "fixed, staring eye attracting attention" but instead an eye that "defies detection." The patient would not shun society, as might one who had an enucleation, but instead would have "no qualms as to personal appearance." And in the case of children, there would be "no interference with growth of orbit."[19]

Mules described the steps of his operation with similar clarity and simplicity.

1. Anesthetise the patient.
2. Use hand spray and thoroughly cleanse and disinfect the appendages with 1 to 1000 corrosive sublimate solution.

3. Transfix and remove the front of the eye with a sharp knife at the cornea-scleral junction; it is better, I think, not to cut the conjunctiva.

4. Empty the contents of the globe in any way that is convenient, taking special care to remove the ciliary body and choroid, leaving only a clean white sclera.

5. With a thin india-rubber tube used syphonwise, run the sublimate solution into the eye the whole time the operation is being performed; to make sure I use the hand spray also, and continue this till the bleeding ceases or nearly does so.

6. Select the size of glass sphere best suited to the case. Slit the sclera vertically until the glass sphere will with difficulty enter the cavity. Understand this difficulty only refers to getting the globe *in*; when inside it should fit so that the sclera unites easily over it and without leaving any awkward angles.

7. Sew up the sclera along the cut edge with prepared catgut, taking care to obtain good apposition.

8. Spread a layer of finely-powdered iodiform over the whole conjunctiva, and dress with wood wool in a double layer of Lister's gauze.

9. Keep patient, as a precautionary measure, in bed for three days, and dress all the time under spray.[20]

When Mules read his paper in 1885, he and his assistant had already treated nine patients with the combination of evisceration and implant of an artificial vitreous. He had learned a lot, especially about the proper kind of antiseptic to use, as he summarized to his colleagues: "Of the nine [cases], the first six gave me some anxiety, for they all suppurated more or less, though finally, with one exception, doing well; these six were performed, as I have previously mentioned, under the protection of 'corrosive sublimate' solution. Fearing that the glass sphere caused the irritation, I removed it from the second, third, fifth, and sixth. Now that I know that it did not do so I proceed with perfect confidence to complete the operation as originally designed."[21]

Frost, for his part, remained steadfastly convinced of the wisdom of enucleation over evisceration. In his article "What Is the Best Method of Dealing with a Lost Eye?" (1887), he was adamant about enucleation simply being safer and about evisceration being something of a roll of the dice. Yet he also expressed enthusiastic praise for the cosmetic results of Mules's operation: "There can be no question in the mind of anyone who has performed the operation," he wrote, "or seen its results, of the excellency of the stump that is produced; not only are its movements free, but the natural prominence of the eye is preserved." He therefore wondered: What if eye surgeons could "combine the safety of enucleation with the cosmetic effect of Mules' operation"? He went on: "The following is a suggestion having this object: that the globe should be enucleated in the usual way, that the four recti [muscles] should then be held apart, and a glass sphere be introduced into Tenon's capsule, and the tendons, capsule, and conjunctiva be united over it."[22]

By the time Frost wrote his article, he had tried this technique only once. It didn't really work because, he admitted, his "method of suturing was certainly defective." After four days, the sutures "cut out," and the glass sphere was exposed. He removed it. Nevertheless, he was hopeful that the bugs could be worked out.

Frost had one other argument in favor of enucleation: it saved more eyes as specimens for medical study. "If all lost eyes are to be reduced to a pulp and removed piecemeal," he wrote, "our pathological knowledge will be at a standstill."[23]

The evisceration-versus-enucleation debates would continue—and would actually never be completely settled. An article in the *American Journal of Ophthalmology* in 1908 listed the four questions generally asked when comparing the two operations: (1) Which operation is simpler? (2) Which results in a better stump—and hence a more successful prosthesis? (3) Which best safeguards against sympathetic ophthalmia? and (4) Which best safeguards against other side effects, such as meningitis, sinus thrombosis, and infection of the orbital tissues?[24] Worries about sympathetic ophthalmia did lessen, if only because the condition didn't occur after evisceration as often as was initially feared. In 1949, a survey of research comparing both surgical options, which of course had more data to draw upon than the few cases Mules and Adams had, concluded "that sympathetic ophthalmia is a definite, although small, possibility following evisceration and that it probably never actually begins following enucleation." The updated advice to surgeons, therefore was to put that fact, for whatever it's worth, in the antievisceration column.[25]

A much more recent report noted in 2012 that the "small" possibility of sympathetic ophthalmia after intraocular surgery is actually 0.01 percent, though it also admitted that the true frequency of sympathetic ophthalmia is an ever-slippery number to pin down because of the lack of a laboratory test, the paucity of cases to evaluate even from a century and a half, and the fact that "most data are from the dated literature that often confused SO [sympathetic ophthalmia] with other forms of uveitis." In a list of surgical procedures after which sympathetic ophthalmia has ever been reported (including two procedures I had: cataract extraction and retinal-detachment repair), enucleation is not mentioned, but evisceration is. The authors conclude pretty much the same thing as the review from sixty-some years earlier: "Although it would appear that evisceration after severe ocular trauma is a safe option with a very low risk of developing SO, it is known that SO may occur due to uveal tissue remaining behind in scleral emissary channels. We suggest the surgeons pay particular attention to the theoretically increased risk of SO after evisceration versus enucleation."[26]

There were no such dichotomous debates in one of the primary areas of ocularistry research during the twentieth century, on the best kind of ocular implant, but there was a great deal of trial and error. The search was perhaps surprisingly difficult because what the implant is intended to replace—the vitreous humor—is transparent and colorless, is composed mostly of water, with a bit of collagen, sugars, electrolytes, and proteins, and has no moving parts or intricate structure: basically a glob with a shorter ingredient list than you would find on a jar of chutney. (After an enucleation, the implant has to replace the vitreous humor and the globe of the bygone eye.) For instance, as Mules admitted right away, a glass sphere would be a mess if it broke, though he did also seem confident that such breakage was unlikely unless the patient got hit by "a direct violence . . . that would rupture the eye in its normal state."[27] As the Mules implant became more frequently used, another shortcoming became obvious, though. The smooth glass ball, untethered to any restraining muscles, tended to move out of the place where it was supposed to be. Sometimes it fell deeper into the tissue and so allowed the socket to retract anyway, and sometimes it came forward, extruding through the tissue behind which it was intended to stay. A report in 1898 surveying the results of 343 Mules operations found that "21.3 percent led to extrusion."[28]

Ophthalmologists experimented with a variety of substances that might do the job of the vitreous well. None really did.

Aluminum balls disintegrated and broke down in the scleral sac. So did silver balls, which also tended to cause argyria: skin turning blue or blue gray from an excessive exposure to silver—not a dangerous condition but unwelcome nonetheless.

Paraffin had a number of advantages: easy to cut to any size and shape; unbreakable; molded by body heat to the contour of the socket; soft enough for tissue to grow into it and thereby for it to be held more firmly in place. Still, this material didn't make the cut as a long-term option.

The first attempts at implanting small chunks of fat taken from the buttocks or fat and skin taken from the deltoid region began in 1901, and the results over the next decade were generally good. The fat almost inevitably shrank some but in most cases retained its shape well enough to provide a prominent stump on which an artificial eye could rest. Because fat grafts come from the eye wearer's own body, they have the advantage of being unlikely to cause any "chemical antagonism."[29] They're still common today.

One surgeon thought a hollow rubber ball could work well. He tried it on a rabbit. The rabbit "accidentally died," and that was the end of that experiment.[30]

Initial good results, though from a very small sample, came from attempts with using balls of polished bone and balls of elder pitch, though neither material offered enough advantages to catch on.

Whatever the material and design, implants not only needed to fill the space resulting from an enucleation or evisceration, especially to thwart the accumulation of fluids behind a prosthetic, but also to help give the artificial eye more motility—that is, the ability to point up, down, left, and right in conjunction with a wearer's real eye. The latter quality was what Adams Frost was complimenting when he noted how free were the movements of an artificial eye placed on a Mules implant.

Ocularists had been making avowals about the excellent motility of the eyes they made even well before the arrival of implants, back in the days when "fixed" eyes were common. Such claims were likely built on more optimism than could really be justified. In 1829, for instance, Dr. John Scudder advertised that an eye of his making would "*wink and move with the real eye in any direction.*"[31] An ad for the eyes made by Auguste-Pierre Boissonneau in 1863 did not specifically claim motion but implied the consequences of it: "It is well known that a frightful Glass Eye, motionless, dirty, and corrosive, is superseded by a little *chef oeuvre* of enamel, solid, light, comfortable, and endued with the most expressive power of emotion."[32] And the Victorian journalist Henry Mayhew's portrait of makers of doll's eyes and human eyes in 1850 quoted one eye maker's claim that "our artificial eyes move so freely, and have so natural an appearance, that one gentleman passed nine doctors without his false eye being detected. There is one lady who has been married three years to her husband, and I believe he doesn't know that she has a false eye to this day."[33]

The Mules implant kicked off the first phase of implant design: the *buried implant.* Until the 1940s, everyone sunk the implant, whether of glass or any of those other materials, behind the tissue of the eye socket.[34]

Then came the *exposed integrated implant.* "Integrated" meant it was sutured to the eye muscles, the thread woven through mesh or tunnels on the implant. "Exposed" meant some part of the implant protruded into the open socket—a square peg, a screw with a notch in the top, two thin stainless-steel or gold pins. There were dozens of various designs up through the 1960s. The protrusion would fit into a "female" receptacle on the back of the prosthetic eye. Less often, the peg or maybe a small sphere was fused to the back of the prosthetic, with the female receptacle exposed on the implant. Either way, you would essentially plug the implant and the prosthetic together, like Legos. If the recti muscles were connected directly to the implant, and the implant was connected directly to the prosthetic, the contractions and elongations of the

eye muscles would transfer through the implant and into the prosthetic with very little loss of force. Hence, motility.

The big problem, as anyone familiar with, say, a port installed into their chest for the convenience of chemotherapy treatments knows, is that a medical device that needs to be simultaneously inside and outside the body is prone to cause infection. Bacteria can pass through the imperfect seal around that device. (A third of people with implanted ports have problems with infections, mostly ones that can quickly lead to life-threatening sepsis.[35]) Too many such infections arose with pegged implants, and there was also a high rate of extrusions. Pegged implants have not completely disappeared from use, but they mostly gave way after the 1960s to a design that sacrificed some motility for a much lower chance of infection. This third phase of design was that of the *buried integrated implant*.

The integration with the eye muscles was the same in this third design, but the force of the muscle movement got transferred from the implant to the prosthesis through friction rather than through direct attachment. It was all about contouring the front of the implant and the back of the prosthesis so that they snuggled together, even with the thin and protective tissue of the socket between them like a blanket.

Many, many variations of this third design appeared, most dimpled in some way so that hill fit into valley and valley enveloped hill. To create extra hugginess, some ocularists had magnets embedded within both the implant and the prosthetic. The Iowa-based ocularist Lee Allen, who practiced from the 1940s through the end of the twentieth century, worked with an ophthalmologist coincidentally named James Allen to create the "Allen implant" (named after James rather than Lee), the first version of which had a thin and exposed connecting rod, but the second version of which was completely buried. A later version, which came to be called the "Iowa implant," was a ring with four mounds, or pips, protruding upward. Once the implant was in place, the conjunctiva and Tenon's capsule were molded surgically over the pips so that they were prominent in the socket and could fit "into corresponding depressions in the back of the plastic eye."[36]

The fourth and still current phase of implant design began in the 1980s. An ophthalmologist in southern California, Arthur Perry, had been experimenting with making round implants from human bone and bone marrow or combinations of these materials. His tests in rabbits provided good initial results, he told me when I called to ask about the history of that work—that is, until the implants got reabsorbed. One day while preparing to go into surgery but also thinking through the obstacles he was encountering, he asked an orthopedic surgeon how he could get bone to live inside the orbit.

"'Well, you probably can't,'" the surgeon told him, "'because bone, to maintain itself, has to have stress on it.' Just like if you put your arm in a cast for six months, you'd lose mineralization of your bone." But that other doctor also knew of a company nearby that was trying to make artificial teeth using a material that bones are made out of: hydroxyapatite, commonly referred to as HA. "'Why don't you give that company a call,'" Perry said the doctor suggested, "'and see if they can get you some material, and you try that in rabbits?' That's what I did."

The new material mostly worked. However, Perry's implant design included a peg, and drilling the required hole caused sandlike grains to "eke out" of the HA—not something patients would welcome in their sockets. Perry found another company offering a lower-density HA from sea coral, specifically a particular species growing in the southern Pacific, near Bali.

"That's what I used," Perry said. It's what he was still using when we talked. The big advantage of HA is that it has the same micro-architecture as human bone, with a host of tiny passageways snaking from the implant's surface through its interior, labyrinthian-like. If the implant is going into an eviscerated eye, it's sewn inside the remaining scleral sac, which is still attached to the eye muscles. If it's going into a postenucleation socket, according to a patent Perry was granted in 1990, it can be sewn "within a scleral sac, preserved dura or other homologous or autologous collagen graft material"—meaning any such material gotten from the patient or from, say, an eye bank or tissue bank. "The muscles which move the eye are attached to the implant by suturing them to the cover material," the patent explains. "Alternatively, the implant may be inserted into the orbit without being covered by a graft material and the eye muscles sutured directly into small holes drilled into the implant for that purpose."[37] A more recent version of the implant is coated in a smooth and perforated material, allowing it to slip into the socket easily and giving a surgeon holes through which to loop the sutures attached at their other ends to the eye muscles.

In the months after surgery, blood vessels and fibrovascular tissue begin to worm their ways into the implant's passages, tightening it into place. "So over a period of time," Perry told me, "it actually becomes a living part of their body."

To hear of anyone harvesting coral for any reason when coral reefs worldwide are under intense stress from warming oceans is to wonder about the ecological sustainability of this application. Perry has been to Bali to observe the harvesting operation. It is, he said, a government-controlled operation. The amount of coral harvested for ocular implants is miniscule. He compared it to "going through a forest in Oregon and cutting down one little sapling." Also, when the divers take a piece of coral, he said, "they break off two and

stick them in the ground, so they take one piece of coral but grow two. They're actually replenishing it [the reef]."

Nevertheless, many oculoplastic surgeons choose artificial versions—or biocompatible versions, to use the marketing term—that have the same implant design. One is made from aluminum oxide, another from silicone (the kind I have). The theory is the same: the blood vessels search out and fill those many tunnels, and ideally the implant is going to transfer the movement of the eye muscles efficiently to the prosthetic and is never going anywhere. Alas, though, nothing is ideal. Reviews of cases with porous implants of all materials during the past twenty-five years or so have cited a not insignificant number of implant exposures, often requiring surgical repair.[38] There have also been suggestions on how to insert an implant so it's less likely to sneak out in the first place. For instance: Don't force in a rough-surfaced implant because it can inadvertently drag some of the tissue into the depths of the socket. When everything eventually relaxes, as it naturally will, the implant will get pushed more forward than it should be because of the dragged tissue and possibly wear through the tissue that covers it. Instead, use a smooth glide, which can be "fashioned from the thumb of a sterile polythene glove."[39]

With an HA implant, the peg is optional, and it isn't even added until about six months after the implant is inserted, enough time for vascular tissue to do its permeating. An unpegged implant, in fact, can often provide plenty of motility. (Porous implants made of silicone or aluminum oxide are not pegged. Mine isn't.) But if the patient does want more movement, the surgeon drills into the front of the implant and screws in a threaded titanium sleeve, the opening of which is accessible in the socket, Perry said, "just at the tip, at the very surface." The ocularist attaches a peg of some design—locking socket, fenestrated, and so on—to the back of the prosthesis. As the eye goes into the socket, the peg slips into the sleeve, from which it's also easily removed.

Perry has been using the HA implant, pegged and unpegged, for several decades. For him, it's "the gold standard." It's not flawless, of course.

"I always tell patients, 'You'll have a little bit more discharge than you'll normally have because you've got this piece of plastic that's moving back and forth all the time. But it's not to the degree that I wouldn't do it.'"

And he insisted that some of the "complications" for the pegged HA implant noted in review literature (the eye moves so much you can see the edge of the implant; there is sometimes a clicking sound from the peg) are things a good ocularist can address. Nonetheless, he recognizes, too, that most surgeons opt for the biocompatible, nonpegged porous implants.

"I've done so many of them it's easy for me," he said of his version, "but it's not as easy, from what other guys say, it's not as easy, mainly making the hole

so it's perpendicular to the frontal plane of the patient, so it's not angled off or in the wrong spot or something like that. Plus, I don't think the surgeon . . . you don't get paid much for it, so guys aren't all that anxious to do it. I mean, I get patients all the time we do it on, but they say, 'Well, the doctor told me, "Oh no, your eye movement looks great. Don't do it. You could get infected and have to start all over."' I mean, you can couch it any way you want and make the patient say, 'Oh, I'd never have something like that.' But I get great results, and people, you know, when they have an infection or something like that, and we say we're going to have to take out, not the sleeve but the peg for a little while, they can't wait until they get it back. Patients appreciate any little bit of movement they can get, to make it look natural."

I long ago began to appreciate a mechanistic handling of my eye, with ophthalmologists approaching it as I would a clogged drain or rusted muffler. In trying to get a good look at my eye's interior condition, one doctor told me, "I'm just going to mash around in here a little." Another doctor and a nurse straightforwardly solved a problem that arose two weeks after the surgery to reattach my retina. A bubble of 25 percent SF6 gas inside my eye, meant to hold the retina in place until it adhered, had deflated. The retina had not yet adhered, so they needed to reinflate the bubble. I sat in a chair while the nurse wrapped her arms around my head. The doctor wielded a long needle. The procedure was as simple as pumping up a basketball. An initial resistance, then the give.

In October 2009 at fifty years old, I felt relatively prepared to have my troublesome eye removed. An ultrasound a week earlier showed that I had no tumor and therefore was, according to the report, "a good candidate for an evisceration of the right eye." I had been referred to a surgeon who worked out of a specialty center rather than a hospital. My wife and I drove there on a Friday morning. The surgery would be outpatient.

In the waiting room, people sat quietly in blue chairs. The TV played softly. Many were twenty or thirty years older than I; a few were younger. This was an oculoplastic facility, and the range of treatments that patients were there for that morning was wide: forehead lifts, skin cancer removals, care of tear-duct infections, Botox injections, skin rejuvenation. Maybe it was nervousness, but I felt a hard nostalgia for the eye I had hated for so long. I recalled fondly an old remark that had seemed to me a compliment. During the years I'd had that upside-down keyhole shape for a pupil, a friend told me it made my eyes look like those of a wild horse.

Outpatient eye surgery is misleadingly casual. I got called back to the preop room, and I sat in a comfy leather chair separated from other comfy leather chairs by blue curtains, while a nurse started an IV, and the anesthesiologist

explained that I would be put fully under but would be brought back to con-
sciousness as soon as the doctor was done. Probably forty-five minutes total. I
could wear the clothes I had on.

And here's what my surgeon did during that brief time: He cut away the
cornea and several millimeters of sclera in a circle, like opening a lid or the
hatch to a deep-sea submersible. From there, he separated the uveal tract from
the inside of the sclera. He cut the retina away from the optic nerve. He lifted
out everything as a whole: the iris, ciliary body, uvea, lens, and retina. He
placed it all in a tray so that it could be sent to the pathology lab for examina-
tion. Before him, then, was an empty sclera, basically a bowl.

I have imagined myself lying on that operating table while the doctor held
the silicone sphere above my empty sclera and dropped it in like a marble into
a cup. That's not how he did it, though, because the ball has to fit too snugly
for an easy plop into its space. So first he made a couple of cuts in the sclera to
create some give, and then he pushed in the sphere with a tool called a "sphere
introducer," which holds the ball within thin curved arms until the doctor
depresses a plunger. (Another matter-of-factly named tool used during evis-
ceration surgery is the evisceration spoon.)

Once the orbital implant was in place, the doctor tugged the edges of the
sclera together horizontally across the front, then sewed them tightly with
fast-absorbing gut sutures. He sewed shut the other two layers that go over the
sclera—Tenon's capsule and the conjunctiva. Atop these layers he set a piece
of hard plastic shaped somewhat like a very thick contact lens or like the part
of the artificial eye the ocularist would later make. This is called a "con-
former," and it would support my eyelids in their proper places for the next
month and a half. (Eyelids can quickly droop and be hard to reshape.) The
doctor threw in some Hypafix and a tincture of Bensoin, then taped a few
stacked eye pads over everything with moderate pressure. Bingo.

The operative report concluded with this statement: "The patient tolerated
the procedure well."

I may have been woken up in the same comfy leather chair I'd sat in earlier,
maybe in the same room, but maybe it was a different chair in a different
room. I know the chair reclined and that a cold pack lay over my eye and fore-
head. As I got more clear-headed, the nurse reviewed post-op care instruc-
tions. I registered them vaguely: ointment, pain pills, if anything unusual
My wife, I assumed, was getting the details. Did I want a snack and a drink?
I might have said yes. Did I want to rest a little more before going home?

I wanted a lot more rest. What I took was probably an hour. Then the walk
back through the waiting room felt much different than my time there before,

not only because I was queasy and weak (and emphasizing my suffering for the crowd by shuffling more than necessary and letting my mouth hang open) but also because I was now a person who had lost an eye. It was an eye I had chosen happily to lose, but now that it was lost, I was simply in a different category—that of Philip of Macedonia, the father of Alexander the Great, who was struck in the eye by an arrow and apparently had an artificial eye carved from wood; of the man (according to a report in 1909) who replaced his lost eye with half of a prune pit, honed to smoothness with a whittling knife and adorned with a pearl button for the iris; and of the guitarist Ry Cooder, whose music I liked and who had lost an eye at three when he accidently stabbed himself with a knife. I understood, even then, that I'd had plenty of time to prepare for this change, that the trauma of my eye loss was not of the same scale as the trauma of anyone who'd lost an eye unwillingly and without warning. But the physical trauma was real. Whatever neatness and simplicity modern medicine projects, whatever nonchalance outpatient surgery implies, cutting and spooning out an eye is a harrowing invasion. The emotional element would make itself felt or not in the coming days and weeks.

Through the afternoon, evening, and night, I took the pain pills and then threw them up. I vomited repeatedly. I tried to sleep but couldn't. I moaned with an intensity that made my wife feel helpless, so that both of us felt that way. The pain was an unrelenting fifteen on a scale of ten. I wanted to think it was unusual, that nothing could compare, but in fact it simply made me recall moments of torment after my previous eye surgery, the attempt at retina re-reattachment. On that occasion, I had woken to the same brilliance of pain but was still in the hospital with a nurse close by. She had hit me in the hip with a shot of Demerol, and I had fallen back asleep almost instantly—a magical liberation. Then, during the following month, a side effect of the surgery lingered. While I'd been on the table, the doctor had nicked my cornea with his scalpel, the way you'd pop a blister, because it had begun to cloud up. The tiny cut refused to heal. Almost every day for weeks I returned to the hospital to have someone tweezer off a layer of epithelial cells that raked into a bramble whenever my eyelids, which were supposed to be held closed with a pressure patch, accidentally swept across them. They felt like shards of glass. My only other relief was when an Arctic freeze dropped over the area, with wind chills at 60 below, and I bundled into wool and down and fleece and layers of cotton, covering everything except my eyes, and went out into the black night, into the bitter wind and dry, blowing snow, and stood on the sidewalk as long as I could—seven or eight minutes—and let the unsparing air freeze away all

sensation, as if I were dropping the eyeball into liquid nitrogen. Some nights I went out every half hour, until the cold began to teeter past medicinal and nearer to calamitous.

Now I had neither Demerol nor numbing cold. My wife called the doctor's office at 2:00 a.m. They were surprised I was feeling so bad. "That doesn't typically happen," they said. I could come in if I wanted. But a car ride sounded as alluring as a stick in the eye. I moaned more, finally fell asleep before sunrise, and could keep the pain pills down the next morning.

The liminal period between my old eye and new eye was one in which I could not stay hidden. And my empty socket was much more startling than anything my eye had looked like before; what I felt was an amplified repulsiveness. An eyepatch I bought at the drugstore served its purpose imperfectly. Since my eyes are fairly deep-set, the lower edge of the patch didn't fit flush against my cheek. Several other patches had the same shortcoming. Anyone much shorter than I who stood in front of me could see through the gap between my nose and the patch's stiff border. I knew this because one day, a few weeks in, my daughter, who was eleven at the time, said, "Dad, I'm getting used to your eye, but it still freaks me out."

Behind the patch, if all were going well, the blood vessels would be meandering into the implant's passageways. The exposed surface of the socket would be turning the pink of the inside of one's mouth, with the same softness and fleshy texture. The conformer would be supporting my eyelids in their proper places.

Most surprisingly, the bad eye's absence gave my good eye a fresh lightness. I could read for long periods, watch a full movie, drive for hours. I did not have to get used to seeing with only one eye because I had always been monocular. The throbbing headaches were gone.

I wouldn't read the pathology report on my eviscerated eye until years later, when I requested it, but it would have been a confirmation then, as it is now, of my choice to be done with the eye. The report describes an interior reality worthy of the eye's exterior ugliness. The cornea was "massively thickened." There was a "thick retrocorneal fibrovascular membrane obliterating the anterior chamber." The posterior chamber was also "obliterated." The pigment of the iris showed "post-necrotic changes." There were no photoreceptors on the retina, a sign of long-standing detachment. The internal limiting membrane was wrinkled. There was "dense subretinal scarring" (the main reason for this scarring, according to the ophthalmologist who had tried to reattach my retina twenty years earlier, was that the thing wouldn't stick back

in place). Interestingly, there was "bone formation" in the posterior uvea. In fact, when the lab received the specimen and tried to cut it in half to investigate, "bone was encountered in the collate." They had to decalcify the eye for half a day before continuing.

I don't know what the lab did with the eye after dissecting it and noting its many failings—probably dropped it into a can of medical waste. "Good riddance," I thought again when I read the report, as I had thought at the time of the surgery.

Dave and Vaune Bulgarelli, Father and Daughter Ocularists

DAVE: All of my employment through high school had been digging ditches and working utilities—where the money was. And before I went into college, I wanted to clean up my act and so applied for full-time work. My intention was to quit in the fall and go to optometry school. But there was an opening in the eye department at the University of Iowa Hospital, making eyes. I interviewed, and I liked it, and they liked me. I started and fell in love with it.

VAUNE: Two weeks later he was making eyes. Just about.

DAVE: My only regret is I finished high school on a Friday and started working on Monday. If I'd have known this could be lifelong, I probably would've taken two weeks.

VAUNE: I've been here full-time since 1988. And when I was in college, I was part-time.

DAVE: She started her training in '88. Actually, when she was in high school, she was in a . . .

VAUNE: A girl's woodshop class. I made my own paint set back then because this is what I wanted to do. I knew since basically third grade. [Laughs] When you grow up around it . . . yeah. I majored in English, minored in journalism. At the university, that's what I was after. But this is what I wanted to do.

DAVE: And she's done very, very well.

VAUNE: I love what I do. I can't imagine doing something else every day. What do I like about it? Too many things, I guess. It encompasses art, it encompasses science, it encompasses helping people. You just get to create, and you get close with your patients, too. You go see them, and there's a bond there. And I like that. I like to work individually with people. Some have high expectations, some have no expectations, and it's just cool to see people's reactions, too. I don't know, I like getting up and doing it every day—okay, maybe not too early. [Laughs] But, once I'm here . . .

DAVE: We're very fortunate that it's a two-day process, and the person's in your chair 80 percent of it. They get to know us, and we get to know them.

VAUNE: There is a lot of therapy.

DAVE: Oh, absolutely.

VAUNE: I am emotionally invested in every person. Sometimes you're exhausted at the end of the day.

DAVE: Sometimes you feel bad because you were not able to fix something to make it look just right. You can make the eye look alive. The artificial eye can—with the painting techniques and things like that—it can look absolutely alive. But sometimes you can't get that utopia thing. And you feel bad.

VAUNE: You know people say, "Why don't you have pictures of your eyes out on the web or up on the wall?" And it's because not everybody's the same, not everybody loses their eye the same. Some people have a horse kick them in the face, and they're not going to look like if you just had your eye removed because you had cancer in it, and there's no structural things that went on, and you don't want people to be too envious of others that maybe don't have those things. I mean, my patient today saw a bunch of polishes come in, and she said, "Why do some look more real than others?" Well, everybody's different. How they lose their eye is different, their lid structure is different, and some people will go around wearing an eye that's thirty years old, and they're okay with that!

DAVE: You have eyes lost in such ridiculous, unrepeatable ways. We had a girl with her boyfriend riding down the interstate, and a truck going the other way was carrying two-by-ten lumber. A piece fell off the truck, tiddlywinked across the median, went through the windshield, and took the side of her face off.

VAUNE: It was right before her senior year. She had to relearn to walk because there was mold in the wood, and it broke away her nerves, and they had to clean out her nerve ends and her spine. It was a bad deal.

DAVE: And there's the wheat combine. A car hit a combine, and the gal had her arms up like this [in front of her face], and the pin went through wrist, wrist, and eye. I mean, there are horrible ways people lose eyes. Being kicked by a horse crushes all the bones and really screws things up. There used to be quite a lot of anhydrous burns, and they'd lose the eye. When I first started making eyes, it was not unusual for people to lose an eye in an industrial or farming accident like that and then within a year lose their second eye in the same way. At the Galena mines, they'd be packing dynamite, and someone would blow one eye, and then a couple years later blow the other. People were working around steel and hammering things in, little chips of metal, and not wearing safety glasses. And then OSHA [Occupational Safety and Health Administration] started up. Bless OSHA because now I haven't seen eye losses like those in forever, that I can remember. The safety regulations made a lot of difference.

* * *

DAVE: I made one woman an eye after her mother-in-law had passed away just a week before. She called about three months later and wanted me to make a new eye because she felt that first eye looked sad.

VAUNE: That's how good you are. I had another patient who had a hard time with his eye loss, and he was, I think, nineteen or twenty at the time, and after he had his eye removed, he basically became a social recluse because he didn't want to have to tell anybody he had his eye removed. Then when I got done making his eye, he wasn't sure how to re-enter the world. Nobody had seen him, really, without an eye or now that he had an artificial eye. He had a beard at the time, and I said, "You know what? Shave your beard, and then when you see people and they ask what's different, just say, 'I shaved my beard.' You're not lying, but you're delaying what you have to say." That's what he did. And then once he was ready to tell the story, people didn't believe he'd ever had his eye removed.

DAVE: It's enjoyable, people are enjoyable. You might run into a grump, but within an hour they've swapped over. It's really crazy. I made an eye for one person, and they threw a party in the town square, and the people paraded by to see her eye. They were so interested in it, and she was interested in teaching. I had a schoolteacher I made an eye for, and on the first day of class she would take it out, tell her students all about it, get the mystery out of the way, so they wouldn't be talking around her back. They'd get a life lesson, and that would take care of it for the year.

VAUNE: My patient who just came in for a polish this morning worked for a home-schooling group. She brought almost twenty students who were at my desk while I was making an eye. Everybody had questions. Why wouldn't you, though?

DAVE: I don't normally carry these in my pocket . . .

VAUNE: What are you carrying?

DAVE: I got an eye in my pocket! [Laughs]

VAUNE: Why do you have an eye in your pocket?

DAVE: Because I'm going to my foot doctor tomorrow, and he wants to see what an eye looks like! [Laughs]

3

Impression

The arrest of Baron Von Schoenewitz in Hoboken, New Jersey, in November 1911 "threw much light on the glass-eye business of the country."

According to the *Brooklyn Daily Eagle*, Von Schoenewitz, who had lived in Hoboken for years with his wife and family and had been a "striking character" in town what with his handsomeness, his blond curly hair, and his blond mustache, had arrived home the previous Monday aboard the steamship *New Amsterdam*, which had sailed from Europe. Other passengers on the ship had conferred upon the baron "all the honors due a gentleman of that rank."

And yet Von Schoenewitz was no baron. He was, in fact, as the article put it, "generally known as plain Bruno C. L. Schulze." The one honorific he could claim because it was given to him by US Customs officials after they raided his office at 511 Washington Street and found 14,000 artificial eyes—all meant for human use, as opposed to those for dolls, and all made in Germany—was "'king' of glass-eye smugglers." Schulze claimed his office was a factory for the manufacture of glass eyes. The feds determined it was a blind for Schulze's smuggling operation.

Schulze's scheme had worked like this: He hired several employees of the German-line steamships to convey the eyes from Germany across the ocean to New Jersey, then carry them off the steamers "by several methods" to a printing office on Bloomfield Street run by a Schulze accomplice, whom the feds also arrested. From that hidden stock, Schulze supplied "oculists and opticians all over the country" at discounted prices that put some other dealers out of business. Over more than a decade, he smuggled in an estimated 100,000 eyes. The *Daily Eagle* summarized his financial strategy this way:

There is a duty of 60 per cent. on artificial eyes. Germany practically controls the trade. Only a small number are made in this country. In the glass eye trade ordinary stock is sold at $60 per 100 eyes. When they are sold in lots less than twenty-five oculists and opticians pay $2.50 apiece. Those that are made by special order cost considerably more. By evading the 60 per cent. duty, the Hoboken dealer was able to

undersell other dealers in the trade, according to the customs men. Artificial eyes of all types come under the tariff schedule as decorated glass.[1]

Schulze was convicted of smuggling, and the 14,000 eyes seized were sold at auction for 24 cents apiece. A few months later, the US District Attorney's Office in Chicago filed *United States vs. 2,659 Glass Eyes* against the Geneva Optical Company, based in upstate New York but with an office in Chicago, for buying eyes from Schulze, despite knowing they had been smuggled.[2] Those eyes were eventually sold at public auction as well. "Want a Good Glass Eye? Officer Has 2,659 to Sell" was the headline of one newspaper article.[3]

Around the same time as Schulze's arrest, in late 1911, customs officials also confiscated a "large consignment of artificial eyes that had been smuggled in at the port of Baltimore," apparently by another opportunist. That event was reported first in the *Chicago News* and then reprinted in the *National Glass Budget*, a weekly review of the American glass industry. But the writer of the article, Ethelbert Stewart ("whoever he is," the editors of the *National Glass Budget* appended to his byline when they reprinted his article), was less interested in the drama on the illicit edges of the prosthetic-eye world than he was in what the smuggling implied about the declining state of American eye making. In fact, he said, the smuggling "reminds one that the industry of making glass eyes has long ceased to exist in the United States."

"In 1883," he explained, "nearly all the glass factories in and around Philadelphia made artificial eyes. But those were the days when a glass blower was an all around workman and a glass factory was a place where all kinds of glass were produced." After that, specialization crept into the field. Each glass blower began to produce only one kind of glass article: a druggists' bottle or a lamp chimney or tableware or a window. Even the window-glass blowers got divided into those that made single-thick windows and those that made double-thick ones. "The practice of making specialties requiring a great deal of skill and labor, such as artificial eyes," Stewart wrote, "had to be abandoned."[4]

This was a time when artificial eyes were more often bought from a premade stock than crafted individually for a particular socket. Such "stock eyes" had been offered for more than a century, sometimes in shops devoted exclusively to eyes and often in businesses with many other prosthetic and medical offerings on hand. John Pinkerton wrote in his collection *A General Collection of the Best and Most Interesting Voyages and Travels in All Parts of the World* (1811) of one of the former in Paris: "At Hubin's, the eye-maker, I saw drawers full of all sorts of eyes, admirable for the contrivance, to match with great exactness any Iris whatsoever; this being a case where mismatching is intolerable."[5] The latter sorts of businesses, frequently opticians

and medical supply stores, were worldwide. An ad from 1900 for an "ophthalmic optician" named T. Peacock in Auckland, New Zealand, described the firm's services like this: "Spectacles of every kind accurately fitted by improved methods. Artificial Eyes of all colours in Stock." The Seattle Optical Company offered artificial eyes along with opera glasses, field glasses, scientific instruments, and "everything for the eye & ear," including accusticons and massacons for the deaf. Pettie & Whitelaw, a maker of surgical instruments, artificial limbs, and bandages based in Dundee, Scotland, had several showrooms offering not only those items but also trusses, crutches, leg steels, ambulance stretchers, medicated wools, and artificial eyes.[6]

Vendors sometimes brought eyes to potential customers. According to one history, itinerant peddlers in the United States in the late nineteenth and early twentieth centuries "traveled the back roads, fixing pots, sharpening edge tools, selling combs and spectacles, and fitting eyes."[7] Chance encounters with such scanty offerings had to suffice for many people in need of an eye but living in remote areas, far from an optician or a jeweler who sold eyes or a doctor who could order one through the mail. If someone isolated was luckier, maybe one of the German craftsmen who traveled the United States in the late nineteenth century would show up. They would stay a few days at each stop and make eyes on demand.

"Modern glass eyes are fitted in much the same manner as one purchases a pair of shoes," said an article in the *Bulletin of the American Ceramic Society* in 1934. "The shape must conform to the defective eyeball and the coloring must pair with the unaffected eye. It is therefore necessary for the optical dealer to carry a wide assortment of shapes and colors in order that the proper selection can be made."[8] While no one buys one shoe to match another already owned, the comparative shopping process was much the same. What fits most comfortably? What looks best? As with shoes, shoppers generally chose from what was on the shelf or in a drawer.

If you bought a stock eye anytime throughout the mid-nineteenth or early twentieth centuries, it was probably made in Germany. (If you buy a stock eye today—they are no longer generally carried by opticians or medical-equipment purveyors, but you can find them online—it was probably produced in India, possibly China.) Opticians and other retailers ordered eyes from catalogs and had them mailed to their offices. Those eyes often arrived in elegant cases made of wood and lined with velour, a small compartment for each eye or for three or four eyes nestled together in a nest of spun cotton, a grid of soft squares like boxes of the glass balls hung on a Christmas tree. The United States imported half-a-million glass eyes a year, according to an article in the monthly journal of the glass industry in 1922.[9] (Another 20,000

were made here.) If the article was correct in its claim that 1 in every 300 Americans of the time wore an artificial eye—that would have been about 350,000 people—there was plenty of stock for each of those people, assuming the distribution system worked, to get a new eye each year. Such frequent replacement was necessary. Even the best glass eye typically had a useful life of no longer than a year or two, by which time its surface had likely been roughened to the point of discomfort, or it had shattered, in the socket or while being stored, because of very hot or very cold weather.

World War I decimated the foreign inventory of German-made glass eyes, first in Great Britain—"A Glass Eye Famine" was the headline of a *New York Times* article from the paper's London correspondent in October 1914—and then in the United States by 1917.[10] Supply lines for both legitimate importers and smugglers dried up. Several American companies—Bausch & Lomb in Rochester, New York; Spencer Lens Company in Buffalo, New York; and Pittsburgh Plate and Glass—tried to fill the void, but only with mixed success. In any case, their main goal was to replace the other kinds of optical glass that had previously come from Germany: the glass used for lenses for reconnaissance and aiming artillery.

Germany started shipping eyes again between the world wars—including the usual half million to the United States each year. By 1933, however, the Nazis began holding tight to that country's raw materials and products, including glass. Preparing for war, the US Army calculated later that decade that there would be enough eyes in domestic stock to fulfill its military needs, even with no new eyes from Germany. The prediction was overly optimistic. Even by 1943, with two years of war still to go, more American soldiers needed eyes than the army could supply, mostly because of eye injuries from battle. But it didn't help that the army, finding itself in dire need of personnel, had inducted close to 10,000 men who already had only one good eye. They, too, needed glass eyes.[11]

Fulfilling demand was a constant struggle for the US Army. In the middle of the war, it was able to make one purchase of 30,000 eyes, the best of which it shipped to theaters of operations, storing the rest in Binghamton, New York. It also sent professional eye makers to army hospitals to make custom eyes for any patients who couldn't be successfully fitted with stock eyes. But the disappearance of the German supply line was a huge obstacle. To the army's annoyance, other difficulties arose closer to home. For instance, civilian American eye makers, of whom there were not many, were unwilling to pitch into the war effort as altruistically as the army wanted. According to a report on the "procurement of problem items" written by the US Army's Office of Medical History, those eye makers "looked upon themselves as the possessors

of lucrative trade secrets, which they had no intention of imparting to others. They possessed a monopoly, and they were determined to maintain it."[12] Hence, there was no way to train a large cadre of new eye makers.

And then there were the one-eyed soldiers themselves. Some of those men, according to that same report,

considered their induction to be unnecessary for the Army and unduly burdensome to themselves. They retaliated by dropping or breaking their glass eyes while inserting or washing them. This led to their hospitalization for several weeks, awaiting the arrival of stock eyes. When the replacements were received, the patients asserted that the new eyes did not fit and that they could not bear the resultant discomfort. Where-upon they were sent to one of the general hospitals, and there waited 1 or 2 months while custom-made eyes were prepared for them. Under these circumstances, many individuals were issued three or four artificial eyes during a single year, with a conse-quent hospitalization of 6 or 8 months.

The report conceded that the army had no direct proof of such shenanigans—only the high incidence of breakage ("so much more than in civilian life") and the reluctant soldiers' undisguised resentment about being inducted into the army.[13]

In 1943, the army dispatched three officers to Valley Forge, Pennsylvania. These men, chosen because they were dentists already skilled at making den-tal prosthetics such as dentures and crowns, drew on what their own report later called "creative thought arising from military exigency." Their job as the main team in the army's Plastic Artificial-Eye Program: to figure out how to make an acrylic eye that surpassed glass eyes in durability, comfort, and nat-ural appearance and that could be produced domestically. Though there are conflicting stories of how the switch from glass to plastic was realized and who had the first successes—both the army and the navy worked mostly sep-arately on their own research and development—credit most often goes to Stanley Erpf, Milton Wirtz, and Victor Dietz in the Plastic Artificial-Eye Pro-gram. Within a few months, they had designed a process that was ready to be used widely. In late 1943, a training center for ophthalmoprosthetists opened in England, and "40 dental officers from U.S. Army General Hospitals were selected for training," along with ten British dental officers. The following year, the army conducted a thirty-day training course for another twelve den-tal officers and then fanned them out to train more dentists and technicians in eye making. By October 1945, Army dentists from thirty different installa-tions "had inserted over 7,500 all-plastic artificial prostheses for patients, many of whom would otherwise have been forced to accept inadequate glass eyes."[14] Those plastic eyes were, with some fine-tuning, basically the same as what I would get more than sixty years later.

One of the great advantages of plastic eyes was the exactness with which they could be fitted. Glass eyes are fitted empirically, which is to say that the eye maker surveys a patient's socket and makes some educated guesses about the shape the prosthetic needs to be. Stock eyes almost inevitably fit imperfectly because they aren't made for any specific socket. A poor fit can result immediately in discomfort and fluid building up behind the prosthetic and eventually in lid laxity and socket contraction. After acrylics came into widespread use, Lee Allen and his fellow ocularist Howard Webster worked at the University of Iowa to refine a technique for crafting an acrylic prosthetic to the exact shape of any patient's unique socket. That technique, as Allen wrote, had been introduced by the military dentists who developed plastic eyes in the 1940s but "because of traditionalism and economics" hadn't become immediately widely used or accepted. It did eventually, after what Allen described as his and Webster's "16 years of development and experience," and it is still used today.[15]

As with so many aspects of ocularistry, the method Allen and Webster pushed forward had begun with materials and technique from dentistry. They described the steps for creating a model of the socket's dimensions, bumps, and crannies in the same way a dentist would make a mold of teeth in the process of fabricating dentures or a crown: fill the empty socket with alginate (a viscous gum); use the hardened result to make a mold in dental stone; fill that new mold with hard inlay dental wax; carve and shape that wax model to the patient's exact needs; embed the refined wax shape into fresh dental stone to create a new mold; fill the new stone mold with acrylic; and then process and harden the molded acrylic under thousands of pounds per square inch. There are many, many minor steps and decisions along the way, including painting and polishing and shaping by hand to make sure the prosthetic points in the right direction and holds up the eyelids symmetrically with the companion eye. But the thrust is to make that initial impression of the socket's geography and then modify the product as you go along. Every step is a further customization.

Though Allen and Webster perfected the process, there was friendly debate among ocularists into the 1970s on what they all should call it: "modified impression technique" or "impression with modification"? At the American Society of Ocularists (ASO) conference in Fort Lauderdale, Florida, in 1978, Allen and three other ocularists were batting around pros and cons for each. In favor of "modified impression technique" were Allen and his fellow Iowa ocularist Dan Yeager. Arguing for "impression with modification" were the Philadelphia ocularist John Kelley and the Boston ocularist Ray Jahrling. All four were big players in the ASO, having helped found it or served as its

president or both. When I visited Yeager in his Iowa City office, he told me they had settled the argument by having a race.

They rented a couple of Hobie Cat sailboats and split into teams of two. Whichever team made it out and around a buoy and back to shore first would have naming rights. Kelley and Jahrling, both of whom had experience sailing on ocean waters, got an early lead, but Allen and Yeager drew almost even at the buoy.

They turned and raced for shore.

"And now we're really catching up, like we got an outboard motor," Yeager recalled. "We noticed they were riding lower in the water than we were. We went blitzing by them, laughing. We skidded right up on the beach. And they stopped about thirty or forty feet out, just like they'd put on the brakes. We went out to help them, good-naturedly. We grabbed hold of the boat, and the four of us couldn't lift it."

The guy who rented them the boats came out to help, bringing another guy with him. The six of them struggled to get the boat to shore. It turned out that the rental shop had forgotten to replace the boat's drain plug. As long as Kelley and Jahrling had been moving fast, they were okay, but when they slowed down to round the buoy, "the water infested," Yeager said. "It was a miracle they didn't sink," he added. "So now it's called the 'modified impression technique.' Don't argue it, don't bring it up again."

Snow had not yet come to upstate New York on the early December day I drove the New York Thruway from Syracuse to Rochester to get my new eye in 2009. It was above freezing and merely cloudy. I had by this time settled on a dark-blue corduroy eyepatch I'd ordered online. I was intensely tired of it, especially when I had to wear it underneath my glasses, which I did while driving. (My good eye is near-sighted.) The patch was slightly convex and cardboard stiff, and it made it impossible for me to settle my glasses solidly on the bridge of my nose. "You should get a monocle for your good eye," some people helpfully suggested. The corduroy also attracted the small white cat hairs from our calico. I was more than ready to throw it out the window.

In contrast, my good eye felt like a fresh and capable enticement to a long drive, like a new set of tires.

This was a solo trip. My wife was working, the kids were in school. Unlike when I went in for surgery, I did not need anyone to drive me home afterward. Whatever happened when I got to the ocularist's—and I still wasn't entirely sure what that would be—it would not involve my being put under or otherwise weakened. We were past the medical procedures in this process. Everything from here on would be craft and art. Besides, I wanted to have the

experience to myself. I had lived for fifty years with an eye that was much more important to me than to anyone else. I felt possessive of its replacement, even though I hadn't yet gotten it, and wanted to spend at least a little time with it before it went on public display, even within my family.

The thruway on that stretch is a straight shot past exits for small towns, past a sprawling outlet shopping center, and past the Montezuma National Wildlife Refuge, a stopping point for migratory birds and fowl such as Canada and Snow Geese and home to maybe a dozen Bald Eagle nests. On the approach from the east, there is a haunting stretch in which dead trees cluster in acres of swamp. Then the refuge itself opens up to the north and south. This place, like so much of America's landscape, had at one time been thriving with wildlife, then devastated, and then inched along a path toward restoration. Every time I drive by or stop and walk its trails, I experience that unnatural history, that need to fix what did not have to be. I felt it deeply as I drove by this time. Bald Eagles had flourished there before Americans began spraying pesticides with happy abandon. By the late 1950s, just about the time I was born, most of them were dead or unable to reproduce. In 1960, the whole of New York State had only one known active nesting site for Bald Eagles. Whether the eventual decision to reintroduce Bald Eagles into Montezuma—in 1976, the year of the country's bicentennial and the first such effort in North America—was more from patriotic nostalgia or a throbbing of pain over a glaring deterioration that more and more people could see, it seemed to have worked and is still working. Besides the Bald Eagles, the refuge is populated by Ospreys, Sandhill Cranes, Peregrine Falcons, Great Blue Herons, Cerulean Warblers, Killdeer, plovers, Short-eared Owls. During spring and fall migrations, tens of thousands of ducks and geese stop to rest and feed.

The openness and liveliness of the refuge added to the liberation I could feel expanding. The bygone eye's history and weight on my psyche had been diminishing slowly for the previous six weeks and felt light and almost distant when I found Strauss Eye Prosthetics, Inc., in a medical park at the end of a one-story building that also houses a podiatrist and a dentist. Nearby were an orthodontist, a veterinarian, an optometrist, and a dermatologist. Just across the four-lane road from which I'd turned to get into the medical park was a community college.

No one was in the waiting room when I entered. Bluish-gray chairs lined three walls, and the décor was medical-office austere. I checked in at the sliding-glass window, then spent a few minutes reading a full-page newspaper article from 1994 headlined "A Better Look," which was framed and hung on a wall.[16] It was a profile of Jim Strauss, who'd become an ocularist in the

1960s and then founded Strauss Eye Prosthetics. He was mostly retired by the time of my visit, and his son, whom he had trained, would be my ocularist. The article's subheadline said: "James Strauss doesn't offer the gift of sight, but he does help people see themselves anew." The profile began with a story of an eighty-year-old woman coming to get a new eye. She had lost vision in the real eye fifty-two years earlier after a "blow to it" had caused internal bleeding. A decade or so before her visit, the eye had begun to drift off on its own, and then a series of surgeries "left her with a horribly protruding eye, lids sewn partially shut and a lot of pain." She'd been wearing a patch, despite the extra pain that caused. "It shames you, you know," she was quoted as saying. There was a large photo, shot from over the shoulder of the woman in the story, in which Jim holds a mirror so the woman can see her new eye. Jim wears a dark tie, a striped shirt, and a lab coat. His wire-framed glasses reflect the lights from the ceiling, and he is looking with concentration at the woman, who, in the mirror, has a cautious smile.

The article described the office—not the one I was in but an earlier location—as "rife with the odor of the plastic used to make the eyes." I didn't smell anything like that. The air was not quite antiseptic, but it was free of a hint of whatever work was being done.

Michael Strauss, Jim's son, was wearing a white short-sleeved lab coat and an open-necked shirt when he came out to greet me. He was tall and stout and in his mid-thirties. I liked his direct eye contact and found myself, while we shook hands, trying to reflect back his ease of manner, to be as casual as if I were there to pick up a pizza. His ease seemed true, and mine felt forced. As I followed him down the hall to an exam room, he was talkative and welcoming. There was a subtle feeling different from walking into a hospital or medical clinic: this person was going to do something for me rather than to me. I found myself relaxing into a trust in his competence and feeling, too, a hope for his virtuosity.

In the exam room, I sat upright, like at the barber's. Michael was on a backless stool next to a small desk. There was very little equipment. It wasn't like a dentist's office: no drills parked within easy reach, no sink to spit in, not even a bright light mounted on the end of an elbowed metal arm capable of being whooshed into position. On the desk was a magnifying lamp and what looked like a few small knives. To my right was a sink and a shelf holding small plastic cups. On the wall above that was a metal paper-towel dispenser. Next to it was Michael's diploma from the American Society of Ocularists, declaring him a diplomate.

We chatted about the few times I'd been to Rochester (to take my kids to the children's museum), about Michael's history of working with other

patients who'd been operated on by my surgeon, about the luck of my having no snow to drive through. We didn't get to the business at hand for ten or fifteen minutes. Then he said, "Let's take a look."

Besides my surgeon, Michael was the first person to get more than an unintentional and brief glance at my empty socket. He shone a small flashlight. "This has healed perfectly," he said brightly. "This makes my job very easy. So, what we're going to do is first make an impression of your eye socket."

I'd had a crown for a broken tooth made before. As a teenager, I'd had braces. For both, dentists had made impressions of my teeth. I remembered being asked to sink my teeth fully but without extra force into a mold filled with gooey alginate, holding still while the alginate set, and then having it lifted carefully away from my teeth. Later, I'd see a perfect plaster version of my teeth made from the geography of that hardened alginate. Michael would begin with that procedure: fill the space you want to map with an elastic impressionable material, give it a minute to firm up, remove it, and there's your terrain.

He mixed alginate powder and water in a cup. He placed an impression tray into my socket, so that it was held in by my lids. I didn't feel it beyond a sense of its presence. Impression trays for eyes look like small plungers, with a hollow stem attached to the outside of a bowl the size of a sugar spoon, but they're hard plastic. There are different sizes of trays to fit different sizes of sockets. The bowl sits inside the lids, leaving as much space as possible for the alginate to fill. Michael fed the alginate into a wide syringe, clipped the syringe to the end of the impression tray's stem, and softly depressed the plunger. The alginate, the consistency of whipped cream, needs to ooze into the socket under little pressure—just enough to ensure the material fills every bit of space but not enough that it distorts any tissue out of its resting position.

"This might feel a little cold," Michael said.

It felt like the cool of all medicine, the air of an operating room, the wetness of a compress. I held still. Michael counted to himself.

I didn't get a look at the alginate mold Michael lifted out. He wasn't hiding it but had that easy and swift efficiency of a person moving along without hesitation in work they know well. He went across the hall to his lab, where he set the alginate impression atop a small mound of freshly mixed and soft dental stone, a plaster-like material. Once that stone dried, he poured more dental stone over the top, totally encapsulating the alginate mold, and let that dry too. He separated the two halves of the dried stone and saw that the texture of the original impression had been conveyed to the inside surface of the stone mold—"the negative curve to the positive curve," he would explain when he came back and I asked him to review for me again what he'd done. There was a hole in the top of the stone mold where the stem of the impression tray had

been sticking up, and through that he ladled hard inlay dental wax of an ivory color. He waited for that to harden, for that original shape to "lock right in." It took maybe twenty minutes, maybe thirty. It was a meditative time for me, and I considered and then dismissed the necessity of putting my eyepatch back on. I've thought a lot about why the one-eyed soldiers in World War II needed artificial eyes, especially if they were just going back into battle. What was the urgent need for facial harmony? Wouldn't a battlefield be a place where repulsiveness would be less powerful? The best explanation I've found was in a postwar report in the *Journal of the American Dental Association*, which proposed that self-image was surprisingly vital even when it was not what would keep you alive. "Many patients were wearing black patches over the eye socket," the report said, "their explanation being that they would rather acknowledge an eye loss or a diseased eye condition than subject themselves to the readily obvious imperfections of inadequate restorations. Embarrassment necessitated a delay in return of the individual to previous whole or partial military duty or to normal civilian pursuits."[17] Likewise, a report in 1944 about US Navy efforts at making plastic eyes said, "Often eye replacements made with glass or acrylic resin are apt to be a source of extreme embarrassment and may retard the patient's rehabilitation because of the disheartening cosmetic results. Delay in return to limited military duty or to civilian life is often necessitated. Should the prosthesis not provide the essential qualities of an adequate restoration, its psychologic value will be destroyed."[18] I understood that embarrassment. I understood why the woman in that news article hanging in the lobby said, "It shames you, you know?" But I understood, too, that embarrassment and shame have the power you give them. I was alone in that exam room where there were no mirrors, and so it was about the safest context in which I could practice accepting the reality of an empty socket that would literally repulse many people. I left the patch off. Anyone who might open the door would expect to see a person missing an eye.

Michael wanted to know my story. I started with the congenital cataract and ended with the ophthalmologist who refused to remove my eye. He was familiar with that part: the eye doctors who didn't really know the talents of eye makers or who had their own reasons for never nudging their patients in the direction of ocularistry. "There's a lot of misconception there," Michael said. He told me the story of a recent patient. She was an optician, a licensed fitter of contact lenses and glasses. She looked at eyes all day in an office she'd taken over from her father, who'd also been an optician. Care of eyes was the family business. She had injured her own eye more than twenty years earlier but had simply lived with its "unsightly" appearance. Even her father, who

once sold stock eyes when he ran the business, apparently didn't think to tell his daughter that she could benefit from seeing an ocularist. When she finally did, and Michael made her a prosthesis so that "she looked great and everything was wonderful at the end," she nonetheless regretted that she hadn't done it all earlier. "'Why didn't I know about this? Why didn't my doctor tell me?,'" Michael recalled the woman asking. "A lot of it is the doctors just don't know. And your doctor," he said to me about my old ophthalmologist, "the one you saw for years, is a perfect example of that. They're so used to treating healthy eyes that the removal of an eye or the cover of that eye just doesn't even come into question."

Michael told me he had been helping his dad since he was fourteen, not seeing patients back then but "processing molds and working with plastic." He went away to college, majored in English, and expected upon graduation to come home and slide right into a job in the family firm. He already knew that this was the work he wanted, that "this business is kind of a calling." He was so sure, he admitted, because his father was an ocularist, because the work ran in the family blood, but also because he had his own independent passion for the field. He had been all set to dive in.

"And my father tells me," he said, "'I'm not going to hire you.' 'What do you mean you're not going to hire me?' He basically wanted me to work for somebody else to see what it was like so that I didn't come in with a swelled head and kind of an owner's mentality."

Michael worked, therefore, for a year at a construction site. Now and then his dad let him do some tasks in the office, a small chance to brush up on his painting skills.

"And then finally my father hired me," he said. "I didn't have very nice things to say about him at the time, but, fifteen years later, I would say it's one of the best things he did for me. He didn't want his business to be left to somebody that didn't care, somebody thinking: Young punk kid can do what he wants in a nice, air-conditioned office. I wasn't looking at it that way, but it worked out in the end."

Michael went to work on the wax model of my new eye with the knives and a small torch. The back of the wax model—the part that would fit against the flesh of my socket—was all set, and so his focus was on the front, the "anterior curve," as he called it. To get that part right was to assure that the prosthetic eye would hold the eyelids open symmetrically with the lids of the other eye.

"We're going to be kind of molding and shaping this piece so that it fits you a little more custom than just taking the impression," he said. "Normally

when patients come in, their eye is significantly closed compared to the companion eye. So we need to build the eye up a little to create symmetry."

He also held up a small blue-gray disc and compared its color to my real eye. This was an iris button. It was made from the acrylic my new eye would eventually be made from and prepainted. Michael had a large stock of them—hundreds—of all colors along the spectrum of human-eye colors. The disc itself was thinner than a dime and glued into the base of a clear dome of plastic. A thin stem protruded from the dome's apex and would be trimmed off later. It looked like a model-kit piece that you'd want to keep away from small kids who might swallow it. Michael tried several buttons in the same color range, and when he found the best match, he scraped some of the wax off the front of the model, making a flat space into which he could jimmy the iris button. That blue gray was the base color. More extensive and detailed painting would happen later.

A real iris is thin but not one-dimensional. It's made up of two sheets of smooth muscle, one responsible for making the pupil dilate, the other for making it contract. In front of and behind the iris are pools of aqueous humor. Looking at a real iris is like looking at an object slightly below the surface of water. The cornea adds another layer in front of all that and slightly magnifies the apparent diameter of the iris. Giving an artificial eye a natural appearance of depth has always been difficult. It didn't happen with the ancient Egyptians, who painted one-dimensional eyes onto pieces of clay or metal and wore them outside the socket. Nor did it happen 2,000 years later, in the late 1500s, when Ambroise Paré painted irises on gold shells.

The iris button, even in its simplicity, is a much more sophisticated tool of illusion. It gets layered upon with clear acrylic and paint made from a powdered form of that same methyl methacrylate, so that the coloring itself becomes an integral part of the eye's structure. The process is not at all like rolling paint onto a wall.

Michael whittled, occasionally smoothing out his cuts with the flame from the torch. He worked without rush. When he was ready to check the fit, he lifted my lids and eased the model in.

"It might feel a little awkward, a little full," he said. "That's because there's something in your eye. No way around that, unfortunately. Now look way down. Usually most patients feel a little fullness, a little awkward, maybe a little pinching in the corner."

"It's not pinching at all," I said.

"Good. And it'll be even more comfortable when it's in a plastic form because it'll be smooth. Wax has kind of an abrasive, sticky friction to it." He

stepped back to see from a distance. "That's going to look beautiful. Just stare right at my nose."

He lifted the model out and whittled more, flame-polished the surface again. Back in.

"What you feel right now is not what you'll feel in the end," he explained. "A lot of that is that stem sticking out of the eye right now, which you're going to feel but it won't be there when we finish."

To "finish" for the day meant meeting two goals: getting my lids to rest in exactly the same positions as those of my other eye and making sure the iris and pupil were pointed in the right direction. The ultimate goal, Michael said in a way I would later hear other ocularists summarize the fundamental measure of their success, was to make it look as if I "didn't have an eye."

"Don't have an eye?" I asked.

"An artificial eye," he said.

I was fortunate, he said, that even having waited so many years, I'd avoided the complications he often saw in such cases. A woman he had been working with just the day before, in fact, had lived with a bad eye for thirty-five years, during which time it became more bulbous, stretching out the lids. "So now she's got a very droopy lid," Michael said. "She's got to go back and have it tucked."

He took the model out one more time, made a quick adjustment, then put it back in. He seemed to have it where he wanted it.

"We're going to let that settle in just for a minute," he said. "And then I'll come back and get a closer look at it."

And then he left. I sat with the well-shaped precursor to my new eye in its place. There was a fullness to it, but no discomfort. In Lee Allen's article on modified impression fitting, he wrote: "The orbicularis muscle will go into a spasm when the wax pattern is first inserted. The patient wears the pattern for 10 minutes or more during which the muscles may relax. Otherwise, too large a prosthesis will be planned, and the final plastic eye will pop the lids open too widely."[19] I didn't feel any spasms at all. The stem did keep me from blinking, but what was there didn't need to be moistened. And even though I knew the wax model was not meant to stay in place for more than those brief minutes, my possessiveness of it arose almost immediately. It already felt like a gift that fulfilled a deep and lifelong need, the half of a locket missing in a fairy tale.

The only flat surface in the room with any reflective quality was the paper-towel dispenser. It was brushed metal. I did not at the time own a cell phone with a camera. After about ten minutes of stillness, I got up and took a step or two, moving softly because I wasn't sure whether the eye would fall out. It

didn't. I crouched slightly to put my face a foot or so from the dispenser. My image was fuzzy, the metal's textured surface like the fog of morning.

There is an episode of *The Twilight Zone* in which a woman undergoes plastic surgery in order to look "normal." When the bandages wrapped around her head are unwound, she is beautiful according to our current standards. The surgery, alas, was a failure. She lives in a society in which everyone else, including her doctors, is what we might consider hideous. Such melodrama. And yet. Through the indistinctness of my reflection in that paper-towel dispenser, a sharpness stood out, like a splotch of bright color in a monochromatic abstract painting. There were two pupils precise and aligned. Two eyes balanced. A sight as ordinary as a human face, something most of us see hundreds of times a day. But this was also completely new. *My* eyes had never looked like that. Only in the anguished dreams of my teenage years, when I had wanted to slip out my bad eye with my pocketknife. Only in every other dream about my appearance in every year since then. Only in the images of what I wished for every time I was in face-to-face conversation with someone or looking in the mirror while brushing my teeth.

Every one of those imagined manifestations had been a fantasy, and sometimes they felt like hallucinations, so far from the reality of my existence as to be about someone else altogether.

Who was in that rough but surprising reflection? I was maybe past the usual time for my own conception of self-identity to shift radically. But it didn't feel too late, not as I stared and felt my throat tighten, my knees soften into delicacy, my cheeks flush, and my nose start to run. Both eyes watered a little.

When I sat back in the chair and waited for Michael to return, I was in a different kind of stillness, a sort of waxy revelation that heavy parts of my being would be lifted away, that something new in reality but ancient in my imagination would come forth. Maybe it all would be an illusion, and in that first study of myself in the dispenser—which already felt like both a wispy flash of an overwhelming dream and a factuality revealed into all time— maybe I had been fooled into believing that a perfection was possible. I already understood that an unseeing artificial eye could offer nothing but illusion. That was okay. Even the rough sketch of what would become my eye had delivered, out of the blue like an iris button, a truth that entered into me as a gust of delight, a recess of joy.

Phil Cenci, Eye Wearer

When I was seven years old, summer of 1969, right after the Fourth of July, I spent the morning harassing my sisters as my mother begged my father to take me with him to do some work. At the time, he was doing landscaping work with my older brother Al, who also had one eye. Al did not have a prosthesis. He was born with retinoblastoma and as an infant had his eye removed and thirty-plus treatments of radiation. They must have burned his face badly because he had a huge hole in his face growing up. The chance of him reaching adulthood was very low, but he died two days before his fiftieth birthday. That is relevant to my story only because when I lost my eye, it was no big deal. There was no sympathy; there was no treating me special.

On that morning, my dad took me to work. He had a commercial brush hog. It could cut down small brush and bushes and tall grass, and he was clearing an area in a field. I was instructed to stay away. He had a Chevy van, and I was bouncing a ball off that and catching it. But the ball got by me, went down towards where he was working. I was probably about twenty or thirty feet away from him. As I bent down to pick up the ball, I heard a loud noise. I looked up to see what it was, still bent over. There was a porcelain insulator from a telephone pole buried in the grass. When the brush hog hit it, the shards got kicked out and went straight through my eye. I got knocked onto my back. I remember my father standing over me. It was midday in July, so the sun was straight up above, and I remember thinking, "The sun is hurting my eyes." When his head blocked the sun, there was some relief. Then he held me in his lap as a friend of the family drove us to the hospital. I remember the emergency room, and I remember being put on a stretcher, and I remember them pulling the curtains. I have no memory after that. I can only assume they sedated me. I was in the hospital three or four weeks. They had my head wrapped, both eyes wrapped, because they didn't want me moving my left eye. I'm told that my mother stayed there twenty-four hours a day. While I was in the hospital, the men landed on the moon. I didn't get to see that until years later. There was a prosthesis that had holes drilled into it, so air could get in and out. At that age, my mother had to help me care for my eye: cleaning it, bandaging it, taking it in and out.

Even with one eye, I played baseball, and I was always an above-average batter, fielder, everything. Part of that is because my brother Al, who I mentioned had one eye, was also very athletic, and he was six years older than me. I was playing with him and his friends. As a ten-year-old I was playing with sixteen-year-olds, and as an eight-year-old I was playing with fourteen-year-olds. So when I played with kids my own age, I was very athletic. My eye never caused any issue with that. When I was younger, I had glass. Never broke. Never chipped, never broke. But the edges would cut on the inside, and there would be some blood.

We used to have rock fights with kids from a different neighborhood. That was stupid, someone with one eye throwing rocks.

My neighborhood was mostly white, but they'd bus us down into a poor Black neighborhood. All of a sudden I found myself being made fun of. I would be fistfighting. Someone would say something to me about my eye, and I'd pick up a chair and throw it at them. They'd call my father to come get me because I would have blood coming out of my socket. I had a lot of trouble in junior high school. It became a nightmare for me.

I'd had a regular prosthetic made as soon as everything healed. My father had no health insurance, so these prostheses had to be paid for in cash. So instead of getting new eyes made when I was growing, I would wear the same one after I outgrew it. My eye mostly was drooping. Because of that, the weight of this thing would mostly be on my lower lid, so the muscles stretched. When you looked at me, my right eye could've been pointing down and drooping. And, of course, somebody would say something, and either my smart mouth or my fists went flying. My eye never got knocked out once.

I had been going to the same ocularist from the time I was seven to the time I was thirty-eight, thirty-nine. Then my insurance changed, so they sent me to somebody else. He took my eye out and said, "Do you have any pain?" I said, "Yeah, my eye has been hurting me since the day they put it in; it never stopped hurting." And he goes, "Well, I can't give you a new eye. You've got to go to a surgeon." So I went into Manhattan to see a specialist, and they were like, "Oh my God, this is a big problem."

What they had done in 1969, it's almost like a rubber ball they put in there, and then they tied the muscles around it, and it had no movement, no support. And that rubber was decaying all these years, causing inflammation and pain. I never complained about it, never thought to get it fixed. I always had a lot of discharge, tenderness, and swelling and pain. Then I went for reconstructive surgery. They put in that calcium one. The doctor said, "You're going to have a little movement, we hope. I did the best I can to find the different muscles and separate them and connect them, but I don't know what kind of result

we're going to have." I didn't really care at that time about movement. It did get rid of the pain, though.

In any photo you ever see of me, it's just my eye drooping down. They were able to do some cosmetic surgery to make it look a little better. They shortened up the eyelid. But at that point I already had a family, five kids, everything. My wife always, thank God, was able to see past that. As a matter of fact, up until about nineteen years old I just assumed I would never get married. Never have kids, never find a woman that would want me. I just assumed I was going to be a marine like my brother Chip. When I was in junior high school, there was a girl who lived two blocks up. I always had a crush on her, and I asked her to go to the movies. She told me no, she didn't want to be seen with me because of my eye. I'll never forget that because I was devastated for that moment. So when I was seventeen, I went down to the recruiting station. I walked in, and on the paperwork it asked about your vision. I said I had no vision in my right eye. The recruiter asked me what happened. Then he made a few phone calls, and when he hung up, he said, "I'm sorry, we're not going to be able to take you." That was the first time anyone told me there was something I couldn't do. Literally hit me like a brick. I was 165 pounds, I had the build of an athlete, I felt like I would've been a great soldier.

There was no plan B. I wanted to do some traveling, so I decided I was going to be an airplane mechanic. I enrolled in the Academy of Aeronautics. The first year I learned how to do some mechanical drafting, how to work on aluminum for the skins of planes. I did very well, but I also realized that's not what I want to do with my life. I didn't go back the second year. I went into Manhattan to get a job, with just the high school education. I started working in an import-export brokerage firm. I was doing that until one day commuting into Manhattan I got mugged and somebody put a gun to my head. I decided I was never going to go back to Manhattan again, so I quit that.

Then I started working for my father, the same business where I lost my eye. The pay wasn't so good. The job was okay for my father, but it wasn't okay for me. Then I had a revelation. It was a hot summer night. I was standing on a street corner with my buddies drinking beers, just wasting my life. Later, lying in bed on a hundred-degree night, sweating, it's two in the morning, I started to cry. I said, "I am the biggest loser on earth! What am I going to do with my life? I'm just spinning my wheels. I'm going to be thirty years old just being the biggest loser, hanging out on street corners drinking beer." So that week I called the local community college. That September I was in school. And it changed my life.

I wanted to be a computer science major. It was 1981, and everything was on mainframes. The programing was done on punch cards. I would have to

reserve my time on the terminals: Tuesday night between 1:00 a.m. and 3:00 a.m. and Thursday night between 12:30 a.m. and 2:00 a.m. I would have to wake up, go down, and I was like, "This ain't for me." Plus, I had always considered myself more of a social person, so I didn't like the isolation of sitting in front of a computer terminal. By then, I was doing very well in biology and sciences, so I applied to the nursing program. I had straight A's, so I got in. I met my wife in the program, and the two of us graduated together in 1985. We got married in 1986, and we've had a great life. We're still together.

The accident really shaped my whole life. In the neighborhood I grew up in, I know at least half-a-dozen kids who died of drug overdoses. And I honestly think the accident kept me away from all those things. That and my very, very, very tough father, who kept a very short leash on his boys. My father certainly didn't treat me any differently. He was just very tough with me. No one ever said, "Let Phil do it, oh, Phil you can" No, I was always treated normally. It was never an issue, never brought up. Which is a good thing, by the way. I'm very happy about that.

I didn't start really taking care of my eye until I started working on my own, had my own insurance, my own income. I never paid any attention to it. It's not like I fussed over it; it just didn't exist. I totally blocked it out. But I also ignored it, didn't really care for it the way I should've. I just did not care.

I've been an RN for thirty-eight years. I worked fifteen years in a cardiac intensive care unit. Then I switched to cardiothoracic, where we would do open-heart. And for the last twenty years I've been working in the cardiac-cath lab, doing angio-cardiac, angiograms, stenting, TAVRs [transcatheter aortic valve replacements], valve replacement—everything to do with the heart and the lungs is what I'm doing now, but I'm in the testing and stenting side of it now, more vascular.

I can't tell you how many times at work people tell me they're inspired by me, and I'm like, "What? Why?" People think you're going to lay down and die. They think it's this disabling injury, and it's amazing that you've come back from this, and I'm like, "Come back from what?" I mean, no. Whenever I've had any kind of application to fill out, for disability I always say, "No."

All I do now [for my eye], literally, I almost do nothing. When I'm in the shower, I remove it, I let the water run through it, I put it back in, and I'm done! On occasion, especially during pollen season, my eye will get irritated, and then I have an ointment I'll put on it: tobramycin. TobraDex, actually, which is a combination of an antibiotic and a steroid. I'll just put it on the corners of my eye and let it go. I think the steroid reduces the inflammation a little bit, and the antibiotic will prevent an infection from all of the swelling.

And I maybe do that twice a year, if I even need it that much. So that's all I do to care for it.

My ocularist is always yelling at me that I don't go often enough to get a polish. I'll think, "I just went to him a couple months ago," and he'll say, "I haven't seen you in almost three years!" He says, "How is it?" and I say, "I don't know, it's fine, I guess." It's actually great compared to what I had my whole life.

It's been four, five years, maybe, since I got a new eye. Maybe six years? I am a little worried about what's going to happen when I retire because right now I have excellent insurance, and I'm going to lose that. I envision myself as an eighty-year-old with a twenty-year-old prosthesis, looking funny again. But, you know, I have grandchildren that scream and jump in my lap when they see me, and it doesn't really matter to me that I have this, and nobody sees it. I think my personality is the first thing they notice when they meet me, not my eye.

4

Painting

Before Michelle Strauss began painting eyes, she specialized in portraits that were not strictly realistic but instead captured what she felt about her subjects. "And so, maybe you'll be green or blue or red or whatever, and maybe you'll have feathers for hair," she told me. She painted a woman she saw as "full of passion and intrigue" red. The result was not well received. "She didn't want to be a red person, apparently." But when she painted her own sister and constructed the face out of champagne bubbles to convey effervescence, her sister loved the truth of the image so much that she stole the picture before Michelle could give it to her, as Michelle had planned to do.

Michelle is the eye painter at Strauss Eye Prosthetics. She married into the Strauss family and its business rather than having grown up in either. Through her childhood and early adulthood, like most people, she knew nothing of ocularistry. Then one day, having earned her BFA in painting and having exhibited her canvases in art galleries around town, she was reading the want ads, looking for a job that she assumed, as most people with a degree in painting must, would not make the best use of her painterly skills. She saw an ad that said, "Fine artist needed."

"I think synapses were exploding all over the place and an aneurysm," she said. "I was like, 'Should I call 911 or the number in the paper? I don't know.' I was so excited."

When Jim Strauss interviewed her, he could see from her portfolio that she understood how the color of an eye is not flat and uniform but is instead made from a "crisscrossing of fibers." A blue eye, she explained, is not simply blue but is "more like yellow, gray, green, brown, all on top of each other. And then when you look at it from away, it appears to be blue. Like an impressionistic painting, dots of color that make up a color."

Though Michelle had never painted a prosthetic eye, she had long been fascinated by the infinite combinations of eye colors—"tiny and meticulous and detailed." Even in all of the portraits in her portfolio, which were "a little

on the strange side," eyes were the focus. She suspected her eventual ability to capture the essence of a human eye on a piece of plastic was more instinctual than taught, like cooking might be for someone else. "You either understand how you mix things together to make a flavor, or you don't," she said. "Everything I make is called 'goulash.' It's not good. But I can look at a color and dissect it and understand the colors that are inside of it, that make it itself. I look at your eye, and I say, 'Oh, it's got this, this, and this,' and then it kind of comes together."

By the time I sat in front of her and her array of paints and the big, lighted magnifying glass, listening to the soft whirr of a fan pulling fumes out of the room devoted to her work, she had been painting eyes for ten years. It had been about seven years since she and Michael had fallen in love and gotten married. She assured me she could think of no better job in the world, except maybe ice cream taster. But she'd learned to be careful about revealing her work to strangers.

"You go to a party," she explained, "and people are like, 'What do you do for a living?' 'I'm a waitress.' 'Oh, where do you work?' 'Applebee's.' End of story. You tell someone you're an artist. '*Realllly?*' 'Yes.' 'What kind of art do you do?' 'I paint prosthetic eyes.' 'You do *what*?' And then it's forty-five minutes later, that kind of thing. Everyone always wants to know. 'Oh my gosh, isn't that disgusting? Isn't that gross?' And I'm like, 'No.' And they're like, 'Well, don't you see inside people's heads?' And I'm like, 'Not really.' And they're like, 'Isn't it disgusting?' And I'm like, 'No." 'Well, what does it look like?' 'It looks like the inside of your mouth, like your cheek. It's nothing, it's whatever. You know, it's not bad at all.' And they're like, 'You put people's eyes in their head?' Yeah. I think being a dental hygienist would be way worse. Way worse! I've got nothing on them."

However, when I asked her whether she'd really never gotten even a little queasy, she admitted there'd been two times.

The first was a routine polish (to get rid of the protein that builds up on the surface of an artificial eye in the same way plaque builds up on teeth), and the patient said he was feeling some pressure behind his eye. Jim Strauss was caring for him. Michelle was observing. When Jim took out the eye, Michelle recalled, "A long worm-like tumor fell out, and it was, like, hanging to here. I mean it was all I could do not to scream right in front of the patient. I don't even know what I did. And Jim actually stuffed it back in, and he didn't even tell him. He's like, 'Yeah, I think maybe you're right. You should see a doctor.'"

The second was with a man who had a flesh-eating disease.

"I'm not sure, but I swear to god I saw his brain," Michelle said. "He kept coming back, and the eye wasn't big enough. There would be more space. The

eye wouldn't stay in, so we needed to make it bigger. I repainted his eye like three times in a year. And every time the hole just kept getting bigger and bigger. Oh my god. And eventually he did pass away, but it was just bloody and rough."

Beyond that, though, she let her gusto for her job spill out fully. She was maybe thirty-two or thirty-four at the time, with wavy hair to her shoulders and glasses. Someone could have painted her as champagne bubbles.

In *Man with a Blue Scarf: On Sitting for a Portrait by Lucian Freud* (2013), the British art critic Martin Gayford describes his experience of having a famous artist create two images of him—one in oils, one etched—over the course of a year and a half. He discovers that Freud's process is slow and deliberate, and it's not until two weeks in that Freud finally begins sketching the eyes, the left appearing midway through that day's sitting and the right by the end of the day. The rest of the canvas is still mostly an initial charcoal drawing, but, Gayford writes, "suddenly a person is looking out from the picture." He realizes anew something he had long known as a critic: that the "eyes are the source of presence and power" in a painting. "They contain the force in the image of a god or saint, in the icons of the Orthodox Church for example. That is why so often those who do not wish to feel that force scratch out the eyes, leaving the rest of the picture intact." He calls eyes "the best clues we human beings have to each other's feelings." And when he sees the images of his own eyes, he feels a change happen in the experience of being painted. "Altogether it is not surprising that, with the appearance of the eyes—my eyes?—on the canvas, comes the impression that there are now three of us in the studio."[1]

Eyes give life or are perhaps the most powerful conduit through which the presence of life is communicated. An eye not in symmetry with its partner—crossed, pointing outward, scarred or clouded as mine was—causes confusion about how to interpret the person whose eye it is. A badly made prosthetic eye can fail by not conveying any or enough of the signifiers of life: color, luster, movement.

When Michelle began painting my eye in 2009, she said her goal was "perfect congruence," the prosthetic eye an exact copy of the natural eye it would sit next to. She planned, for instance, to replicate a freckle that's on the iris of my real eye. She would paint it in the same place and of the same color, Mars Brown. My goal, I had been half thinking, was to be made as symmetrical as a butterfly. I once heard of something called "Marlene Dietrich lighting." Most actors look better lit from one side or the other. Dietrich's face was so balanced she could be lit dead center over the bridge of her nose

and would look stunningly etched from any direction. I didn't have quite those unrealistic illusions. My nose would remain crooked, my smile lopsided. Anyway, as Michelle pointed out, two natural eyes belonging to the same person rarely, if ever, match exactly. Just as with the rest of the face—earlobes, contours of cheeks, thickness and growth direction of eyebrows, wrinkles—small differences abound from one eye to the other. Michelle had a collection of magazine photos proving that even models have two different-shaped eyelids. One of her own eyes, she said, is a smidgen higher than the other, though that seemed like something she may have noticed and had anxiety over as a teenager and had long since assigned to its proper place of insignificance.

"But as soon as you lose an eye and you come to get a new eye made, suddenly that is the most important thing, that they are exactly symmetrical," she said. "Even if they weren't before. I'm like, 'Go look at an old picture.'"

Later, I would run across a series of photographic portraits, covered in *Time* magazine, exploring the asymmetry of human faces in an unambiguous way. The photographer, Alex John Beck, first took straight-on shots, then for each subject created two edited images. In one, he copied the left side of the person's face and mirrored it onto the other side of the face's middle axis. In the other, he did the same with the right side of the face. The resulting two images—each perfectly symmetrical—are significantly different. Jaw lines are narrower or wider. Eyes are more widely open or more narrowly shut. Ears are higher or lower. Since Beck worked mostly with models, there was a higher natural symmetry to the original faces than would be the case throughout a general population. In fact, some edited images did not differ all that much from their original portraits—as, apparently, Marlene Dietrich's would not have. Most, though, provided surprising revelations, and the eyes were often key to how the two edited images differed.

One set of images is of a man whose right eye turns inward toward his nose, a misalignment called "esotropia." The image that mirrors that side of his face shows him bilaterally cross-eyed—a presentation that would make many people with whom he interacts uncomfortable and uncertain of how to look at him. The image that mirrors the other side of his face shows him with two eyes looking straight ahead, a "normal" appearance that would not invite any questioning whatsoever.

Another pair of images was made from a portrait of a man whose face is so naturally symmetrical that the edited images look as if they could be used for one of those "Spot the Differences" puzzles. A few strands of his short hair stand up in different directions. One picture shows more freckles on his neck. The real divergence between the images comes from the eyes—not in where

they're pointed or in their size or color, but in their energy. The image mirroring the left side of his face is "just a little more vacant," Beck said. "One side is completely present and alert and getting ready and interested, and the other side is half asleep."[2]

What I realistically wanted for myself, I actually knew, was "harmony of the visage," that enticing nineteenth-century phrase from Auguste-Pierre Boissonneau. Harmony is not necessarily symmetry. I'd previously learned that lesson from a late-twentieth-century furniture salesman. My wife and I were trying to buy some chairs to go with a cherry dining-room table we'd found at a garage sale. We assumed we wanted cherry. The salesman had said, "No, you don't want them to *match*; you want them to *blend*." Possibilities became infinite, and we bought light-oak chairs that blended wonderfully.

Through the window in Michelle's office, I could see grass and another one-story building of the same design. The walls were eggshell. I was sitting in a cloth office chair, at the same level as Michelle, whose swivel chair was at a table stocked with paint vials and a selection of brushes that looked exactly like the paint brushes my kids kept at the time in a drinking glass on their art shelf, near piles of construction paper, glue, and markers. The sun was diffusing softly through a sheer. It was one week after I'd been in Michael's office, down the hall, to have the wax model made. In the meantime, he'd fabricated the acrylic version of that eye, and it lay on Michelle's table in front of the paint vials. It was thin and curved, longer than it was wide, like something you might drill a small hole through and wear around your neck on a delicate chain. There was little color to it except the iris button.

Michael came into the room, as he would occasionally during the several hours Michelle would be painting. He slid the eye into my socket: raised the upper lid, levered the eye in behind it, pulled out the lower lid, rotated the eye in, let the lower lid ease back into place. He studied the fit. It was close to what he wanted but would likely need some adjustments before the day was out.

"The key thing with your eye," he told me about the painting of it, "is that it's just so contrasty. You have a really distinctive limbus, which is that outer, darker ring. And then you have a pretty light center field. It's quite unique, actually."

"It's one of those ones that makes you stop and double take," said Michelle. She was excited by the challenge of re-creating it, and her enthusiasm gave me a sense of tranquility, a happiness that my future presentation to the world was in her artistic hands. I remembered the compliments I'd received about my eyes when I was young and felt churlish for not having accepted them with grace. It was strange but a relief, I thought, that I was so ready to receive the

compliment from Michelle and Michael. Maybe I was simply old enough to act better. Maybe it was that the two of them had never seen me with my bad eye, had never made judgments about that person at all, and didn't even really see me with an empty socket, or at least not as someone who would have that emptiness for long. What they saw, I realized, was imminent potential, the upcoming harmonious me.

Michelle's paints were made from the same clear powdered acrylic resin Michael used to make the prosthetic, the same substance from which the dentists at Valley Forge made plastic eyes in 1944, the same substance used since then in everything from plumbing fixtures to floor polishes. The online sites of plastics manufacturers describe PMMA, or poly(methyl methacrylate), as having excellent transparency and weatherability as well as—a bonus for an environmentally minded person getting a plastic body part—easy recyclability. The material's main drawback in terms of prosthetic eyes is that it's hydrophobic, especially compared to glass, meaning it doesn't hold wetness on its surface well. Hence, wearers can get a good case of dry eye. An ocularist in New Zealand has led recent experiments with grafting ethylene glycol dimethacrylate, or EGDMA, onto PMMA. That combination, he and his coauthors report, has shown a "significantly improved" wettability and "the potential to significantly improve wearing comfort and socket health."[3]

To make each color of paint, Michelle mixed PMMA powder in a light-proof jar with a pigment and some oil, then spun it for eight hours. It's not the easiest paint to work with because it hardens quickly and begins evaporating if left open to the air for more than a brief time. When Michelle needed a particular color, she opened a jar, dabbed in her brush, screwed the lid back on, then painted. The extra meticulousness pays off, she said, because the paint diffuses into the prosthetic more completely. "So instead of having plastic and then a layer of oil paint and then plastic, and then God forbid you drop it, what if it just separated?" she said. "This makes it more cohesive."

There are justifiable concerns, though, about working for thirty or forty hours a week in a small room with potentially toxic fumes. I caught the faint smell of plastic. In nail salons, where some nail polishes and fake nails had once contributed to excessive levels of breathable PMMA, products made fully from the material had long been banned. In 2015, California's Board of Barbering and Cosmetology went further and prohibited the use of all nail products that contained *any* PMMA in licensed nail salons and cosmetology schools, claiming that exposure to it "has been linked to adverse health effects including dermal toxicity and respiratory tract effects."[4] Michelle and Michael had hired a specialist to test their air. After some adjustments, such as moving

the fan to below the level of Michelle's table because PMMA fumes are heavier than air, his final test showed a concentration of 3 parts per million, well below the OSHA recommended limit of 50 parts per million.

"I don't smell the fumes anymore, but maybe you do," Michelle told me. "Unfortunately, it's the kind of substance where no matter how many parts per million, it smells the same. So if it's 3 parts per million or 5,000, you can't tell just using your nose. Hopefully they won't kill me."

At the end of one sitting, Martin Gayford asked Lucien Freud how he thought the picture was going. Freud told him that "each painting is an exploration into unknown territory" and then quoted Pablo Picasso: "That marvellously arrogant thing that he said to a woman who asked about a painting he was working on. 'Don't speak to the driver'—which is a notice you saw then on French trams and buses. I suppose," Freud said, "that if you had another temperament you might say: 'The driver doesn't know where he's going.'" Then he cut off the line of questioning by saying he could "only regard any enquiry about how a picture is coming on as a particularly irritating sort of humorous remark."[5]

I didn't want to intrude unnecessarily on Michelle's process. I could only get a distant—and fuzzy because I wasn't wearing my glasses—view of how she was mixing and layering paint colors or moving around the surface of the eye. Even with the details of her goal right before her in my good eye—like an art student copying a piece in a museum—Michelle's path was full of small determinations. Every ten or fifteen minutes she would dry the prosthetic under a stream of warm air, then swivel toward me and slip it into my socket. She'd lean close, looking from one eye to the other, sometimes for a very long minute or two or even three, it felt, sometimes for only a few seconds. I found it unnerving and exhilarating—the first because I had almost no experience at even that much unrelenting staring, the second for the same reason. There was, too, another odd sensation. With each insertion and removal of the eye, it would feel to me as if the piece of plastic transformed from inorganic to organic: live while in the socket, a mere but fascinating object while on the table. An hour into the process, it seemed as if the plastic were changing in its nature.

As it had been with Michael the week before, there was no hurry in the room. I was Michelle's only patient for the entire afternoon. That slow pace, she said, allows her time to get to know a new person or to reconnect with someone she had painted an eye for years earlier. She especially likes talking with farmers, asking for all the details of their work. But having an eye painted requires a surrender to stillness, to the place and moment. It was for

me. Looking around the room, I could barely find a distraction if I wanted one. There wasn't even a mirror. When I told Michelle about the moment the previous week when I'd made do with the paper-towel dispenser in Michael's office, she said she'd learned something early on: getting an eye painted is not like the potentially collaborative process of getting your hair cut. She used to let patients see her work in progress, but they often got anxious. She would have to explain that until the end "the eye doesn't look the way it's going to look. I mean, it's really close, but there's a marker, there's water floating in it, it's not polished."

"And once someone gets a mirror," she said, "then they want to go in another room, and they want to check outside, and they want to go out to the car. I mean, I've actually had a guy, and usually it's girls, but I've had a guy that looked at himself in the mirror for literally like two hours. And he took the whole day. He just stared at himself all day. I'm like, 'Oh my god. Do you want me to paint? Or do you just want to look at yourself? Because I need to do my job.' He was like, 'Well, let me just see. Something's not right, and I can't figure out what it is.' I'm like, 'It's plastic. That might be what you see. You have to let me finish. Then we'll polish it, and it'll look better. I promise. Just trust me.' But he was like, 'I don't want to trust you.' I can understand, though. I think I would be that person."

Pupils are tricky. If you place one directly in the center of the iris, it's likely to make the eye seem to be gazing outward rather than straight ahead. Usually, you want it slightly up from the horizontal center line of the iris and slightly inward of the vertical center line, toward the nose.

And then there's the fact that a pupil on an artificial eye doesn't dilate or contract. It needs to be painted in one size that fits all conditions. Michelle said she aims for "a natural-looking eye in normal lighting." She turned off the overhead light to see how big my real pupil got in the dimness. Not very. My pupil, it turned out, is "on the smaller end of the spectrum" and pretty much stays there. Therefore, Michelle could make some assumptions about the conditions in which people would be looking at my eyes. In bright daylight, I would probably be wearing sunglasses. In the dimness of, say, a bar, the difference in my pupil size would probably be within the range of an almost unremarkable asymmetry.

Dilating pupils have long been an unfulfilled aspiration. A patent for one design, issued in 2000 to Fredrick Schleipman, Russell Schleipman, David P. Van Sleet, and Paul A. Duncanson, surveyed the limitations of several designs previously patented before explaining how this new design would work better.

The inventors argued, for instance, that a design embedding a "transparent annular display" with a light sensor at its center, in front of a painted iris (the display would be the size of a fully dilated pupil and would darken when activated, covering part of the iris with black, then return to clear when it was deactivated by more intense light) would tend to "affect the appearance of the iris image even when it is deactivated" and "may not match the appearance of the pupil of the natural eye in moderate ambient lighting environments." Equally significant shortcomings existed, they said, for a design using "photographic-type diaphragms for simulating an iris," another design that included "a mechanical structure to alter pupil diameter, not an electronic display," and yet another that "suggests an artificial doll eye which allows light to travel through a lens some distance into a solid, transparent light shaft in the center of the lens and pupil to give the impression of a real human eye." That last one, they noted, "does not suggest actual manipulation of pupil diameter." Their own invention put a light source behind an iris created from a digital photograph of the partner eye rather than a painted iris. Some pixels would be removed from the photograph to form concentric rings of "clear, non-image areas." The light source would have a matching "series of independently activated concentric rings." A light sensor would determine how many rings of the light source should be darkened or lightened, and hence how dilated or constricted the pupil would appear to be. An embedded battery would power the light source for as long as the battery lasted.[6]

And you can go back much further. An article in the *Boston Courier* in 1830, for example, reported on the advancements of "Dr. Scudder, the ingenious oculist, whose artificial eyes are said to have pupils which contract and dilate." Scudder was making glass eyes, and he apparently hit upon making the edge of the pupil indistinct, the kind of softening Michelle was doing for me at that moment. "The effect of this is admirable," the article said. "If we bring the eye to a strong light, the line of the circumference of the pupil is clearly distinguished; if we now remove it to a less powerful light, this line is not discerned, and being lost in the deep shade of the margin of the iris, the effect is an apparent increase of size, or, in other words, dilation of the pupil itself."[7]

"Someday somebody will figure it out," Michelle predicted.

Michael popped back in during the second hour. The basics of the painting were done, but plenty of fine-tuning was left. He studied me closely, then had me stand so he could look from a different angle. He thought there could be a little more color in the nasal corner. He thought the inner portion of the

limbus could be thinned "ever so lightly" to give it more blend. "If you look at nine o'clock down to six, that's where I think the limbus is still a little too full," he said to Michelle. "If we soften it a little bit, I think we're going to be on target. Maybe strengthen that vein at about three o'clock." (The veins in the white of the eye are not painted on but are instead red thread. Michelle zigzagged them onto the surface and then locked them into place with a clear coat.) "And maybe a little more wash, like a raw umber in the temporal side," he added. "It's a little too white for me." He thought the color of the iris was very cool.

"I'm going to probably wind up in a straightjacket someday, trying to be perfect," he said.

Michelle had her own high level of precision. During one inspection, she frowned and said, "Slightly softer pupil. My pupil is a little sharp. Yours blends more with your iris. And mine is kind of striking, so I'm going to soften the edge."

When I wondered why she couldn't take a picture of someone's real eye and paint the artificial eye from that, she said, "Go to Wal-Mart and get it printed, and then go to Kodak Easy Share, and one of them comes back, it's this color, and one of them comes back, it's that color. That doesn't help me. I have used photographs for patterns. Like if somebody has a freckle, and I need to know the exact position. Or if somebody's iris shape is not round. A lot of times people have oval-shaped eyes. I need to know what direction the oval goes in. But not for color, ever—never, never for color."

And well into the third hour, scrutinizing harder still, she said, "I'm looking for flaws, which is why I have that serious look. I'm not looking to see how great it is right now. I'm looking to see what's wrong with it, so I can correct it. So that when you leave, you can be happy."

She called Michael back in to see once more what he thought. He suggested muting a vein a little bit, giving it "a little bluish tinge, just a little flow." Then he'd be good with it. "Everything else is just right on," he said.

Michelle had to leave for the day. She had a kid coming home.

"Hopefully Mike will take good pictures," Michelle said. "I'll ask about you when he gets home. 'How was it? Was he happy?' I hope the answer is yes."

I'd had many doctors look at my eyes, but no one had seen in them what Michelle had: the network of colors, the subtle contractions and dilations of my pupil, the delicate specter of the limbus, the ramble of veins across the sclera, the Mars Brown freckle—everything aesthetic that made the eye my own, which in the moment felt like much of what made me. I thanked her. She told me again how excited she was for me. She would be back to paint

someone else's eye the next morning. It was a really busy time. "Every year in November and December it's the same thing," she said. "Everyone wants a new eye for Christmas."

I moved to Michael's office and sat for ten or fifteen minutes while he worked on the eye in his lab. When he came back, he said he had added more plastic to it and that it might feel a little full when he put it in. First, though, he showed me its details.

"On the top portion there's a date," he said. "Just remember the date goes on the top. And that pink part goes toward your nose. You're probably not going to have to take it in and out, but I always show my patients how to do it, just in case. You will get one of these little suction cups, which I've got right here for you. And I've got a bottle of artificial tears as well. So the easiest way to put this in is put the suction cup right on the iris, like a little bull's eye, and you want to put it underneath the upper lid first. Just take your middle finger and your index finger and just pull on the upper lid, slide the prothesis underneath the upper lid. Take that same hand down, pull down the lower lid, and it pops right in. Once it's in, just squeeze the suction cup, and it releases it. It really can only go in one way and one way only. Meaning that if you forgot that the date went on the top, you couldn't put it in that way. It just wouldn't go. It always wants to lock to a certain position. And everything has been carried from your impression mold right here all the way down to the permanent mold, and everything fits like a glove. So everything is a copy of you, from the impression all the way down."

He slid the eye in.

"I don't even feel it basically," I said.

"That's what we're looking for," he said. "Your movement is unbelievable. Look left and right. Yeah, you have better movement than most. Your lateral movement is pretty impressive. Now look up and down for me. Yeah, you've got good up and down. You're getting more superior movement, which is very rare because you're asking tissue to push a heavy object up. It's just tough. I mean, it naturally wants to look down because of the weight of it. But yeah, that all came out beautiful."

"It feels really good," I said.

"It looks fantastic."

He had me put my glasses on and liked what he saw there, too.

But with the glasses off again and one more close inspection, he decided that the upper lid was not resting on the new eye with exactly the even arch that it should.

"It's a little bit high at maybe eleven o'clock," he said. "I want to thin that down, just a little bit. But I do like it, man. It's impressive. Look left and

right again for me. Color's good. Yeah, Michelle did a good job with that. So just a little thinning, just a little bit. Okay, I'm going to take it from you, unfortunately."

"Oh, I just got it," I said.

But he was back in minutes, and when the eye was in place once more, he took a hand mirror from a drawer and held it up in front of me.

"Recognize that guy?" he asked. "Have you ever seen that guy before?"

Anna Boyd Jefferson, Ocularist

The business, Carolina Eye Prosthetics, was founded in 1987 by my uncle and my dad. They worked together for twenty-five years. I started an apprenticeship with them in 2003, but it wasn't your typical apprenticeship. It was kind of sink or swim. I observed them for about three months, and then they started giving me patients. I honestly think they assigned the patients to me that were more challenging, or at least that's how it felt at the time. I remember one patient had dementia, and every twenty minutes or so she would become irritable because she thought I was going to hurt her eye. And I would remind her, "The eye's been removed," and she was, "What?! My eye's been removed?!" I was very green and very young. In hindsight, I probably could have used more time to mature before engaging in this profession.

Then in 2011 my dad was diagnosed with ALS, but not before the partnership between him and my uncle grew apart. That's when I came in and took things over. The business was not in a great position, but it forced me to evolve. Health-care laws were changing, and I had to shed old policies. I found that I really enjoyed rebuilding the business. When I went to my first ASO conference, I was a nervous wreck because I had the impression from the prior generation that I would not have a good experience. And that wasn't at all the case. A lot of people wanted to help me because they saw I was nervous, really scared that the business wasn't going to do well. With a small business, you're either too busy, and you're not going to be able to keep up with the demand, or you're not busy enough, and it's like "How am I going to make payroll?" Luckily, those days are behind me.

When I first started, I took failure very, very hard. When you first start, you're not that good. It's so defeating. It takes a long time to learn how to do it. The more I've done it, the more I see that it comes down to the evaluation and vetting the patient. I mean, the product and skill level are important, but that's a given. So I spend a lot of time with the patient. "Tell me what it is you don't like." I do a lot of replacements. When you have new surgeries, those are the easiest ones because they're just so happy to move on. It's the second eye that is the most challenging because you're never going to top that first eye. I think I have messed up a lot in the past. I mean, you learn from your mistakes. I did not properly vet the patient, I did not properly validate the patient. When

I go home after working on an eye, if it's not a good fit, they're going to call the next morning. And I'm never surprised because I knew something wasn't quite right. I haven't had that in a long time because I don't take on everybody anymore, or maybe I've gotten better. Maybe I didn't set reasonable expectations, but I would go into shame spirals some days. I'd go home and be like, "Oh my gosh!" I could feel that they weren't happy. But that's just learning. And I think it's because I'm very, very sensitive. I have a lot of grace for people who are very sensitive. It takes one to know one.

My joy comes from visiting with my patients. I know their families, I know their history, for the most part. It's just like visiting with friends. We do polishes two Fridays a month, with a few exceptions for people who happen to be in the area. But that way we can see a lot of people in a day, spend time with them, and not be interrupted with the eye-making process. The work itself requires focus. If I am having some sort of personal crisis, it ultimately will find its way into the work. I do my best to start my day clear-headed and upbeat, not only for the sake of the product but also to present a demeaner that the patients can trust. There is a lot of energy patients bring that can be very heavy. I've had many sleepless nights, a lot of anxiety, but over the years I've learned to compartmentalize. I've also been making prosthetic eyes for over twenty years now, and the experience itself has been more calming for me. This is particularly important for working with children.

I work a lot with kids. I work with pediatrics who have—not a lot because it's very rare—congenital anophthalmia. These are kids who are born without eyes. I therapeutically stretch out their sockets and fit them with conformers, with graduated-conformer therapy. I make them progressively bigger. When you're born without eyes, most of the time there's some sort of little bud of an eye back there. And that puts you ahead of the game when you're fitting because it's enough to stimulate some sort of fornical growth, though every case varies. When you're fitting [for eyes in cases of] congenital anophthalmia, you don't have the eyelid pockets. The role of an ocularist is to gently stretch out these spaces. And we usually start with a stemmed conformer, which provides stability and torque. Most of the time, if you fit them with a regular conformer, it just slips right out. Once we get some fornices established, then we can get rid of the stem and start really building it up. And then when it gets to a good point, which can take years, then you send them to a surgeon and have an implant put in. But this is a long, long process.

And then other pediatrics I work on have microphthalmia. They have an eye, but it's just disorganized, and it's not as big. I don't fit them right away if they have a fairly large globe because they can't always tolerate it. When I feel like there is adequate space, [in] maybe one or two years, then I'll fit them. It

just depends on the presentation. Some patients I fit right away. My youngest was just ten days old. But I've had too many babies we were overeager to fit, and they did not do well with it, and I think the parents gave up on it.

Working with kids, they are the most stressful ones. But they give the most joy. They're difficult to work with because of low cooperation, and the parents are often still processing grief, but children also get the best results because they typically don't have as much volume loss in the socket after an enucleation that an adult may experience.

You've got a lot of emotion, especially with parents who've just gone through retinoblastoma with their kids, and those are usually toddlers. Everyone's got some degree of trauma. Working with kids mainly means having the trust of the parents. So when they come into the office, everyone's a little bit jittery. I have two different conversations: one with the parents and one with just the child. I leave my door open so the parents can hear everything. And usually with the child, depending on the age, I'll try to start them with a tour and show them everything. I call it the eyeball factory. We'll go in the back with my lab tech, and I'll say, "This is where we make eye soup," and we've got the pressure cookers back there. I have fun things to distract them with, or I'll let them draw on a whiteboard so they can "paint" while I am painting. I don't want them to feel like we're doctors. Ocularists are not doctors, but that's how patients feel when they come here, and it's at the end of a long, difficult journey. We do not have an anesthesiologist nearby, so we must find ways to work with unwilling participants. I'll try to figure out what works for each child. If there's no cooperation, I'll speak to the parents separately, so they can ask all the things that they want without making the child nervous. They need to know how we are actually going to accomplish the daunting task of making a lifelike eye with low cooperation. I tell parents that their space is in the lobby unless the child is not able to cooperate, and then the parents will quietly come to the exam room to hold their child, then exit, with the door left open. If their child wants to follow, that's fine, but the parents cannot hold or coddle their child because once the child gets into a habit of hiding their face in their parents' arms, I will not be able to see the direction of the gaze or how open the eye is. Once the toddler knows their crying won't change the outcome, then we begin the work of de-escalation of trauma. I give the child a choice: "We will work a little, and we will play a little. How would you like to get paid? Cash or candy?" And if we have to hold them down, then they will not receive anything (until the end of the day, but they don't need to know!). I have a wonderful playset that boys and girls can't resist, but it stays in the exam room. If they want to play, they have to walk away from Mom and Dad.

I tell the parents, "Don't talk about the eye before the appointment." Talk about going to see Fifi. We have an emotional support animal who's actually missing an eye. She lost it in 2020. Go figure. We call her an empathy dog rather than an emotional-support dog since she's been through the wars, too. It was a COVID-related injury. My dog groomer wasn't taking any appointments, so Fifi's hair got long. She pouts when I don't bring her into the office, and with COVID I wasn't sure how to deal with that, so I wouldn't bring her in. And she was pouting, and then my husband told me she hadn't been eating, so I knew there was something wrong. She had injured herself, but her hair had gotten so long. In Shih Tzus, they have really shallow fornices, and their eyes are proptotic [bulging]. They're prone to eye injuries, like Pekingese are, too. It's really common, but some of my patients teased me: "Anna, did you do this on purpose?" To be fair, I felt awful but also thought it was wonderful. The little girls especially get such a kick out of the fact the dog is part of the club now!

For the parents, validating the trauma is really important. I really think the parents suffer more, especially when the child is young. One of the most damaging things I've seen with the generation that grew up in the '50s or the '60s or even younger is when they were told by their parents, "Don't ever talk about it. You have a prosthetic eye, don't talk about it." They had to hide it, which instilled a sense of shame. I've seen people that just have terribly low self-esteem even if they have the greatest result you can imagine. When I see that dynamic, when I see parents projecting their grief, I'll say, "Let them be honest about it. They're survivors. Treat it like a Purple Heart." If they feel good about it, they can roll with the criticisms they're going to have at some point in middle school.

With a lot of my trauma patients, when they come in initially, I take the conformer out, put it back in, and do it over and over and over again. I have them touch their eyelid. I have them open up their eyelids just to look in the mirror. A lot of people won't do that, and that's not great for the healing process. They have to be able to be hands-on because, I mean, prosthetic eyes fall out, and sometimes they rotate. I spend a lot of time just making them be tactile with it. I gave one little girl a fake prescription with just my name on it. I told her, "Every night before you go to bed, tap your eye, and then you can take your medicine." And I gave Grandpa a packet of M&M's to take home with her. That was her medicine. After she did that for a while, she was more cooperative. With kids, if they're able to do that, the work is an absolute joy. I am hard on myself, but I feel so good about my days with pediatrics, and I take a lot of pride in it. I do have some kids that are overly comfortable. They'll take out their eye and chew it or something. You've got to have a sense

of humor about it. It is funny when a kid takes his eye out and throws it. And there's ultimately a baby who comes in, and the eye was found in a diaper, and we're like, "Oh, boy. Let's go give it a long boil."

I try not to let the work go to my head. People are so grateful to feel put back together or at least to be able to move on. I have been told I was blessed by God, that I am a miracle worker, and the like. All ocularists have this sort of feedback at one point or another. And we all know that we got here either by nepotism, extreme artistry, or just luck. There have been so many times when I felt people were put in my path at the right moment. I made an eye for a hospice nurse right after my dad was diagnosed. I saw my dad break down in tears and my mother trying to comfort him as he said, "I don't want to die." ALS is incurable, and most people don't survive five years. I opened up to my patient and said my biggest worry is that my dad was afraid. I asked her if hospice nurses believe in God. She said, "We all do, Anna. And don't worry, most of the time it's peaceful. And he won't be alone; someone will come get them, and it's usually the mother." And she was right. My dad passed in his sleep holding my mother's hand. After that, I decided there are angels on earth. I have relayed that story to patients after bad news in hopes that it will give them the comfort it gave me.

5
Glass

In Germany, it's best not to refer to an artificial eye made of glass as a "glass eye." That's a criticism meaning the same thing as "Are you blind?!" when you can't find something right in front of you. Instead, one should say "eye prosthesis made in glass."

An ocularist in Stuttgart, Ruth Müller-Welt, told me this when I visited her to see firsthand how artificial eyes are made out of glass because a number of American ocularists had told me that though *glass eye* is still a common synonym for *ocular prosthesis*, Germany is the only place where such objects are still produced and used widely. (The country's German-speaking neighbors, Austria and Switzerland, also fall into this category.[1])

Ruth asked to borrow my notebook. In it she wrote "Das Glasauge" and put a frowny face next to it. Then she wrote "Künstliches Auge aus Glas" and put a smiley face next to it.

Germany's dominance in the history of ocularistry was deep and long. On my trip there, besides spending time with Ruth in Stuttgart, I also made what felt like a pilgrimage to Lauscha, a small town of less than 4,000 in the central east part of the country, founded in 1597 by two glassblowers and prominent in German glassmaking pretty much since then. Evidence of Lauscha's importance in ocularistry appeared as soon as I got off the train on the south end of town next to the Goethe Schule, an imposing three-story, red-brick building that did not seem to be in use but that had metal plaques near the front door celebrating six "Outstanding Personalities of Lauscha [Herausragende Persönlichkeiten Lauschas]." On the top left, number one, was Ludwig Müller-Uri (1811–1888), "Inventor of the German artificial eye made of glass [Erfinder des deutschen Kunstauges aus Glas]." That invention happened in 1835.

Müller-Uri, the son of a glassblower, had been making eyes for dolls and toys, and his talent had been noticed by a physician from Wurtzburg named

Heinrich Adelmann, who asked him to make eyes for humans. After two or three years of experimentations with bone glass (sand, soda, and bone ash from domestic animals added to the normal raw materials for glass) and enamel painting, Müller-Uri's eyes surpassed in quality those made in Paris, especially in the detail and liveliness of the iris. Over the next several decades, Müller-Uri developed a way to "paint" irises with colored glass rods rather than with enamels, and in 1868, in collaboration with several other glass masters, he invented cryolite glass by adding "ice stone" (sodium hexafluoroaluminate), a natural raw material discovered in Greenland, to the glass recipe. Cryolite glass becomes translucent at high temperatures but finishes to an opaque white that can be pretty close to the white of a real sclera. Many recent descriptions say it has unequaled "tissue compatibility," meaning it's not likely to irritate the socket, and many others praise its natural-looking sheen, the result of how it allows moisture to spread easily and evenly over its hydrophilic surface.[2] It quickly replaced the lead glass long used in Paris and the bone glass Müller-Uri had been using.

My first research stop in Lauscha was the Museum for Glass Art (Museum für Glaskunst). The exhibitions were devoted primarily to decorative glass—sculptures of reindeer and intricate carousels and human figures, Christmas tree ornaments (Lauscha is also the birthplace of the Christmas bauble), and various kinds of drinking glasses, but there was also a modest exhibit on the making of glass eyes—I mean, eye prostheses made in glass. It included archival photographs, a display of glass tubes at various stages of transformation into eyes, and a thin carrying case containing thirty eyes made by Müller-Uri, each snuggled into its own nest of velour. Embossed in the fabric inside the top of the case is "Ludwig Müller-Uri, Lauscha S.M."

Augenprothetik Lauscha is a couple hundred yards north of the museum and is not only the one ocularistry business in town but also the oldest in Germany, in operation since 1835 and begun by Müller-Uri. This was my other research destination in the town. Three of the nine ocularists who worked there when I visited—Thomas Haas and Janice Müller-Blech, both of whom had been making eyes for three decades, and Jacqueline Hähnel, who was in the middle of her apprenticeship—cheerfully and kindly hung around after their workday to answer my questions.

I was curious, first, about how they saw themselves in comparison to the glassblowers who produced the things I'd seen in the Glass Art Museum. Were they artists? Artisans? Technicians? Craftspeople? I told them that American ocularists seemed to fall into any or all of those categories.

They laughed modestly and discussed the question among themselves briefly in German. Then Janice said: "I think that when you make art, you

make something new and creative. But we have a shape, and we just make the same shape."

"We're probably mostly craftsmen," Thomas added, though he added that making an eye "sometimes" feels like an artistic undertaking.

My big question, though, was about why ocularists in Germany continue to prioritize glass even though most if not all of the rest of the world long ago transitioned to plastic. In their own lab, Thomas and Janice told me, 95 percent of the eyes made are of glass. There is one ocularist on staff trained in plastic. I already knew that a German citizen who wears a prosthetic eye can get a new glass one each year for free, so patients have a financial incentive. I imagined, too, that glass eyes, having been invented in Germany, were culturally important, worth national support. I had seen a plaque elsewhere in town that production of handblown glass Christmas tree decorations from Lauscha had been included, upon the recommendation of the German Commission for United Nations Educational, Scientific, and Cultural Organization, "in the nationwide register of intangible cultural heritage." So I suspected the reasons for the dominance of glass eyes in Germany were extremely complex and often intangible. Janice, though, offered a direct answer.

"We feel it's a better material," she said.

"It's better stuff," Thomas agreed. They clearly did not want to discredit plastic eyes. They knew I had one, and they'd complimented it generously. "I think glass looks more natural. And it fits better," Thomas said.

Actually, I knew the specifics of their rationale by having read Augenprothetik Lauscha's website, which directly addresses the question on a page titled "Glass vs. Plastic." Glass has "good wettability." An eye made of glass is light because it's hollow and has thin walls. Its shine or "gloss" is "very close to that of the natural eye due to good light reflection." Its colors don't fade. And an ocularist can make a glass eye in an hour or two. That page does note the fragility of a glass eye "when handled carelessly" and that you can't really modify it or repair a damaged one.[3] The advantages listed for plastic are essentially about its durability, which Janice confirmed.

"I think the only advantage of acrylic is that it doesn't break," she said.

In Stuttgart, Ruth would tell me at length about the attitudes among German ocularists toward glass and plastic. She makes eyes in both materials, with the numbers about equal or slightly in favor of plastic. Her movement into making plastic eyes, years earlier, had not been welcomed by most of her German colleagues, though those tensions had eased significantly.

"Some of them say, 'I still don't want to work with the crappy plastic,'" she would tell me, 'but I'm happy that you can do it, and I hope that it's going on in the future with our sons and daughters.'"

Even Ruth admitted, though, that she prefers to use not the word *plastic* but *acrylic* instead. Plastic is the trash along the side of the road, the junk that fills the oceans.

Janice asked whether I had tried a glass eye. I admitted I hadn't.

"A lot of patients say glass feels very different," she explained. "Not always better. Sometimes better, sometimes worse. It depends on what you're used to."

I would like to have gotten one made to know firsthand. But I wasn't a patient there, and it was the end of their workday. They had been extremely generous, and I needed to let them get home. I asked one final question: How did they imagine the foreseeable future of ocularistry in Germany? Would it be glass?

"We hope so!" Thomas said, laughing.

On the way out, I stopped to look at a tall case just inside the front door, which contained memorabilia from Ludwig Müller-Uri. There was his gold medal from the Leipzig Trade Fair. There was an intricate poster advertising his services, with beautiful line drawings of variously shaped eyes. There was a thin carrying case with fifty square compartments, each of which nestled an eye made by him. His name was embossed fancily in what looked like silk on the inside of the case's top.

Ruth Müller-Welt's ocularistry business, the Institut für Künstliche Augen, is in a three-story brick house, with tall, round-topped windows, the third floor exterior a white stucco with brown trim. It is on Sonnenbergstraße, a pleasant street of large brick homes, many with pointed turrets. A sign next to the front door announces that Ruth is a member of the Deutsche Ocularistische Gesellschaft e. V. and the ASO. Michael Strauss had given me her name, and he knew her through her regular attendance at ASO conferences in the United States. Ruth is among a small number of German ocularists who have formal connections with the ASO.

Once you enter her business on the second floor, you can turn right to go into the glass-eye lab or left to go into the plastic-eye lab. She showed me the glass-eye lab first. It was quiet that morning. Ruth employs three other ocularists who would normally have been in that space with their patients, but they were on the road for the week, making eyes across southern Germany. The room looked slightly like a chemistry lab in an American high school, if only because it had large workstations with wide black countertops. Mounted on each, near the edge on the side where the ocularist would sit, was a gas burner: silver, five or six inches long, the diameter of a candlestick, angled toward the wide middle of the station so the flame that torched out would be

pointing away from the eye maker. Two tall cabinets in one corner were made of stacks of wide, glass-fronted drawers as thin from top to bottom as those on a music cabinet. Each was filled with eyes. Because the traveling ocularists didn't need the room that day, Ruth had laid out for me across one of the workstations an exhibition of old photographs, important documents about the history of the Müller-Welt business, news articles about it from years past, and other memorabilia she thought might be interesting and helpful for my research.

She picked up one black-and-white photo and showed it to me. It was of the room we were in, but from what Ruth guessed was the early 1950s. The large windows and tall ceilings were the same, but the furnishings were distinctly of the time: tiled walls, metal work desks, a white-enameled sink, drafting lamps on extendable arms. It showed four ocularists at work, each in a white lab coat, three of them making glass eyes, one studying a case of eyes already made. A woman is sitting in a chair and writing on a pad of paper. She is not an ocularist because there were no female ocularists in Germany at the time. (Ruth was the second woman to become an ocularist in Germany.)

One of the ocularists in the photo, a man with a high forehead, wire-rim glasses, and a neat mustache, wearing a shirt and tie under his lab coat, is Ruth's grandfather, Otto Müller-Welt. He had been trained in eye making by his father, Adolf, who had become an ocularist in part because he'd been born near Lauscha. In the last decade of the nineteenth century and the first two of the twentieth, Adolf had worked for a firm in Wiesbaden. The family moved to Stuttgart in the early 1920s, and Otto bought the building we were in. He made eyes on that same second floor. The rest of the house was his family's home. Adolf died in 1938. Otto ran the family business until 1976, when his son, Jörg, took over. Jörg was Ruth's father.

She picked up a photo album and flipped through it. In the middle was a series of eight-by-tens of her grandfather—same lab coat, same tie—demonstrating key steps in the making of a glass eye.

"First you have the tube," Ruth explained of the picture of Otto with a thin cylinder of glass in his right hand, which he had already heated and from which he was in the process of pulling away a small piece. She flipped to the next photo.

"And then you blow this little piece to a bubble," she said. "This is the bubble, which is a little bit pointed on one side, and on this side we put the base color, and then take the color rods and make the color. And then blow flat, and then finish it."

I tried to follow the steps. They seemed straightforward. But even though I had watched a couple of videos of glass-eye making before I left home, I

knew I wasn't getting the subtlety. A dozen pictures from moments in the entire process can only illustrate what things should look like here and there, not capture the art or craft itself.

"Rahel will show it to you," Ruth said.

Rahel was Ruth's daughter. She was twenty-seven when I visited, just beginning the final stretch of a nine-year apprenticeship with her mother. She would be the fifth generation of the family to make eyes professionally.

Ruth picked up another album, this one filled with before-and-after photos of patients who had gotten eyes made there back in the 1940s and 1950s. They were black-and-white head shots, with white borders, one pair to a page, held in with small black corners. The subjects look directly into the camera, without smiles. They reminded me of the portraits by August Sander, one of my favorite photographers, who in the 1920s began documenting Germans of various social and economic backgrounds and captured a captivating certainty of presence in a pastry chef, an architect, a farmer, a musician, and hundreds more. In many of the "after" photos Ruth showed me, it was impossible to tell that the person had an artificial eye. In the "before" photos, either the socket was open and empty, or the lids were closed. With other patients, the damage was severe enough—such as the man whose brow was mostly missing—that the new eye went only partway toward restoring an appearance of normality. This is the same range of results ocularists can get today.

The other documents included letters of gratitude from patients; official correspondence from the Deutsche Ocularistische Gesellschaft e. V; feature articles about eye making and the Müller-Welt firm, such as one titled "Am Anfang was das Elfinbeinauge," which my Google Translate app told me meant "In the Beginning Was the Ivory Eye." There was a newspaper announcement from 2005 commemorating Jörg's fiftieth anniversary as an ocularist. It had an accompanying picture of him with his wife and Ruth. The article read: "Today the company . . . specializes in eye prostheses made of glass and plastic. . . . Technical perfection, empathy, and devotion to the patient justify the long tradition of the company [Technische Perfektion, Einfühlungsvermögen und Zuwendung zum Patient begrüden die lange Tradition des Unternehmens]."

I picked up a glass eye from an open drawer.

"You won't break it," Ruth said when she saw my hesitation.

And, in fact, the eye was surprisingly sturdy. It would shatter if dropped, but if I were someone from outside Germany who knew only plastic eyes and assumed that's what all artificial eyes were made from, I probably would have assumed that this eye, even as it lay there in my palm and I ran my finger over its curved surface, also was made from plastic.

Ruth had a patient in the plastic-eye lab. She said I could come in and watch, that the patient had already said she didn't mind a visitor. The room had the same airiness as the other lab, but with Ruth's paints and brushes spread across the black countertop and various plastic-eye-making equipment, such as ovens and microscopes and sinks along a couple of walls. I took the stool on the far side of the one workstation. The patient, Louisa, was seventeen and was missing school that day to be there. She had been getting eyes from Ruth since she was three months old after being born with microphthalmia, her left eye never having developed. During the earlier part of her childhood, when she was growing fast, she'd gotten a new eye every six months or every year or two years. She had all of them at home, each in its own small box, she said. She thought maybe one or two of them were glass, but mostly they were acrylic. Now she had grown enough to need her first new eye in five years. It was acrylic. Ruth had already molded and fit it. That day she was painting it.

Louisa seemed as relaxed as if she were visiting her grandmother. Ruth joked with her and teased her a little, even while she kept asking Louisa for her evaluation of how the eye was looking. Every once in a while one of the women who worked at the front desk came in, and they would make a joke with Louisa or touch her head or shoulder lovingly. They asked her what she wanted for lunch—the painting would go into the afternoon, so she would eat with us.

Ruth pointed out a diploma hanging on the wall to my right. I hadn't noticed it because it was on my blind side. But once I turned to look, I saw it was actually hard to miss. It was an award given to Adolf Müller-Welt, Ruth's great-grandfather, for winning the gold medal for eye making at the World Exposition in Brussels in 1910. The diploma was probably three feet high and five feet wide, covered mostly by an image that looks to have been drawn originally in pencil or charcoal. A naked man is standing tall, facing to the right, with a hammer and a book tactfully held in his right hand, a cloak over his left shoulder but not covering much else of his trim body. A female angel with breasts exposed and heavy-duty wings is placing a laurel crown on the man's head. There are other female angels and two other men, each raising a hand in honor. Below the image are these words:

SOUS LE HAUT PATRONAGE de S.M. LE ROI DES BELGES

Group III—Class 16—Allemagne

DIPLOME DE MEDAILLE D'OR

Décerné a

Monsieur Müller-Welt, Adolf

Collaborateur de la Maison Müller Sohne (F.-Ad.), a Wiesbaden.

There are signatures from various authorities, including le Ministre de l'industrie et du travail. It is a diploma appropriately impressive for a gold medal at a World Exposition.

I asked Ruth how all-consuming it must have been for that building to be for generations not only the location of the family business but also the family home. Ruth's great-grandfather, Adolf, the gold-medal winner, had first moved his family into the house when his kids were teenagers. Her grandfather, Otto, moved across town when he got married, but his son, Jörg, moved back into the house when he got married. Jörg and his wife had raised Ruth and her three sisters in the same rooms.

Home and business were all one, Ruth recalled. She and her sisters ran through the business space all the time, where her father and grandfather were working together, to get to the swing set in the backyard because it was easier that way than going out the front door and all the way around. Conversation in the house was often about the business they lived amid. Ruth's dad would bring up work all the time, and her sisters would say, "Oh shut up, can't we talk about something else besides eyeballs?"

And yet, despite that unbroken family work history, it was not clear for a long time that the family business would continue beyond Jörg's generation. German ocularistry was not merely male dominated for most of its history but nearly male exclusive. For Ruth, there was no striding into the job simply by virtue of being born a Müller-Welt.

"My dad was very disappointed because he had only four girls," she said as she painted, magnifying lenses held in front of her glasses from a strap around her head. The room had the familiar smell of monomer, the fumes being pulled into vents atop the workspace by low-whirring fans. "Not because of himself. He loved girls, but his parents always told him that's a problem that you have only girls. Four children but only girls. And so he was very upset about that."

The tension increased when Ruth, unlike any of her sisters, began to realize early on that she did want to be the fourth generation of family ocularists. As a young teenager, she had often joined her father in a little lab he had on the third floor of the house, and he would show her some of the things he was doing, not only with eyes but with silicone replacements for eyelids and brows and other parts of severely damaged orbits. At fourteen, she asked for and got her own bit of space in that lab, a place to use her hands.

She also drew a great deal, she said, especially with pencil.

"I loved to do portraits, and I loved to do eyes," she said. "What I did was I was just copying some music idols from records. I'm an '80s child, so I love Depeche Mode and Culture Club and things like that."

Then, when the family was on one of its regular hiking vacations, she con-
fessed to her father her revelation. "One day I just told him that I would like to
do it," she said. "Same job. He said, 'You go to school, and you finish school,
and then we talk again.'"

So she did finish school, then completed a year in what she called a training
school, but not for ocularistry, because even in Germany, as in the United
States, there were no such formal educational programs. At eighteen, though
family disagreements and doubts about her aspirations and abilities were far
from over, she began an apprenticeship with her father. He started to teach her
glass. That's all the firm made at the time, though Jörg was experimenting
with acrylic in his making of those eyelids and brows, which he would mount
on thick sunglasses.

Ruth spent long, self-directed hours in the library, reading about the anat-
omy and pathology of the eye and the eyelids.

In the lab, working side by side with her father, she learned by example not
only technique but also more of his philosophy of patient care—"The patient's
always first," she said he made clear—and began to see how her father's
thoughts of himself in the history of the family business were complicated
and difficult in their own ways.

"He told me that he was often very afraid that he couldn't do the job right
because he had his ancestors who were so perfectly working," Ruth recalled.
"But I said, 'Dad, probably they had the same problem. We're all from the
same family.' So doing every prosthesis, especially in glass, it's such a risk all
the time. If you don't do the right thing in the minute, then it might break. It's
fragile. Then you have to do it all over again, and the patient is very impatient
sometimes because he's used to getting his prosthesis in a short time. When
people figure out that you are anxious, then they can be very nasty to you.
They push you, and they say, 'Why are you so slow? Your father did this so
much better.' It's sometimes really bad. And this doesn't help."

Jörg's grandfather's huge diploma from the king of Belgium could not have
helped, either.

Even though Ruth's seven-year apprenticeship in glass was underway, even
though her father was passing on his deep knowledge about those glass tubes
and those color rods and those gas burners that she had shown me in the other
room, even though she was all in on her career choice, her mother, a strict
woman to whom her father often deferred, insisted she quit when she got mar-
ried and then pregnant.

"My parents were even thinking about selling the company because they
said they don't have anybody to follow," Ruth said. "I was just having a child,
my God. I mean, I couldn't travel when I labored my child, but I said, 'I'm

going back to work.' And my controlling mother said, 'No, you're not. Because you have a child.' Because she did it this way. She didn't think that there was a possibility to do it in another way."

Ruth and her husband, though, figured out how to share childcare with fellow parents of young kids, hiring nannies as needed, cooking for the group every third week. For a while, that worked. Then she and her husband had a second child, and her husband got a new job and became, she said, much less available for domestic duties.

"So I started to be a machine," Ruth said. "I was working, I was taking care of the kids, came home, I was cooking. It was really hard for me personally. I knew it was a hard choice to keep the job. And I told my parents, 'If you're selling it, it's okay. It's your business. If you don't trust me, it's your business. I just want to stay an ocularist. That's all I want.'"

She laughed and said she'd sometimes think: "Okay, good job, wrong family."

I told her I had been under the impression—mistaken, obviously—that ocularistry is a profession in which gender should not matter much at all. I had been thinking of the intricate nature of the work itself, of the independence in self-employment, of the fact that if one generation in a family is teaching the next, daughters and sons would be equally capable of learning the craft and running the business. It was true the job could sometimes be very physically demanding; for instance, in the years immediately following World War II, when many of the roads in Germany were destroyed, ocularists had to travel to where soldiers and civilians had lost eyes, and they had to carry with them the glass and the gas tanks and all the other equipment they needed. But how often would an ocularist have to do that?

"The problem is not the technique and what you're doing," Ruth explained. "The problem is that you have to learn such a long time, and you get a sort of number of patients at your company, all the time, and we are so rare." She meant ocularists in general. "So if you're getting a child, and you're away, then there's your patients, and there's not a neighbor or another practice in town who can help you with that. This is the problem."

You need, she said she'd learned, a very supportive family—or, it would also seem, a society that offers childcare.

In the late afternoon, after Louisa was finished for the day, a couple in their twenties arrived with their two-and-a-half-month-old baby, born without a right eye. (They also said they had no objections to my hanging around during their appointment.) The conversation was in German, so I understood nothing. But there was calmness and lots of what seemed lighthearted chat. I could

tell, though, how extensively Ruth was explaining things to them. She took a long time and showed them pictures of other patients with similar conditions and what she had done for them. She gently examined the baby's socket, talked baby talk, took photographs. I found myself smiling along with the parents. If the parents had come to the appointment filled with apprehension and worry, as I would have, Ruth was able to dispel it. Once the baby fell asleep, Ruth kept talking to the parents for another twenty-five minutes. This was at the end of the day. Everyone else in the office had gone home. Then Ruth gave the parents her personal phone number in case they had any questions outside of working hours.

I asked her afterward how she had decided to handle that meeting.

"Well, I try to let them feel comfortable," she explained. "And I always imagine, 'What would I do if I would be in this situation?' I was also worried. I have two daughters. Of course, everyone is worried that your child is okay or not. And I see so very often that people expect a healthy baby, and it's a healthy baby, but he doesn't have eyes. So then they're in shock. I try to figure out how they are. When I first see them, usually I see how they are feeling at the moment. If they try to stay in the waiting area and take a long time to get up, I know it's going to be a problem. I would have asked you to go in another room. But when I went out, they were already standing, they were smiling, they were very cute with their baby, and they were happy that they had an appointment so fast because they just called last week. I saw that they were just confident people. They were very young; it's their first child. I think maybe they don't know, but they're not over the shock yet. It takes a while. I'm kind of part of the puzzle, a puzzle which helps them to see a future. I saw that it helps a little bit."

I told her how impressed I was by her unhurried care for her patients' physical, intellectual, and emotional well-being, the ways she seemed genuinely empathetic, her ability to convey that to suffuse the room with tranquility, even hints of joy, despite the seriousness of the reasons patients had come to see her.

"This is a stupid question," I said, "but are you so friendly because you're an ocularist or just lucky that as an ocularist you have natural friendliness and openness?"

She laughed but took the question seriously.

"You know, I think it's because of coming of age a little bit," she said. "In the beginning, I was very shy; I didn't speak much. It just came with more confidence in doing the job."

But she also gave credit to an American ocularist whom she'd mentioned several times throughout the day: Randy Trawnik from Dallas.

"The openness came, I think, because I saw Randy working," Ruth contin-ued. "And I just modeled how he had been working, and I said to myself, 'Life can be so much easier than being quiet, being anxious about whether you do things right or not.' I figured out it works out for me, too. I was happy to learn so much from him."

Trawnik had come into her life in much the way I had been able to find her—through the networking that the ASO's existence allowed. According to Ruth, her father had begun to understand at least back in the 1990s, in ways most of his German counterparts didn't or didn't want to, that there was value in broadening what he could offer his patients. It was a rebellious idea within the German ocularistry world. His own experiments with plas-tic were frustratingly unsuccessful. He'd gotten materials from local dental technicians, but the results were so poor compared to the eyes he'd long been making of glass. Finally, in an even more rebellious move, he and Ruth real-ized it was inefficient and foolish to try to invent something that had already been invented.

"Americans had worked with it for so long, and they have an association where they teach other internationals," Ruth said she remembered thinking.

She and her father wrote a letter to the ASO, asking whether an ocularist in America would be willing to teach them.

Trawnik was at that time vice president of the ASO. I called him later, when I got back home, and could tell immediately that he's exceptionally friendly and outgoing, someone it is easy to imagine being inspiring to work with, someone whose way of being an ocularist would be worth modeling one's own on. He and I talked for almost an hour, until his wife called him to breakfast. He had more to say, though, and called me back immediately after he ate. He was just as enthusiastic about Ruth's work as she was about his. He said she is "the person who is changing ocularistry in Europe."

"Their letter ended up on my desk because it was German, and my family's from Germany originally, and I travel to Stuttgart regularly," he told me.

The Müller-Welts invited Trawnik to meet with them when he was next in Stuttgart visiting relatives—a meeting that sounded, in his telling, like a classic collision of American breeziness and German formality and meticulousness.

"Jörg arranged it at a big, fancy hotel in downtown Stuttgart," Trawnik recalled, "and he brought his attorney, his wife, and their lawyer and their other daughter, Christine, who is an international translator, and Ruth. And then I showed up by myself, with a small attaché case, and I'm sitting across a very imposing table. And my first thought was: 'This isn't what I want. I thought we'd just sit down and have a nice chat.' And the attorney, who's a nice guy, but he's an attorney in Stuttgart but also trained in the United States,

and so immediately the attorney was telling me about the business and the protections of the business and everything else, and then I just pulled out of my attaché case a bag of eye prostheses I'd made, and Jörg, who was really not participating, he was just kind of listening to the attorney, he looked at me, and he walked around the table, and he sat by me, and he pulled out his bag of eyes. And all of the sudden we had the connection because both of us, we are professionals and artisans and are patient oriented, and all of the sudden the whole thing started off in a different way. I speak German. And so we were able to make a personal contact, and then it rolled from there."

Trawnik invited Ruth to Dallas, gave her a room in his house for two weeks, and began to teach her how to make acrylic eyes. Whenever he was back in Stuttgart, usually twice a year, he devoted himself for several days to making plastic eyes for an increasing number of the Müller-Welts' patients, some of whom transitioned from glass and others who were getting their first eyes and had complicated cases better served by the wider range of fitting possibilities that plastic allowed. He also continued the training for Ruth and another ocularist in her firm.

"We'd be doing it together," Trawnik said. "I'd say, 'Here's how to take the impression.' Then the next one I'd have Ruth take the impression. I brought tons of material there—you know, impression trays and that kind of stuff—to where they would have the equipment to do it. And then they could do it themselves."

Ruth began yearly trips to the United States to attend the annual ASO conventions and complete the workshops required for certification by that organization. It took her ten years rather than the usual five because of working full-time and raising two kids. After she finished in 2009, though, she was able to list her membership in the ASO on that sign outside her front door.

The next morning Rahel set aside some time to demonstrate for me the making of an eye in glass. As she was getting started, I asked whether she could tell if a finished eye she hadn't made was glass or plastic. She had been working with both materials for eight years, and she had helped her mother fabricate and fit many eyes of each kind. She would soon be fully qualified to do all that on her own. If a new patient walked into the office and already had a prosthetic eye, would she know from a glance whether to direct them to the lab for glass eyes or the lab for plastic eyes?

"No, at the instant, no," she said. "I have to look at the prosthesis. I mean, when they come very close, I can probably tell. But there's so many differences and different acrylic work, especially. There are so many quality differences. Some are very bad, and some are very, very good. On you, I couldn't

tell from the first moment that you had a prosthesis. Until you told. I think I observe something is with someone's eye very quickly, but I could not tell the material by the looks."

"Or by the way it fits?" I asked. One of the major differences between glass and plastic is the process of fitting. There's a bit of guesswork with glass, whereas there's the very exact impression method for plastic.

"No," she said again. "I could say someone has a very bad-fitting prosthesis. Could be glass or acrylic. Before you had a closer look, you couldn't tell. You know, maybe this person has, like, a very bad accident, and this is the best way the prosthesis could fit. You don't know."

"Empirical fitting" is what ocularists call the technique for determining how to shape a glass eye. The ocularist essentially looks into the patient's socket and surveys its geography. There's some measurement that happens, but mostly it involves eyeballing the space. Where are the dips and rises? How much of the tissue has drooped into the lower part of the socket?

Each eye socket is, of course, unique, but ocularists see patterns. For instance, there's often a small bulge of tissue in the upper nasal side of the socket. A prosthetic for a patient with that bulge would need to have a little notch built to accommodate it. But the fitting of a glass eye always involves a bit of trial and error.

Since there was no actual patient in the room with Rahel and me, she pretended she had already eyeballed an imaginary socket. Then she went to the drawers of eyes and picked out a few that might fit. (Actually, she picked only one, but she would have chosen several in a real-life situation.)

There are two kinds of eyes in all those drawers. The ones Rahel searched through were completed and ready to wear—off the rack, so to speak. But they're meant to be only models, which is why there are lots of them. Other drawers are filled with eyes that are round because they have been only half-made. An iris and pupil have been created on them, but that's as far as the fabrication process has gone. The final shaping hasn't been done. Those eyes are meant to go to patients. The ocularist chooses a globe with the right iris color, then finishes the fitting process. Starting at that midpoint, especially for those patients who get a new eye every year or two and whose socket hasn't really changed shape, knocks some time off an appointment.

The process involving the completed eyes from which Rahel selected wasn't unlike a shoe salesperson taking a measurement then going to the back room and getting three or four pairs of sizes close together. With shoes, of course, you would buy whichever pair worked best. The salesperson would not say: "Okay, these eight-and-a-halfs are closest, so let me make you another pair just like them, but with a few adjustments so they fit even better." At

least, that wouldn't happen in the places I get my shoes. It might, I imagine, for someone in the shop of a high-end Italian cobbler, spending a couple grand on fine leather loafers.

The ocularist is similar to that imaginary cobbler, though: try out a few premade eyes; choose the one that fits the best; use it as a model for a brand-new eye. "I have to look at it and mostly have to just try," Rahel said about finding an appropriate template eye. "Most of the time it's not perfect. I have to do little adjustments, or the iris needs to be a little bit bigger or whatever. Moved down. Tilt[ed], or whatever. But I choose a shape, and then I copy it. That's the way it works."

For that initial choice—unlike with the half-finished globe—shape is the only criterion that matters. If a patient's companion eye is blue, and the best-fitting one from the drawer is green, that's okay. The shape gets imitated, and the color gets made fresh.

The only other choice Rahel needed to make was between a single-walled eye or a double-walled one. Samples of both were in the drawers.

For the single-walled eye, imagine slicing a ping-pong ball in half. A glass prosthesis is not nearly so simplistic, but a single-walled one would have that same kind of structure. The inside surface is the back side of the outside sur-face. The is the "original" glass prosthesis, and at the time it was invented—in Lauscha in 1835—real eyes were often not surgically removed because the operation was high risk, often fatal. So a single-walled prosthesis was primar-ily meant to fit atop an atrophic eye—that is, an eye that was blind but had also shrunk enough to allow space for a prosthesis to fit under the lids. It's still chosen for cases like that or when there's not a lot of room in the socket even with the eye removed.

For the double-walled version, imagine instead taking a round ping-pong ball and pushing in one side with your thumb, hard enough that it caves in most of the way toward the far wall. Again, that's an overly crude representa-tion of how a double-walled prosthetic eye turns out, but the process and the result are similar. The pushed-in side of the ping-pong ball won't—unless you push really, really hard—touch the other side. Interior space will remain. The enclosed hollowness of the original ball will have been altered in shape, but it will still exist.

Similarly, a double-walled eye begins as a round ball, and then its back side is collapsed in until it is appropriately concave yet still has a buffer of air between it and the front wall.

This is called a "reform eye," first made in 1892. Enucleation—the com-plete removal of a bad eye—had become safer and more common in the later decades of the nineteenth century, but orbital implants were still in the early

stages of experimentation. A Dutch ophthalmologist named Herman Snellen (inventor of the eye chart with the big E at the top) thought it would be helpful if artificial eyes could be thicker to occupy more of the bigger space left behind when an eye was completely gone. But simply making a solid piece of glass thicker would quickly create a prosthetic much too heavy to be wearable. So Snellen, not an ocularist, asked some ocularists in Wiesbaden to take a shot at making something thick but light. Hence, the double-walled eye is also called the "Snellen reform eye."

"I always choose a double-walled if I can," Rahel said. "It takes up more volume, and it's more comfortable to wear as the edges are more soft. If I can't, if the room [inside the socket] is just too thin, I choose a shell, but I mostly have to try it. And I make it as big as I can without making the patient uncomfortable. It's always a trial."

Rahel sat in front of the burner at one of the workstations. There weren't a lot of supplies necessary. There was a tube of cryolite glass, which looked a bit like a fluorescent light bulb, the long kind common in offices and schools. It was skinnier, though, maybe an inch in diameter, and the walls were a bit thicker, enough to give some heft and sturdiness but still thin enough, as I would see, to soften easily under a flame. The tube Rahel had was white with a very soft bluish tint, meant to be a good base color for the sclera.

There were also color rods, sticks of glass the length and the diameter of kabob skewers, dozens of them in different colors. It was with these that Rahel would "paint" onto the cryolite.

And there were a couple of small ovens—actually, thick brass cups dropped into the surface of the table and heated from below—where Rahel could place eyes in progress to assure they wouldn't cool down too quickly and potentially crack.

Once Rahel had her model eye, it would take her a little more than an hour to make a new one. If I had taken pictures at key moments while she worked, I could have replicated that series of photos that Ruth had shown me of her grandfather, Otto. Instead, I recorded a video. I wanted to better understand the movements from one of those key moments to the next.

1. *Remove a section from a tube of cryolite glass.*
 One end of the tube had already been extruded into a long, narrow strand, from a previous eye being made, and Rahel pulled gently on that while rotating the body of the tube in the fingers of her other hand and directing the torch's flame at about an inch and a half back from where the tube was still at full diameter. That's about how much glass you need for one eye. From a tube one meter long, you can make about thirty eyes.

Separating one piece of glass from another under heat leaves a string of it trailing behind, like mozzarella from a piece of hot lasagna being lifted from pan to plate. Rahel let that strand stretch to about ten inches from what would become the back of the eye, then sliced it cleanly in the middle with the flame. It had thinned to the diameter of a toothpick but still had the hollowness of the tube. She clipped off the end to open it up like a straw.

2. *Blow the glass into a ball.*

Now she had a short capsule narrowing into thin extrusions from each end—shaped sort of like a float fishing bobber or a very small cattail clipped from its stalk. She got the middle section nice and hot, then blew softly into the end she had opened. The capsule expanded into roundness and translucence, like bubble gum. She stopped blowing and let that ball fall in on itself a little, blew to expand it again, let it contract, and expanded it again—repeating the process until she got the roundness she wanted. Much of the expanding and contracting throughout the eye making would be done to get the walls of the glass evenly thick, to distribute the mass of glass perfectly. With the flame focused tightly, she cut off the front extrusion near its base but left just enough glass there to create what she called a "tip" but that looked like a nipple or an outie belly button. What was left had the silhouette of a Tootsie Pop: the ball with the remaining extrusion—serving as both straw and handle—coming out of the back. The tip/nipple/outie was where she would create a pupil and iris.

3. *Begin to make the iris.*

She used first a black color rod, holding one end against that tip on the ball, letting the two melt together in the flame for fifteen seconds or so. For another ten seconds, she heated the ball's tip by itself, then blew into the straw ever so gently and sucked in ever so gently to expand and shape the tip, which changed eerily and sci-fi-like from bright red at its hottest to orange to black as it cooled. She held it up to show me. "This is my iris base now," she explained. "I blew into it to make it a flat surface, and then I let it fall back, so I have a surface to 'draw' on now. It's a lot smaller than the actual iris at the end because I can always blow to make it bigger, but if it's big for once, it stays like that." Her first bit of drawing was with a white color rod, which she held like a pencil and with which she etched little stripes from the outside of the iris base to its center, all the way around, starlike. Every once in a while she used a small stick of clear glass to pull away excess material from the tip: touch in the heat,

pull away threads. The goal was always lightness, thinness, smoothness. Then she etched in with a gray color rod and then a blue one.

4. *Begin to make the pupil.*

 A real pupil has sphincter muscles around it to control its contraction and dilation. These muscles halo the pupil with the merest hint of purplish brown. Rahel drew in some of that color, then again melted everything back to an even surface.

5. *Blow more.*

 I asked how gently she was blowing into the extrusion as she subtly tweaked the shape of the ball itself and the surface she was coloring. The blowing seemed to be nothing, like a frog breathing through its skin.

 "It depends on the thickness of the material," she said, "but"—she laughed—"quite gently, I'd say. The thinner it is, the more gently you have to blow."

 It must be a touch she had learned, I guessed, by having sometimes blown too hard.

 "Oh, yeah, yeah, yeah," she said, laughing again. "You need a *lot* of patience for this. I've had many days in which I was really frustrated."

 For instance, she said, the pupil is not always exactly in the center, "which can be a problem but doesn't have to." She evaluated her current attempt and decided it was okay. "I often have to redo stuff, but that's really what it is forever. It takes a lot of patience and a lot of practice. Even with the ball you start with, it takes you three months to make something that people could use."

 She'd already spent years watching experienced ocularists in the Müller-Welt firm, including her mother, work in glass. What had she learned, I asked, from those observations about making good eyes?

 She thought for a few seconds.

 "I think you have to love what you do," she said. "I would say I totally do when I'm here and I don't have any pressure, and I have a good day, where everything succeeds and everything turns out nice. It's a lot of fun. It really is. Super special and fun artwork. It's just difficult, and it really puts pressure on you when it has to be perfect, and it is dependent on things, like it can break, or there's a wind coming in, or someone smashes the door, and then, you know, it breaks, and there's nothing you can do."

 Most of the time, though, she said, "it works out very well."

 The risk of breakage for glass doesn't end once the eye is made, of course. An ocularistry firm in Cologne, Germany, surveyed 101 of its

patients in 2018, asking how many of them had ever had an eye break. Lots had—nearly two-thirds. But the prosthetic eyes weren't fracturing all the time. On average, it happened only once every twenty-six years or so. (The patients surveyed were longtime wearers of eyes.) Still, the 101 people surveyed reported a total of 134 breakages, so some people got unlucky at least a couple of times.

The most likely time for an eye to break (126 of the 134 breakages) was when it was being removed or cleaned. Most of those eyes probably got dropped. The bright side of that statistic is that the eyes were outside the socket when they broke—hence, no danger of glass shards getting embedded in the tissue. Six patients, though, did have an eye crack or shatter while they were wearing it: "four of these due to trauma during ball sports, one due to a slap in the face, and one due to very high temperature differences after sauna use." And six of the patients had at some time simply lost a prosthetic eye—five during "swimming, diving, or jumping into water" and one "during a bout of heavy drinking." Because 97 percent of the respondents to the survey reported having a spare eye, it seems most people keep their old eyes, just in case.[4]

6. *More pupil, then cornea.*

Rahel touched the black color rod again to the center of the iris and let it melt in. Pupil. To make a cornea, which on a real eye is a clear hillock, she melted in a globule from a rod of crystal glass, which is clear. That globule went atop the iris, enough to double its size. She patted it down with a thin metal tool and spread it just to the edge of the iris.

"This is more crystal than you would need to mimic a cornea," she said, "but I'm going to need it because what I do now is form it into a drop. Then the cryolite glass and the crystal glass melt together."

I wasn't sure what I was looking for when she said I should soon see a "burning edge." I was sitting about four feet away, across the table. What I did understand was what the burning edge was supposed to accomplish. On a real eye, the circumference of the iris—the limbus—does not have a stark definition to it. An artificial eye that has such definition would look completely fake, as if it came from a cheap doll. Rahel wanted to give that border just a touch of feathering, to have a realistic distinction between iris and sclera but also create the appearance of an organic blend of adjoining components.

For several minutes, she directed the flame at that globule and gently rotated the extrusion in the fingers of her right hand for even heating. She held a small glass rod into the tip of the globule to keep its shape. She was being careful, she explained, not to get everything too hot, so the iris did

not lose its shape. Suddenly the base of the globule, at the outer edge of the iris, began to glow a light red. The burning edge, the cryolite and the crystal merging. For several more minutes, Rahel let that ring migrate outward, ever so slowly. When it was nearly to the tip of the tip—it kept its thinness and did not consume the entire tip—she began pulling away threads of crystal with the glass rod in her left hand. Heat, pull. Heat, pull. Soon, the red ring was gone. The crystal left behind would imitate a real eye's anterior chamber. It would give some of the depth that a real eye has.

Back at the limbus, the cryolite had flowed over the crystal just a bit to create the softness Rahel wanted.

7. *Reshape.*

"Within the process of making the iris, most of the glass has shifted forwards," Rahel explained, "so I need to make it even again." She spent a couple of minutes heating the full body of the globe so that it sunk in on itself a little, then blew it back into roundness. She did this twelve or fifteen times. She was also trying to get the iris exactly in the middle again.

And then the thing looked like an eye. There was a beautiful blue grayness to the iris, and the limbus was definite but soft. She created even more realistic features by moving the globe in and out of a soft flame for several minutes, in part to smooth the surface but also to rid the glass around the iris of its transparency, which a real eye of course doesn't have.

"When I take it out of the fire for half a minute or so," she said, "it cools down a little. And when I put it back in, it gets opaque." I hadn't even noticed the change happening, but once she pointed it out, I could see that the sclera was suddenly whiter, no longer that translucent and very fragile-looking ball, but something that seemed to have gained solidity. (The translucence returned whenever Rahel put the globe back in the flame, but it would be gone permanently once the eye was complete.)

It was a small moment of magic, I thought, and I felt a twinge of envy, the way I have when I've seen other ocularists do cool stuff or heard them talk about the delight and satisfaction of making beauty with their own hands.

"How did you know you wanted to do this?" I asked Rahel, meaning being an ocularist. "Your mother said no one pressured you to go into the business. How did you make that call?"

"Good question," she said. "I always was interested in it. And during high school, during summer vacation I would come by and help in the lab and maybe sometimes even work on glass. But not really able to do anything, just for fun." She continued to twirl the eye in the flame while she talked. "And I was always interested in it, and even though I knew it was

always there, and nobody from my family would ever pressure me to do it. I have a sister who's totally not interested in it. And I thought it would be really hard to find out if I was interested in it just because it was there or if I really wanted to do it. I was always interested in art and always part of the social side, so I thought about doing psychotherapy a lot and going more in the psychological field, but I thought the practical part I'd really miss. So, after finishing high school and after taking a gap year, and being here and there, I just thought, 'Maybe I'll start, and if I don't like it, I'll stop.' And here I am, eight years later." She laughed. "It really scared me at the beginning. I was worried that it was a long way and really difficult. And I thought, 'You know, I am practical in doing stuff with my hands, but it's really different when you're getting judged in this.' So I really didn't know if I could cope with this. And, you know, it is a challenge definitely, but I really love the social part, and I feel like I have such a big impact on people psychologically. So I'm really not missing anything on this side. And I think being an ocularist, you can really perform it the way that suits you best. So you can be more of a lab worker. You can be more on the creative side. You can do more psychologically. You can be more social. You can be medically interested. We have colleagues that go to Africa or South America to work voluntarily. You could be more involved with children or disabled people. It's really a huge variety of things you could be in this job. I think I would always have the freedom to shape this profession in my way, to be the kind of ocularist I want to be."

The obvious follow-up question, then, was how much she wanted to be like those four generations of family who preceded her, who created an intimate world that allowed her—required her—to grow up amid artificial eyes. Does becoming a fifth-generation ocularist shape how she thinks about the ocularist she wants to be?

"I mean, I get reminded of it a lot, of course," she said. It all gave her mixed feelings. "One part is that working with your family members is special in every way, I think. Even just the two-generation thing." She said that she and her mother are best friends.

On the other hand, she said, she has patients expecting a lot from her because she's her mom's daughter. "Some people think I'm born into this, and I'm here, and it was the easiest thing for me to take on this profession, and probably I'm supertalented because of my family," she said. "And that's just not true. I sometimes think it's even harder for me because of that. So I have mixed feelings about that. On the other hand, it really makes me proud. And having the family history is amazing. There's a

lot that comes with it. In Germany, I have lots of colleagues who are like me, there for the fact that they were born into it. And we all experience the same."

One small but significant difference for Rahel is that she is not literally carrying on the Müller-Welt name. She has her father's last name. She is Rahel Feil. It's sometimes a relief, she said, not to consistently have to present as her mother's daughter. And she doesn't always tell people who don't already know. In the case of one woman who has been coming to the firm for sixty years and knew Rahel's great-grandfather, though, Rahel is quite happy to for her to know who she is.

"But sometimes I have people treating me unfriendly before and very friendly after the fact that they know," she said. "For those people I'm like, 'Why would I deal with you? Like me for myself or not.'"

And it matters, too, she stressed, that she felt no family pressure to join the business. That's not a universal experience in multigenerational ocularistry families, any more than it would be in families with generations of butchers or soldiers or lawyers or farmers.

"I feel like some of my colleagues are just ocularists because they could be," Rahel said. "And for some I feel like you maybe should have thought about what you really want in life. It's really a cool and nice opportunity, but it's not an easy profession."

8. *Create the blood vessels; color the sclera.*

Rahel took a red color stick for blood vessels and a grayish-blue color stick for the general hue of the sclera. She touched the heated tips of both together, pulled them apart so that little strings extruded from each, and then melted first the red string and then the grayish-blue one across the surface of the sclera. Repeat and repeat. If a thread didn't lie the way she wanted, or if a too-large drop of glass coagulated, she scraped it away with the edge of a small knife. The blue, formulated to melt faster, diffused across the white. The same would happen with yellow and the bluer blue she would add soon after. She didn't have to worry about how those threads landed. They'd quickly become generalized. The red, made with a very small amount of gold to give it more hardness and a higher melting point, kept its definitiveness.

"For the vessels I have to be very careful because you can see every string," Rahel said.

At the top of the eye, far enough above the iris that it would be hidden behind the upper eyelid, she printed the year with the red color rod—a record to know when to replace the eye and a reminder to the patient of which side is up.

9. *Reshape and smooth.*

More shrinking and expanding, shrinking and expanding. "You have to make sure that the surface is really even and that everything is really melted in."

10. *Copy the shape of the model eye.*

Looked at from above, the model eye had the outline of a skipping stone with a perfect notch for the tip of your index finger. It was more triangular than circular, but with all corners rounded as if it had been at the bottom of a brook for hundreds or thousands of years. It was time for Rahel to start to shape the new eye with the same dimensions.

"I copy the shape by blowing and shrinking in at the exact spots," she explained. She turned up the air control on her burner to narrow the flame. "I heat it at the exact spot where I want to shape it outwards or inwards."

As with the part of the empirical fitting when a glass-eye ocularist takes a visual survey of a patient's socket, this part involves a similar kind of eyeballing. Rahel held the model up and memorized the way an edge curved.

"I really just look at the margins and see how the shaping is here, and then I just compare it," she said. She heats the small section she wants to shape and then blows into or sucks from the extrusion, to move the glass little by little. "If it's too much, I just melt it in and let it fall back. I always have to blow in a little to reshape it, but it's the amount of blowing and the amount of melting that makes the difference. So that's why it's really an intuitive thing."

She shapes it a little bigger than she'll ultimately want it, so she has some glass to work with. "Making this smaller is always easier."

It didn't take long for the eye to start gaining edges, for the perfectly round bubble to begin looking like an apple being nibbled at haphazardly. Once she got close to the shape she wanted, Rahel got more exact by measuring with some small calipers. She measured first the iris diameter of the model eye. It had looked as if it were bigger than what she'd just made on the new eye, but the measurements were much closer than she'd guessed.

"Then I measure the distances from the edges to the iris," she said. "I'm still on the rougher side, so I'm just going as close as I can. And once I melt in like the model, I'll suck in the air, so it really gets to the shape it should be."

I watched in silence for a minute or two, then wondered whether there was any taste to the air she was drawing from inside the eye. I'd heard

about legitimate health concerns with the making of acrylic eyes, mostly with the fumes. There was no smell at all in the glasswork.

"Only if something burns inside," she said, "a little piece of dust or something or water or oil. But usually not. To burn the chemicals, it would have to be way hotter. So it's not poisonous or anything. I think the monomer is really more dangerous. We have active-charcoal filters and everything, but we still smell it way too much."

11. *Refine the edges.*

She grasped the eye from the front with a long, thin clamp that had tiny claws to wrap around the edges formed by the rough shaping. She directed the flame just at the back, to thin out the back and allow her to draw glass from there rather than from the front of the eye. Every twenty or thirty seconds, she heated the entire eye to avoid one side cooling too much and creating internal tensions between that and the hot side, which would be a recipe for the whole thing to shatter.

12. *Collapse and smooth the back.*

She worked slowly for a good ten minutes, narrowing the glass on the back of the eye, sucking it in the smallest bit at a time.

"So I suck in the air as long as I can until I only have a little tip," she said. "And that gets removed." She pulled away the last of the excess material the same way she had removed threads of glass from the tip on the front of the eye. "And now it's closed," she said, meaning there was no longer any hole to blow into, that the back was now as solid as the front. "And I heat in the back." She pointed the flame directly into the concave interior, one last smoothing of any lingering rough spots.

And that was it. Ein Künstliches Auge aus Glas.

She placed the eye in one of the little brass ovens, put a heavy lid on that, then lifted the oven with some tongs and set it on the countertop to cool, the way you would a pie. If all went well, as it had through the past hour, the eye would slowly harden into its final self. The temperature inside the hollow of the eye and the temperature in the rest of the oven would cool at the same rate, and there would be no excessive tensions between inside and outside. No frustrating and surprising fractures. No need to do it all over.

"That's amazing," I said because it was and because I was imagining the thrill and happiness a patient would feel to have an eye like that made right in front of them and presented to them and then to wear it out into the world—fresh, luminous, realistic, theirs.

Sebastian Fredette, Eye Wearer

I was born with retinoblastoma. Actually, bilateral retinoblastoma. It was more developed in the left eye. It was really much more traumatic for my parents than it was for me because I was six months old, eight months old. I didn't know what was going on. But we were from kind of the middle of nowhere, so the hospitals around us, a lot of them aren't superfamiliar with intricacies of childhood cancers. Tiny clinics. I grew up near Oneonta, but thirty miles out from there. Upstate New York. Half an hour from Walmart. Only fifteen minutes from Dollar General, though!

But my parents had taken me in a few times because I was just kind of colicky and headachy and crying and not super with-it. They had two other kids at this point, so they knew it wasn't normal. And then eventually they started taking family pictures, and one of my eyes was bright yellow, and one eye was red. So they started taking me in, and the doctors kept saying, "It's a phase, don't worry about it. He'll be fine." Eventually they trusted their gut and went to a different doctor, and they basically went from that doctor to Philly. Maybe they went back home and packed, but it was in a hurry. They didn't know much about medicine, but they knew that when it's in a hurry, it's not generally a good thing. We went down to Wills Eye Institute. And pretty much immediately the doctors took the left eye out. In the right eye, they froze the tumors, which in 2000 was not super common, I guess. It was fairly—I won't say experimental—but it was a fairly newish thing to just go in and freeze these in the eye and trust that it would work. But they wanted to leave me with some vision if they could.

For my parents, there were the logistical difficulties of it. It just sucked to live in upstate New York and drive to Philly all the time. I think it was like twice a week at first and then once a week, then once a month. But the experience manifested in a strange way for my dad. He really hated going in and not knowing what was happening. He hated being the person in the room that knew the least, even though it was his kid. He was in broadcasting his whole life since college. He worked into public broadcasting and worked at PBS stations. But in 2001, the year after I was born, I think the summer or fall after I was born, he went back to SUNY Oneonta, took pre-reqs, and then went to med school in 2001. He graduated in 2007, 2008, whatever. And he's been a

pediatrician since then. He's never actually told me to my face that was directly the thought process he had, but the fact that it was a few months later that he was in med school, it seems like more than a coincidence.

My mom is a high school science teacher. And she teaches a lot more about genetics and childhood cancers than I think most high school science teachers would teach. I think I've changed her curriculum a little bit. But she is also just fiercely defensive of our health and an advocate in the way of trusting your gut and going to multiple doctors and finding the right solution. I think she's like a bridge in our community between people who grow up and just see a high school nurse and then never go to the doctor again and medicine. There's a gap in the community where I'm from, and there's mistrust, and there are people who just don't take care of themselves or their kids, and she tends to step in where she can, where it's appropriate, and be an advocate for kids. She just has this knack for educating that I think rubbed off on me a little bit. I really admired that. So anytime I could, instead of just saying, "Yeah, I have a prosthesis," and move on, I would try to educate. And that was in science classes, in health classes, and anything I was in. My whole family turned it from trauma to education, I think. I've never thought about it like that.

And then they had to deal with raising a kid who had one eye and who couldn't catch a ball. I remember them telling me that when I was two or three, and I didn't get what I wanted in a grocery store, I'd take my eye out and just throw it across the aisles and send them running. I knew I could get a reaction. Or I was in my crib, and they'd walk in to check on me after I was crying, and I'd just look up at them with one eye. And they'd be like: "Freeze! Everybody stop moving!" And they'd have to dive under all the furniture and look. I'm surprised I didn't eat it, to be honest.

So it was pretty early on that I realized that not only is this something that belongs to me, but it's something that if I lose it, everybody freaks out. It became an empowerment in a very strange way. That was pretty fun, I think, for a three-year-old to have that gadget.

After the surgery, we went to the LeGrands in Philly. I still argue—and my parents don't believe this is even possible—but I have such a vivid recollection of the office and sitting there as someone put something in my eye for the first time. I was definitely too young to remember that, so it might have been a different appointment. But it is one of my earlier memories, that office and sitting on, I think it was, my dad's lap and just looking at this stranger who was poking me over and over again in the eye. But it was interesting to keep going back to that office because I got the eye when I had no bearing of reality, and then every year or every couple years as I grew and as my ocular chasm grew, I understood a little bit more each time. I would understand:

"Oh, this is the same guy I saw." And then I would understand: "Oh, he's painting this by hand." And then I would understand: "Oh, this isn't all covered by insurance." There was this expanding awareness of how weird that whole process was. But it was always a comforting thing. I do remember that. Because it's not often that you get to sit for three or four hours with somebody who all day deals with people with one eye. Even at Wills Eye Institute, they don't exclusively deal with monocular patients. So I think there was always that awareness when I stepped into that office that I was like . . . my parents were the weird ones because they had two eyes. I fit in with all the kids waiting in that office. And that was pretty cool.

Each time I went back, it felt comfortable and familiar, even though sometimes it had been years. I think the last time I went—I need a new one now, and I never get it polished, which I should—I think the last time I went was maybe junior year of high school, sophomore year of high school, and I hadn't been in like four years, five years. And I still remembered how to get there and where to go and that office. It's always been a cool experience. Joe LeGrand also seems to remember all of his patients. I don't know how that's possible, and I don't know if I made that up in my head. But it's a cool experience to go back.

Anyway, every time I'd need a new one, we'd go back down. Get in the van, go get a new eye. There was one time I was really little, and I think it was on the way back, with a brand-new eye. We would always stop at Clark's Summit in Pennsylvania and get something to eat. I had taken my eye out in the car, like as soon as we got back to the car from eating. I took the eye out and lost it between the car seats. And my dad was convinced I took it out in the restaurant. So I sent my dad Dumpster-diving at a Friendly's in Clark's Summit, desperately trying to find this eyeball. It was in the car the whole time.

I was the crybaby for years. Until I was eight or ten years old, I would just start crying, and my brothers hated it. I would use it at the worst time. For instance, we didn't grow up with video games or TV for a while. Eventually we got them in, I think, 2007-ish, when Dad graduated. And whenever I wanted a turn on the PlayStation, I would walk up and be like, "I had cancer. You have to give me the controls." At some point, they were like, "You gotta stop using that."

My school was tiny. I graduated with twenty-four kids, and I think at least eighteen of them were the same kids K–12. There wasn't a person in that building who didn't know I had an artificial eye. And I never noticed how strange or different it might have been in a bigger school of walking in and knowing you're completely different in one very particular way from all these other kids. We would get new kids every so often, or kids would fail from the

grade above, and they'd join our class, and they would be not so friendly because they were not familiar with any of the history that I had. And so in gym class or wherever—that was where I was the worst—they'd start picking on me, and all of the kids that I had since kindergarten would fiercely defend me. Even kids I wasn't getting along with. And so instead of being this alienating thing, for some reason my having a prosthetic eye brought the class together. I knew I was lucky when kids started backing me up and when people would defend me. But I don't think I realized until later just how backwards that probably is from most people's experience.

In those years, I don't think I liked the eye very much. I just tended to not look in the mirror or ignore it. When you look in a mirror, you're looking straight ahead anyway, so that didn't bother me too much. Your eyes are looking in the same direction. I hated being in pictures, especially candid photos, because then I'd be looking all over the place. Cross-eyed, cross-wide, whatever you want to call it. That bothered me far more than looking in the mirror.

I never was made to feel uncomfortable, I think, by anybody that I really cared about. I think I was probably the only one who made myself uncomfortable about it. And that hasn't changed too much. There's nobody in my life that I care about that would ever make me feel bad about it, besides me. So, I make jokes, a lot of the time, saying, "Oh, that's why I picked up photography and videography, so I'd be the one behind the camera." But there is absolutely truth in that. If I'm behind the camera and pressing the button, I don't have to worry about candid pictures. I don't have to worry about being the person who's wonky-eyed in one of the photos. That was definitely a protection thing, 100 percent. I don't regret going into it because I love it. I really do, and I'm lucky that I love it. But that was absolutely why I picked it up. Hundred percent.

It shocked me how scared I was when I came to college because I had never worried about it. I never had to. There were so few people where I was from that even when I met someone I had never met before, they were at most a second- or third-degree contact, so they had already known that I have one eye. I literally never had to tell anyone, growing up, even when I went to different schools or did All-County or whatever else. I was way more uncomfortable than I'm even prepared to admit when I got to college, for no really good reason. Especially that first day, when everybody comes onto campus, and nobody knows anybody, so they're all terrified. But I didn't even want to look at people because I didn't know where this eye was going to be. I was petrified for the first time. That sucked. I would just slowly, strategically tell people, so that they would tell networks of people, so that I wouldn't have to. I tried to

expand that circle again. But starting that was really scary and way more scary than I thought it would be.

And it was always a joke. One hundred percent of time. I will never tell someone, straight-faced, that I have one eye. I've always coped with humor, and I do that now. I don't remember exactly how I told people, but it was always as like a shock factor or like in a drinking game or as a joke. And then they'd be like, "Really?" And then we'd move on; that was it. Especially because unless you're having a really intimate conversation with somebody, it's way easier to say you have one eye than it is to say you had cancer. Because once you say the word *cancer*, the whole conversation shuts down. It is such a roadblock for people.

And I think the first people I would tell were my roommates, and then I would tell the circle of friends that we had. Any circle of people that I figured I'd spend more than a year with, I would let it slip. But otherwise there wasn't really too much point. Also, it became less an issue because we weren't kids anymore. People don't bully people for having one eye when they're eighteen, nineteen years old. Usually. And when you do bully people with only one eye, it's clear that you're the problem.

But it's always an icebreaker that I know I have to get to at some point. I don't usually worry about it right away, but there's always that: eventually this person should probably know that I have one eye. And how should I tell them? There are probably people in the office I work in that don't know at this point still. Because they don't need to or wouldn't necessarily notice anyway. But it's always in my mind. There are two types of people for me: one type that knows and one type that doesn't know. Usually I try to get everybody over in one group. Any new circle is a quandary of: When will you know? How will I tell you? Or do you already know? I don't need to tell everybody, but some-times it's nice to have some people who do know.

My habits for eye contact these days are worse than I want them to be. Years ago, I remember being told by my dad: "You've got to work on this. You've got to look people in the eyes." Because it's not supercute once you get to be twenty years old. I had to make a conscious effort for years, and it's still not where I want it to be. Especially when I have to think. I can't think when I'm looking someone in the eye. I can hold a conversation, but if there's some-thing that requires a lot of thought or introspection, I need to be by myself for a minute and not worry about that. And I don't know if that's just because of who I am or it's because I have a prosthetic. It's likely that it's partly due to the prosthetic. I need to be not worried about how I'm looking in order to form a cohesive thought. But I do find that if I'm just getting to know someone, or if

I'm meeting them, it's better than if I'm actually trying to think of something. And listening is easier. I can look them right in the eye while I'm doing that.

There was this one . . . not to get superpersonal, but the person I'm in a relationship with now, I had never had a conversation with someone who wasn't my ocularist without my eye in, that I can remember, until this person. The eye was getting uncomfortable; I didn't want to sleep with it, so I just kind of took it out and put it in a glass of water, as you do. And went to bed. But it was just such a crazy experience. And because I'm now the age I am and somewhat self-conscious, somewhat on this plane of existence and not five years old, I was conscious of it the whole time, of how crazy that felt, to have a conversation with someone without it put in. It was *way* more vulnerable than, like, literally than being naked. It was way weirder to have one eye in and one eye out. But it was such a cool experience. It was so cool.

I wrote my honors thesis on prosthetic eyes. I hate history. I hate studying history. I hate going to history classes. I hate all of it. But, man, learning history that I actually cared about? Game changer. That was so cool. I had to stop myself from writing too much about it because that wasn't what the thesis was about. But I just wanted to keep writing, and it was so fascinating. I think that was the first crazy experience, actually enjoying the research I was doing. Because at first I just thought, "Well, this pertains to me, so I'm interested." Dr. Fee pointed out, after I defended the thesis, he was like, "You talk about this, and I don't know if you realize this, but this is a healing process for you. You would not be talking about this this way if it wasn't." And I said, "Oh. You're right." I think that's partially why I was so enraptured by that process.

I wanted the discussion to be about 3D printing and what's next for ocular devices. I studied it in a context of material science: learning about why we used the materials we did, why we changed, why things were cheaper, why things were more expensive, why we adopted PMMA at all. That was so fascinating. I was asking: Can we realistically print these 3D devices? And what might that do for the industry and cost, and what it would mean for ocularists? And, naturally, I was like: "Well, how far can we take that? How cheap can they get? How accessible can they get? And how form fitting can they get?"

In the process of the thesis, I 3D printed my own eye. I scanned and reproduced it. That made me think: Well, all you need is 60 cents of resin, and you can make a new $4,500 eye. But, honestly, by the time I had printed the eye and held it and put it in my own eye socket and reproduced something that I thought was absolutely a one-off piece, I could not have cared less about my thesis at that point. Or about the actual writing of the thesis. I was so taken aback. I remember there was one moment where I just, like, I was writing,

and I just closed my laptop and sat there and realized that this is my eye, and this is my other eye, now. I made three more. One of them had a dolphin on it because I painted it. I also made a light-up Terminator eye. And one I tried to paint to match, but it was . . . not good. But it was just the coolest experience. And it was such a gift to be able to do that.

But I was totally writing in the way of, well, at some point we won't need ocularists. Or if we do, they won't fit the same role that they do right now.

Until I emailed Joseph LeGrand Jr.

And you know when you're writing a paper, and you find one piece of evidence that completely eviscerates your whole paper? And you either have to somehow rewrite the paper and incorporate the evidence or just brush it under the rug? That's what that was. So I talked with him, and he shattered the whole paper by saying, like, "Yes, we make the eyes, but the three hours that we spend or four hours that we spend looking at this person that just lost an eye and looking them in the eye and reminding them they're still human and helping them cope with something that nobody has prepared them to cope with . . . we're half psych, and we're half artists. And the eye is a relatively small component of the healing process." His wording was different, but it was to that effect. And that was mind bending. And I realized there was no denying that. He was totally right. And that experience I just talked about where I took my eye out and talked to somebody and felt so vulnerable and so reaffirmed was recent to that experience, to his writing. I was, like, "Yeah, he's totally, 100 percent right. Damn it."

So, I went back and reorganized the paper. I sewed this thread throughout it that was: "Yeah, but wait. This seems great, but wait." And I built in a section about ocularists and LeGrand in particular. There were just so many parts of that thesis that were so much more than a thesis by the time I finished it—like realizing how true those words were. And by the end of it, I said: "Yeah, at some point we'll probably be able to print these. And we already are. But we're not going to replace that." . . . I think you would need basically a therapist who only sees people with one eye, all day, to fit that role. And we're not going to find that. So, yeah, we can make an eye in twenty seconds. But should we?

And I defended that thesis and stood there, and I got called back into the room, and they said, "Listen, this is the grade you're going to get. But if you write some kind of afterword, some kind of discussion where you knit all this together in a more permanent way, then we'll boost it."

And it's so funny because looking back on it, grades are stupid, and page requirements are stupid. Writing that discussion—it was only a page and a half—I just had to sit there in a dark room, with no sound and just reflect on

the whole process of writing that piece and what it meant and why I wrote it and what the through line is in all of history, in 3D printing in ocularistry. It was like an examen. It was sitting there and just thinking, and I got to tie all of it up in my head. And that was way more important than any grade, the stupid thing that seemed so important at the time. But, yeah, that whole process was a gift.

Also, LeGrand said, "You should probably come down and get your eye polished." I thought, "This one's two sizes too small. I need a new one! No use polishing this one!"

6

Illusion

I was riding up the escalator Saturday morning at the Linq Hotel in Las Vegas to get the breakfast included in the registration fee for the fall 2023 AOS conference. The din of the casino at the base of the escalator faded quickly, and I was in a mindless state, needing coffee and a little nervous about making conversation and about who I would be able to talk with one-on-one during the day between the scheduled presentations. When ocularists gather for their conferences, they are a close-knit group, and many of them who have been coming to these conferences for years (one in the spring and one in the fall) clearly enjoy their time together, especially after working individually in their scattered offices the rest of the year. Randy Trawnik, whom I'd interviewed on the phone a few months earlier about his role in helping Ruth Müeller-Welt make acrylic eyes in Germany, had told me at the previous evening's opening reception that the conference for him is as much "familial" as it is professional—not only because he has long been friends with many of the other ocularists but also because some of them are *family* family. His daughter, also an ocularist, married into another family of ocularists. The web of formal connections is wide and intricate.

I was gazing at the wall as the escalator took me upward. The wall was concrete, and it had an interestingly distressed texture, with little pockmarks and scratches and variegations in gray. On some subconscious level, I think, I was taken by it because Las Vegas is such a city of facades. I had been there many times and in fact had lived there for two years as a teenager, when my father was stationed at the nearby air force base, but I had always been skeptical and aware of its fakeness. What looks like marble or limestone, for instance, is usually plastic, and I remember once, at some hotel meant to look like a replica of a structure from ancient Rome or Venice or Paris, knocking my knuckles against an outdoor wall and hearing a hollowness. Vegas is nothing if not an impressive impression of something else.

Concrete, perhaps the most common building material in the world, com-
bined with the actual metal escalator under my feet, the actual rubber handle
I was lightly gripping, and the actual coffee and food waiting in the Social B
meeting room made me feel a solidity at least to that moment in that place. I
was a bit disappointed, to be honest, that the conference was in Vegas. It had
originally been slated for San Francisco in conjunction with the much bigger
convention for the American Academy of Ophthalmology (AAO), which typi-
cally pulls 15,000 or 20,000 attendees. For decades, the ASO had its fall con-
ference at the same time and in the same place as the AAO. But hotel prices in
San Francisco were exorbitant, and the city was struggling with a spike in
crime and homelessness, so the ASO made a late switch, which resulted in a
much more intimate event. As the president of the ASO would announce in
his opening remarks after breakfast, 123 people were registered for the con-
ference. Still, it had an international flavor. The attendees represented ten
countries besides the United States. Ruth and her daughter Rahel had made
the trip from Stuttgart. Other ocularists had come from Venezuela, Canada,
Argentina, Italy, Japan, Morocco, Australia, China, and France. The only
ocularist in Puerto Rico was there.

Two-thirds up the escalator, I was starting to get my head in the game. With
my left hand I double-checked to make sure my name tag hung on the lanyard
around my neck. I replayed putting my voice recorder and my notebook in my
bookbag before I left my room and assured myself that my phone was fully
charged. I was tempted to take a quick selfie and check my eye one more time,
to know again it was straight, but I had checked it just minutes earlier. To
release a little anxious energy and root myself even as I was in motion, I
tapped the concrete wall with the middle knuckle of my right hand. The sound
and feel were hollow. It wasn't concrete at all. It was wallpaper on sheetrock.

At many professional conferences, you have to choose an agenda for yourself.
Each hour or two there will be multiple presentations and panel discussions
and workshops running simultaneously. At the ASO convention, there is one
agenda, one presentation or workshop at any one time, and everyone is there:
the older ocularists who have sat through presentations on maybe the same
topic a dozen times, the midcareer ocularists, and even the younger appren-
tices who are earning credits toward their certifications. (The ASO has recently
begun referring to those in training as "interns" rather than "apprentices.")

The first day of the conference—the Friday when I flew into town—was
devoted to required courses for the interns, each an hour long, each taught by
an experienced ocularist. These courses are part of the curriculum for the
ASO's College of Ocularistry, a division of the organization formalized in

2017 to give additional structure to the training of interns. (The rest—and bulk—of the curriculum is on-the-job training.) One course that day was on common causes of eye removal; one was on waxes, carving knives, casting stones, polishing agents, and other materials and tools of the ocularist trade; one was on the three methods for fitting a prosthesis or scleral shell (impression, modified impression, and empirical); and one was on impression materials—alginate and vinylpolysiloxane. That evening was the opening reception, which I had been able to make after checking into my room. It was near the open bar, where I chatted with Randy Trawnik about the family feeling of the conference, said hi to a few other ocularists I'd met before, and introduced myself to a few others.

At breakfast that Saturday, after my discovery of the concrete wallpaper, I sat next to an ocularist I hadn't met. He asked me where I practiced. I explained I wasn't an ocularist, that I was writing a book about ocularistry. Not a lot of nonocularists attend the ASO conventions, and this person was momentarily confused and maybe even wary.

"So this is like a book that makes fun of people who have prosthetic eyes?" he asked.

I was taken aback. I couldn't imagine why anyone would write a book like that or think that someone else would, though I also immediately remembered all the eye wearers who had told me about being teased or bullied because of their "imperfect" eyes. And a deeply buried twinge of shame over the bad eye I had lived with for so long arose unwelcomingly.

"No, no, no," I said. "I'm trying to write about, you know, the history and culture of ocularistry and the technical stuff, and it's a book, I think, full of gratitude for the profession. I *love* ocularists," I said, sounding to myself as defensive as he seemed to have felt.

"Ah," he said, clearly relieved. He told me about his own career, plus a couple of interesting stories that I didn't write down or record because I wasn't sure his skepticism was completely gone. When he excused himself to get to the morning session, which would be starting soon, he cheerfully wished me luck.

For that morning session, the interns got the stage. Over the course of an hour and a half, eight of them gave presentations on topics of their choice: a right of passage for anyone on their way to ASO certification. The person introducing the session joked that he hoped the open bar of the evening before—plus the endless and easily accessible offerings of Vegas—wasn't having lingering effects on the young presenters, most of whom looked to be in their twenties. But it didn't, not that I could tell. There were occasional small moments of nervousness (forgetting to advance to the next PowerPoint

slide, for example), but the presenters were otherwise poised and articulate in speaking to a ballroom full of their professional elders.

One told of her efforts to fabricate silicone conformers for babies with anophthalmia. Hard, plastic conformers—which are used to gradually increase the socket size in preparation for an eventual prosthetic—sometimes don't fit so well into severely underformed sockets. "What if it were squishy?" the intern wanted to know and then explained what worked and didn't work with her prototypes.

Another intern talked about painting techniques.

One explained how to avoid improperly curing plastic and inadvertently ending up with embedded bubbles ("porosity").

There was a comparison between prosthetic contact lenses and scleral shells, the former sometimes better for patients who don't have adequate socket space but also not nearly as durable as the latter; they tend to fade quickly because they're stored in a contact-lens solution when they're not being worn.

And a few presentations were more general: best practices for emotionally supporting patients; a comparative survey of anophthalmia and microphthalmia; and "The Ancient Remains of (Very) Early Ocularistry," which told about that discovery in 2006 of the prosthetic eye in the 4,000-year-old skeleton from the Burnt City and the one in the 7,000-year-old skeleton in Spain.

What struck me through the session was not so much the presentations themselves—each person had only twelve minutes, and they were students rather than experts—but the attention and graciousness the audience gave each presenter. There was applause, laughter at the appropriate moments, polite patience during those rare flashes when a presenter seemed briefly unsure. Most if not all of the older ocularists in the room had been mentors to their own apprentices. That's five years of working side-by-side, guiding someone into the intricacies of craftsmanship, patient care, ethics, business operation, and probably a million other things. And the relationship is not meant to end there. An ocularist who takes on an intern is often intending for that person to become a long-term partner, to take over the business someday. It's a huge investment, and in part it's why apprentices are so often sons and daughters of ocularists. You don't want to train someone and then have them set up shop across town as your competitor. So there was, it felt, a sincere kindness in the room. Which is not to say there was an uncritical enthusiasm for anything that was said. All of the presentations were solid, but there was an inevitable variation in quality, and the audience, while supportive of each intern, also seemed to subtly appreciate displays of the extra detail, care, intelligence, and confidence that I've seen ocularists expect of themselves in their own work.

When I had visited Dave and Vaune Bulgarelli in Iowa City, Dave had told me what happened at ASO meetings early in his half-century career. "We drank," he said. "We went to bars, and you learned absolutely nothing about eyes because they were all individual secrets." I had heard similar memories from other older ocularists—of how it took a long time for the organization to chip away at the deeply entrenched habits of professional self-protection. I had read that report from the US Army's Office of Medical History about eye makers in the 1940s who "looked upon themselves as the possessors of lucrative trade secrets, which they had no intention of imparting" to the army or even to fellow ocularists.[1]

The first official meeting of the ASO took place in 1958 in Chicago. At a meeting fifty years later, the longtime ocularist Raymond Jahrling, who had begun his career in 1949 in Chicago and later started his own business in Boston (still run by his children today), gave a lecture called "The Maturing of the ASO." In 2007, he recalled his own initial experiences with the organization: "It was in 1962 or later that I began sitting in on some of the annual meetings held here at the Palmer House, and it wasn't too impressive. To me it was a tax write-off to revisit friends and relatives in Chicago. The size of the classroom was smaller than those in a grammar school. These lectures were not too specific. Besides, the speaker was often interrupted by comments such as, 'That's not the way we do it in our part of the country.'"[2] But as Jahrling also explained in that retrospective, the ASO gradually in the 1960s and 1970s worked through the deep obstacles to openness. It restructured and expanded its educational/trainee program. It began a newsletter and then a professional journal (initially called *Today's Ocularist*, then *Journal of the American Society of Ocularists*, then finally, as it remains today, *Journal of Ophthalmic Prosthetics*). In 1980, it formed the National Examining Board of Ocularists (NEBO), "an independent agency whose primary function is the assessment of competence of ocularists or the professionals who fit and fabricate ocular prostheses" but that also requires that information be shared so that professional standards are observed widely.[3]

In Vegas, everyone seemed eager to talk, compare notes, and ask questions. Jim Strauss, even though he'd retired from eye making, had set up a table in the hallway to display and sell a new invention he had designed to simplify the making of iris buttons. On Sunday morning, there was a panel discussion called "Difficulties Encountered with Pediatrics." The three ocularists on the panel talked about their experiences treating children, with lots of lessons learned and helpful advice. The lengthy Q&A that followed was a lively and wide-ranging big-group discussion, with hands shooting up, the person with the microphone hustling from one ocularist in the audience to another,

everyone adding their own tips or sharing their own frustrations and request-
ing (and getting) descriptions of specific approaches that might work better
than what they had tried earlier. No one, as far as I could tell, adopted an all-
knowing tone ("That's not the way we do it in our part of the country"). It was
generous sharing for, it seemed, the betterment of the profession as a whole.

Not *everything*, though, was fair game for discussion. As the executive
director of the ASO reminded everyone, it would be illegal for ocularists to
compare notes on what they charge for their services. They can make that
information public, if they wish, by putting it on their websites, for instance.
But if two ocularists retreated into the hallway between sessions or sat at
adjoining slot machines in the casino, and one said, "I charge this much," and
the other said, "Oh, I'll charge that much, too," they would be bumping hard
against antitrust laws. Federal price-fixing restrictions apply even within the
small community of eye makers.

I was hanging out in the hallway after the intern presentations, debating
whether to go to the next scheduled session. I instead walked over to Jim
Strauss's display table, where he was chatting with someone I hadn't met. It
turned out to be Willie Danz, a fifth-generation ocularist from San Francisco.
This was the kind of serendipitous encounter I had been hoping the confer-
ence would bring. Danz's name had been written in my notebook for several
years and maybe multiple times because it had come up often when at the
ends of interviews with other ocularists I'd asked who else they thought I
should talk with. The Danz family was originally from Lauscha, Germany,
and they'd been in business in the United States since the 1800s. Willie's son
was nearly finished with his apprenticeship and would become the sixth gen-
eration of the Danz family to make eyes. However, it wasn't only the longev-
ity of the family business that made Willie's name come up so often. People
also always mentioned that he had once made an eye for a horse. That seemed
to be unusual trivia even for eye makers who'd seen a lot. I asked him if it
were true. He laughed and said it was, that he'd made eyes for a number of
horses, plus a few dogs. He had also completed the first part of the process for
a Red-tailed Hawk that had been shot in the wild and lost an eye and had sub-
sequently been rehabilitated at an animal park.

"I looked at that bird," he said, re-creating some of the dramatic nervous-
ness of the moment, "and it had talons, and it had a beak, and everything
looked sharp. I said, 'You sure you got this bird under control?' We put a topi-
cal anesthetic on the eye, and we got a beautiful impression." But he never
made the eye. The park apparently spent the rest of the money for the bird
elsewhere.

His first horse job came at the request of a veterinary ophthalmologist in the School of Veterinary Medicine at the University of California (UC), Davis.

"I was expecting the eye to be a little bigger than what I normally deal with with people, and it turns out it was a lot bigger," Danz said. "We had to make some custom impression trays, but we were able to make the eye. They had a nice system where they could strap the horse to a table, anesthetize it, lift it up off the ground, turn it sideways, and then bring it down level, and you could work on the horse."

And why, I asked, would someone want a prosthetic eye made for a horse?

"There was money in the horse," he said, as there was in some of the other horses he had cared for. One was a grand champion supposedly worth a million dollars. Another was a race horse that, because it was blind in its left eye, was always given the inside track. Others were family pets.

"The nice thing about a horse," Danz explained, "is it's pretty much just a dark-brown eye. And even if the color's a little off, you're not really going to appreciate it. The main thing was to get the pupil right because it's an oval, elliptical pupil. And it's got to be horizontal. And also they don't show a lot of sclera. It's mostly all iris. So you just sort of fuzz out the edge of the iris with dark brown. I always put some indicator in it, the name of the horse, to let them know where the top is. One person wanted me to put a phone number on it just in case it got lost."

Two of the dogs he had made eyes for were family pets. The other was a police dog that had been involved in numerous arrests and drug busts. A malignant melanoma had required one of its eyes to be enucleated.

"Because the dog was so loved by the department and even the city," Danz said, "they decided that if they could make an eye for the dog, they'd do that. They actually brought the dog down to my San Francisco office, and it was a huge, big German Shepherd. I don't remember seeing one that big before. And I said, 'Well, the first thing I have to do is take an impression.' And I said, 'I just want to let you know that the dog's probably going to react to this because it doesn't hurt, but you can feel it.' [The officer] goes, 'Don't worry, won't be a problem.' And I go, 'You sure now?' And so the officer said, 'Stay' or 'Sit.' I injected the material into the eye socket, and the dog didn't flinch. It had been told: 'Don't move.' Well trained. That eye was a little bigger than a human eye, but not quite like a horse. They're dark brown, but more of a round pupil. A little more sclera showing, but still mostly iris."

When the ASO and the AAO hold their conferences in the same place, there's informal interaction between the two parties—ocularists stopping by tables for the AAO conference and vice versa, chats in the hotel bar. But the ASO

also always formalizes that cross-feeding by inviting an ophthalmologist onto its own speaking agenda.

The educational goal is to help ocularists understand more about what happens before patients get to their offices. As I found a seat before the early-afternoon talk by Dr. Steven Leibowitz, an oculoplastic surgeon whose practice is based in Las Vegas but who also teaches at UCLA's Stein Eye Institute and has an additional practice in Beverly Hills (his website describes him as "the only UCLA Professor performing cosmetic surgery in Las Vegas"), I couldn't help but wonder if there's a subtler hope at work in these ASO conference invitations to ophthalmologists: to raise the profile of ocularistry within the general world of ophthalmology.[4] I wondered because, though many ocularists have mentioned to me the close, productive, and mutually respectful relationships they have with the surgeons who work regularly with them, other ocularists have lamented the way they have felt unseen or dismissed by ophthalmologists who don't directly perform the eviscerations and enucleations or get sockets ready for ocularists—the ones who might rarely need to think about ocular prosthetics. I wondered more personally because of the ophthalmologist who'd refused year after year to recommend me for eye removal, the one who'd written in my chart, "Use prosthesis as last resort if a lot of pain."

"Oh, you're the guys who take over when we fail," an ocularist from New Jersey, Hank Freund, once told me ophthalmologists had remarked snidely to him. Freund had reason to be insulted. Instead, he had laughed and offered two empathetic theories about why ocularistry might not be better known among ophthalmologists as a group or something to which they direct their patients more readily. The first was that ophthalmologists work in a field of increasing specialization (the glaucoma specialists, the cornea specialists, the retina specialists), so that few of them consider every aspect of eye treatment. The second was that ophthalmologists simply aren't trained to give up on an eye, no matter how bad it might look or feel. (It was interesting, then, at one point in Leibowitz's presentation, to hear him describe his criteria for eye removal: if it's blind and painful, out it comes, and on to the ocularist goes the patient—a recognition that the healing a patient needs is no longer within the power of the ophthalmologist to give.) Freund told me he always responded to the dismissive remarks: "That's not true at all. I mean, there's some people that get hit with a baseball or get hit with a dart. That's not a failure of the ophthalmologist. That's a failure of the jerk in the bar that threw the dart."

Leibowitz's lecture had a couple of obvious purposes. One was to explain the choices he and his oculoplastic colleagues make that directly affect the ocularist's work, the ways in which they try to "optimize the rehabilitation."

He said, for instance, that he doesn't use hydroxyapatite implants, though he did when they first appeared in the 1990s and provided unsurpassed motility. His reason: 5 percent of them extrude. He prefers a $12 sphere, which doesn't provide as much motility but stays put.

The second purpose was a detailed exposition on the surgeries for evisceration and enucleation. Some ocularists present had undoubtedly seen these operations performed in person, though many likely hadn't. Leibowitz came armed with graphic videos.

"You all just had lunch, right?" he asked. He recalled a case he'd had years earlier in which the patient, a miner from Arizona, had had his head "kind of flattened" by a runaway boulder. Leibowitz was able to repair one eye but had to enucleate the other, and a physician in the operating room with him, an ear, nose, and throat specialist, nearly threw up. "You're a snot doctor, and this bothers you?" Leibowitz said he asked him.

Leibowitz commanded the stage with ease, humor, and self-assurance. The videos were up close and vivid, but no one around me showed signs of queasiness. Nor did Leibowitz's medical pedigree—med school at Columbia, internship at Stanford, residency at Harvard—weigh heavily in the room, though it's fair to theorize, I think, that the good-old American class system might be a factor in any possible separation between ophthalmology and ocularistry, not on a consistent basis or maybe not even often on a personal level but perhaps obstinately on a systemic level. Many ocularists have bachelor's degrees, and some have master's degrees, though neither is mandatory to do the work, and the profession is not built around the same requirements for higher education that medical doctors must meet or by association with elite universities. But I sensed no patronization in Leibowitz's voice or manner (the once or twice he mentioned Harvard was a detail important only to a story he was telling) and no hint that the self-assurance I'd always seen ocularists display about the importance and skill of their work was threatened.

"By the way," Leibowitz said about halfway through his talk, "I wanted to tell you why I have always admired ocularists." This could have been a gratuitous moment, but it seemed sincerely based in his having worked with and relied on ocularists for his entire career. "Three reasons. The first reason is the work you do, which is to me like an artist. The second reason is that a lot of the ocularists that I've dealt with come from family businesses, which I think is great because I'm all about family. I couldn't get my kids to go into medicine." He paused to let those compliments have some space. "But the third reason," he continued, "is that some of the ocularists charge about three times what I got for the operation." Everyone laughed. "I admire that," he said. "I'm not jealous; I admire it."

Serendipity happened again at the Sunday afternoon session—a variety lineup of six different ocularists presenting on six different topics—when I found myself sitting next to Shelby Perry. Like me, she's not an ocularist, and so I had no reason to expect her to be at the conference. But I recognized her immediately from her picture on Facebook. She had been posting regularly on the Prosthetic Eye Wearers Support page. It was an odd sensation to encounter her in person, an experience very much like when I'd lived in Vegas as a teen and my buddies and I wasted a lot of time walking the Strip and riding the elevators in the hotels, occasionally running into a famous actor or entertainer—Mary Tyler Moore or Carroll O'Connor or Fred McMurray. Turning to introduce myself to Perry was the social-media-age equivalent of that thrill because what I'd seen of her on my phone was always a little unreal. She was around thirty, had long blond hair, a sort of angular face, and a right eye that was sparkly pinkish and silver. I had already been thinking of contacting her to see if she would tell me about that eye. In person that afternoon, she said she would be happy to as soon as the session was over. One presenter was Christina Leitzel, an ocularist from Portland, Oregon, whose talk was titled "Fun Eyes." Perry had come to the conference with Leitzel, as had three other women who wore their own fun eyes.

For the previous month, Leitzel had been posting pictures on Instagram of the many such eyes she had been making in the lead-up to Halloween: a bright-green eye with catlike slits for pupils; an eye with three irises, all pointing in different directions; an eye with teeth; an eye with a silver stud pierced through the pupil; eyes of silver and gold and glitter.

Fun eyes—or novelty eyes, as they're also called—are not what ocularists typically advertise about their work. Yet most if not all the ocularists I talked with had made them because patients sometimes want them, and there's no law against making a prosthetic eye look like anything you want. Vaune Bulgarelli told me of fabricating one that looked like a golf ball. The patient wore it to a golf tournament. He went up to a golf pro and said, "Did you hear a guy got hit in the eye with a golf ball last week?" When the golf pro said he hadn't, the patient took off his glasses. The golf pro yelled: "Couldn't they get it out?!" Michelle Strauss told me of one of her patients who wanted a gleam in his eye. "I thought he was joking," she said. "I'm like, 'Yeah, I'll give you a gleam or whatever. Everybody gets a gleam. It's free of charge.' He's like, 'No, I'm serious, I want a gleam, and I want it to be noticeable.'" When she told him she wasn't exactly sure how to go about doing that, he said, "Well, I'm sure you'll figure it out. You're an artist." She painted a white asterisk on the iris, like in a cartoon character's eye. He was very happy. (Michelle also

told me she had turned down requests to make eyes with swastikas and raised middle fingers.)

Shelby Perry was the first wearer of a fun eye I met in person. Even for me, someone who had been thinking about prosthetic eyes for years, the experience was jolting in a small but tangible way. It wasn't at all the recoil of repulsiveness that nineteenth-century ocularists described about encountering someone with a missing or maimed eye because Perry's fun eye was not repulsive. Its effect was more of intrigue that pulls one in rather than pushes one away. And, of course, since decorative body modifications are essentially mainstream in the United States—a third of all Americans have tattoos, and there is no rarity of pierced noses, eyebrows, tongues, cheeks, lips, and navels—a novelty eye is not as shocking today as it once would have been.[5] In fact, a fun eye is different from tattoos and piercings, maybe, because only the rare sighted person would be willing to risk sight for style. Rare, but not nonexistent. Some people have gone so far as to have their real, seeing eyes tattooed. The ink gets injected into the sclera. The AAO, not surprisingly, advises against scleral tattooing, as made clear by the title of an article on the organization's website: "Eyeball Tattoos Are Even Worse Than They Sound."[6] The tattoo artist credited with developing the scleral tattooing procedure has likewise counseled that the social consequences can be severe: "When someone wants a black eyeball and they have dark brown irises, I warn them they're going to scare the crap out of everybody forever. You can't tell where they're looking, and it's off-putting. It's a little bit harder to interact with someone like that."[7]

When the session was over, Perry and I found a relatively quiet place on a bench at the end of the hall. It wasn't hard to interact with her. She was open and smiling and enthusiastic. The only odd sensation for me was not being exactly sure whether I should look at her real eye or her fun eye or go back and forth between them, which is what I couldn't help doing. If I concentrated on her fun eye, was I making eye contact?

I began with a question shaped by my own deep desire that my prosthetic be unrecognizable as fake. That desire, to my relief, had been fulfilled so far in Vegas because every ocularist to whom I revealed I had an artificial eye seemed surprised. One had then looked closely and said, "I'm seeing details in there that most people wouldn't see because I make those. It's excellent work." Perry herself didn't suspect I was one of the "one-eye gang" (a slogan she and her three friends were wearing on their T-shirts) until I told her.

How had she, I asked, gotten the guts to wear an eye like that?

She had lost her real eye only two years earlier after a snowboarding accident.

"I remember joking with my friends about getting a bionic eye," she said, "or just something really extravagant, but I didn't even know that was a thing."

Her first prosthetic, then, was a straight-up match for her remaining real eye. But Perry thought it didn't fit well, didn't appear symmetrical to her, sat out farther than her companion eye. "In pictures it looked awful," she said, though her friends assured her it looked fine.

"I couldn't recognize myself," she said.

After her ocularist made several adjustments to alleviate the imperfections, Perry came to feel much better about that eye, even began to love the realism of it, the way it made physical evidence of her trauma mostly disappear. But it also made her lonely. She didn't know anyone else and had never known anyone else who wore a prosthetic eye. "I just wanted to find one other adult that I could talk to," she said. "I'd seen TikTok videos, and I reached out to some of the people but wasn't getting any responses."

She began a blog that featured stories about people who had lost their eyes in all sorts of ways, which made her prosthetic-eye-wearing community grow. Then she met Leitzel. "She had a meet-up in Portland last April, and she invited me out and some of the other one-eyed people," Perry said. "And there she made me my first fun eye. She's made all of my fun eyes. I did a rainbow apple, like the Apple logo. My friends were joking: 'Maybe Apple will sponsor you.'"

"Or sue you," I said, hoping that, too, was a joke.

Here's what she decided about the reality and the possibilities of any artificial eye she might wear: "If it's going to look slightly off, I'd prefer it to look *off*. And expressive."

I admitted again that every one of my appearance goals had been toward "less off." But Perry is a very social person (she said), and I'm not. When she had her natural-looking prosthetic and would be talking with any of the many people she talks with every week ("at least a hundred"), she could tell that people knew something was amiss with her eyes but were too polite to say anything. Conversations had a layer of silent awkwardness that made her feel even more lonely. Once she switched to a fun eye—pushing her prosthetic into glimmering obviousness—people's hesitations evaporated. They asked questions almost without hesitation.

"They'll ask if I have a contact or if I can see out of it," Perry said, "or if I have other ones. 'Can you change it? I've never seen anything like that.' Just flying out here, the TSA agent was like, 'Is that a prosthetic eye? My cousin has one.'"

"This one is an invitation," I said.

"And I'm comfortable answering any and all questions," she said.

A little later that afternoon, another of the "one-eyed people" would describe to me much the same motivation for switching from a realistic prosthetic after twenty years to a collection of fun eyes (she said she had seventeen of them). The person asked to go by her social media handle, "Mrs. Sunshine," because she posts a lot of TikTok and Instagram videos about her eyes as well as about being a high school special-education teacher, and "there are crazies out there" who might target her as a teacher. At the time I met her, she had 900,000 TikTok followers, around 35 million likes, and hundreds of millions of views. She had a couple hundred thousand Instagram followers. She was twenty-eight, and her eye that day had a reflective star in the middle.

"I wanted to take control of the conversations happening around me," she said, "and I didn't feel like I had to hide or try to blend in that part of me anymore. It was empowering for people to actually ask me about it. It wasn't like the stares. Or like someone who told me, 'I just thought you had a lazy eye.' I was like, 'Why didn't you just ask me? You were just making assumptions, and I don't like that.' But it's courteous. You don't usually say, 'What's wrong with you?' I understood. But with this one, people are like, 'Oh, my gosh, it looks like you have a contact in it.' I'm able to educate about the fact that it's a prosthetic, and it makes this a little less of 'That looks a little off.' It goes from 'Yours looks almost perfect' to 'That's beautiful.' I'm able to match with my jewelry; I'm able to match with my outfits. And it becomes a statement piece that is enhancing versus hiding that there's something wrong with me."

After Mrs. Sunshine got her first prosthetic eye when she was seven, her mother threw her a prosthetic-eye party. "She was inviting everyone," Mrs. Sunshine said, "and was like, 'This is beautiful, amazing.'" Having a fake eye was Mrs. Sunshine's "fun fact" about herself all through school. She'd never been made to feel self-conscious. Still, in high school she had started thinking about wanting a different kind of eye. Her mother said no but that she could do whatever she wanted when she was making her own money.

"So after graduating college and moving and after teaching for two years, I was like, 'I want a green eye,'" she told me. She mentioned her wish to her ocularist, and his response was: "Heck, yeah, let's do it."

"My hypothesis," she said, "was people would notice the color of my eye was different before noticing that its movement was different." Her previous prosthetics never had full motility. "I got the green eye, and it was a really beautiful green. It was bright. It wasn't like a sneaky green. I have a pretty bright-blue eye. And so I thought people are going to think heterochromia"—two naturally different-colored eyes—"before they're going to think lazy eye, before they're going to think prosthetic. And that was the case. Everywhere I went, people were like, 'Oh your eye's so beautiful. Oh my gosh, you have

heterochromia, that's so wonderful.' Checking out at the cashier: 'Your eyes are beautiful; you have heterochromia.' And I'm like, 'It's actually a prosthetic; I'm half blind.' And they're like, 'I'm sorry.' And I'm like, 'Don't be! It's fun!'"

I asked her what her students think, which, she said, is something she gets asked about a lot on social media.

"For three weeks, it is the coolest thing," she said, "and they want to know what eye I'm wearing and what other ones I have. After that, I'm just normal. It becomes their normal. Which is part of what I strive to achieve with me posting about it online and just exposing people to it . . . to normalize the experience of having something different. It's not something to be ashamed of."

For the most part, she said, responses to her TikTok and Instagram posts have been "almost unanimously positive." Some responses ("This is so weird for a teacher to post, man") seem to express some kind of confused discomfort with any challenge to a stereotypical image of a teacher.

"Different can be a little weird," she continued, "but it's also normal when you see it and are exposed to it. So my students, this is not weird to them anymore. I'm sure they've gone and told people, 'My teacher has one eye, and she wears these crazy things.' But for day-to-day interactions, they're no longer like, 'What are you wearing?' They've not even noticed that I got my new one."

The trauma of eye loss occurred for Mrs. Sunshine when she was a kid. It happened for Shelby Perry in her late twenties. In whatever healing each needed by the time she got a fun eye, whether it was extra confidence ("I would never have imagined the difference it would make," Mrs. Sunshine said) or social connection (the stories Perry has heard from and shared with others "truly helped my healing tenfold"), the fun eye has been vital but not the sole foundation for progress. Mrs. Sunshine had "the most supportive mom in the world." Perry had learned the value of storytelling by being in Alcoholics Anonymous. She had been sober ten months before her snowboarding accident.

"I was really like: 'Why would this happen to me? This makes no sense,'" she said. "I felt like I was doing everything right in life, and I'd finally gotten back on my feet with the sobriety. So that was really a down time, and I had no idea what that meant for my future. And so I know for a fact that I needed to be sober in order to get through something like this. I don't even know what would have happened if I hadn't already had the foundation that I had. And everything that I learned in that foundation I completely translated into the work I do today, in the way that I give back and connect with people." She told

me about starting Eyehesive, an online community for people who have lost an eye to share stories, and about hosting online Eye Connect workshops. "And it's like: '*This is my purpose*,'" she continued. "As crazy as that sounds, I guess, that I had to go through something like this in order to figure out my purpose. But all the things leading up, I'm like, 'Yes, this is it.' I love connecting with people and bringing people together and just talking with people. That's my healing. I just have these moments when I'm talking with someone with a prosthetic eye or even seeing responses to something I post online. Just sharing my thoughts and stories openly and vulnerably. And someone responds. All of these things have added up into my overall healing. So now instead of 'Why did this happen to me?,' it's like, 'Oh, this is my purpose; it's what was meant to be.' And I was able to get myself there, with the universe or God showing me the way, these signs."

There was a banquet plus a silent auction on Sunday night. It was an opportunity to find some more serendipity, to spend a last couple of hours with friendly people telling interesting stories, to be among what was starting to feel a little bit like family. But after I stopped into the prebanquet reception and had one drink, I decided to cut out. The music was loud, and I wanted to take a walk out among the tourists. The weather was perfect: clear sky, no wind, 75 degrees.

The crowd on the sidewalk was nearly shoulder to shoulder, and the party atmosphere was real despite—or because of—the absurdly unreal setting: the fountains, the half-scale Eiffel Tower replica, the plastic-covered Roman columns. I walked north to Sands Avenue and turned right, so I could get an up-close look at the Sphere, the newest addition to the city's skyline. It's a round building covered on its outside surface by more than a million LED pucks to create one big computer screen capable of dynamically displaying anything programmed into it. As I got closer, the display was first an astronaut's helmet inside of which a baby's face floated and peered helplessly—an allusion, I guessed, to the ending of *2001: A Space Odyssey*. Then it switched into a series of quick-changing designs: white horizontal lines flashing on and off and making it appear as if the sphere were spinning or being shocked by jolts of electricity, a fireball, an orb of lighting like something in a science museum, a container of raindrops, a ball of clouds, an ocean surface. Amid all that, eyeballs showed up and disappeared: an iris with edges that flared out like the corona of a solar eclipse. I've seen videos of the Sphere when it was fully a regular eyeball for long stretches, disembodied but moving to gaze this way and that, the pupil dilating and contracting, an upper lid with lashes rising and descending. I've watched videos of other animations displayed on the

building's exterior, everything from a basketball to the rotating surface of the moon to a carved pumpkin with a flickering candle inside it. But the eyes keep coming back, as if a huge round building in the middle of a city of illusion wants to be an eye, needs to be an eye. The Sphere is 516 feet in diameter. If it were a prosthetic, it would fit a person seven miles tall. Surely someone—its designers, biomechanical engineers, ocularists who were taking their own walks that evening—has wondered whether a one-inch-diameter, LED-covered sphere might someday work as an actual prosthetic, allowing the wearer to change its design instantly to anything imaginable.

Nelly James and Francesca Gelai, Ocularists

NELLY: We were both working in an optometry practice in Melbourne. I'd watched a documentary about the anaplastologist Daril Atkins called *Saving Face*. If you're not inspired to do good, that will make you. And I'd always been interested in ocular prosthetics. It's kind of on the cusp of the optical world and industry. So I watched this documentary, and I was like, "We just have to do it. We have to." An ocularist in the UK invited us to do an apprenticeship. I dragged Francesca along with me. And the whole reason was to do good, not to make money. It blossomed from there. That was eight or nine years ago now.

FRANCESCA: We met in 2012.

NELLY: After we trained in the UK, we went to Greece, we worked with someone in Australia, we went to New Zealand. We've worked in Ghana and Nigeria, and we've learned so many different methods and how to put together the perfect eye for the environment and the things that you have available. We were told there was no ocularist in the whole of Kenya, and we were in touch with someone through LinkedIn who worked at a big eye hospital here, so he asked us to come and do a training in the hospital. We were training two ocularists. We were meant to be here for around six months. We were about halfway through the training program when COVID hit. The hospital shut down for one month, and they were like, "Whatever you want to do, if you want to go back home or whatever." And Francesca and I thought that it would just blow over, and we could finish our training program. And then Australia shut the borders, and New Zealand shut the borders, and we couldn't get home for, like, three years. So we ended up staying and setting up a private clinic. We'd finished the training program, and then we were like, "Well, kinda stuck!" But now we want to be here, and it's been five years. Looking back on it, it's best that we stayed.

FRANCESCA: It's a much-needed service, and there's a huge demand for it. Prior to us being here, it was a lot of fly-in, fly-out missionary services, and then the patients don't get the maintenance or aftercare they need. So it just became more and more clear that we would stay here.

NELLY: In Lagos, we trained a dental tech and two ophthalmic nurses. And here in Kenya, the two ophthalmic nurses. We taught them a lot of the materials and the hand skills. They are making eyes, but if there's anything that's a little bit outside of their scope or a little bit difficult, we still consult, or they'll send their patients to us. There's a lot of people that don't get seen perhaps as early as they might need to. There's a lot of complex sockets.

FRANCESCA: There are delays in getting treatment or falling out of the referral system for things like retinoblastoma. Kenya has a very high rate of retinoblastoma, and they think it's linked with a vitamin A deficiency, which is being targeted with

fortified cereals and iodized salt, I believe. But it's also a matter of when retino-blastoma is detected. I think the average age [at which it is detected] in Kenya is about three and a half [years], whereas in the States it's about six months. It's little things. Like, you might take a flash photo of your baby. And if you see the reflection, that's a big indicator. But people in rural Kenya maybe don't have a flash phone or a camera phone even. It's those sort of earlier detections that really change the outcome.

NELLY: There are cultural things, too. A lot of people are apprehensive about going ahead with a surgery to remove an eye because once a child has a facial issue, they will be stigmatized, probably bullied, probably left out of the workforce. Their family will also feel that as well.

FRANCESCA: The mother gets blamed, sometimes. They think she or the child is cursed.

NELLY: There's a strong belief in some communities that if the child has a facial deformity, then the mother is cursed and should be avoided by everybody. When we were working for six months in Nigeria, a woman brought a five-year-old to see us that had not left the house until that appointment because the mother was so scared of anyone around her seeing her child with microphthalmia. And the doctor that invited us here told us that he had a family who came to see him who had ten children, over time, who had retinoblastoma. You know, retinoblastoma is either a vitamin A deficiency, or it's a genetic link. And the father refused to get surgery for the kids. He would take them to a natural healer, who would put a mix of this plant and this plant and try to heal the retinoblastoma. And he had nine out of his ten children die from this aggressive cancer before he relented and said, "Okay, fine, we'll go for the surgery." Can you imagine? Just because that service of artificial eyes was not available. It boggles the mind when you're from a place where it's very accepted.

FRANCESCA: That was a big reason we decided to stay as well, because without having a suitable rehabilitation option, people are going to be more hesitant to go through with surgery. We felt like if we could provide a solution for rehabilitation for the child, or an adult even, it should make the decision easier.

NELLY: We see a lot of stretched eyelids and very contracted sockets from people waiting too long.

FRANCESCA: Or just the service not being available to them.

NELLY: There was a guy that came to see us in Nigeria, and he had had a tumor the size of a tennis ball in his eye for so long because he'd come to the hospital for treatment, but the machinery was broken, and they hadn't been able to get it fixed. By the time they ended up treating him, his eyelid muscles were so stretched that it would be difficult for them to hold a prosthesis in place. And a lot of people either can't afford surgery or don't want an elective surgery. So we really try to work with our patients and with what we can.

FRANCESCA: We try as many different prosthetic techniques as we can sometimes, before talking about the surgical option.

NELLY: There are a lot of amazing doctors here. A lot. It's just that there's something called the NHIF [National Health Insurance Fund], which is meant to be like the NHS

[National Health Service] in the UK or Medicare in the US. But it doesn't usually pay on time or at all. So, often treatment will be delayed longer than it should be, which is one of the challenges we face by the time the patient comes to us.

FRANCESCA: I think the system is sometimes designed to be complicated. There's always a middle man for everything. It's like a whole part of the economy. You have to know a guy.

NELLY: We have a middle man whom we hand our papers to, who will then go to the government house and do our work permits for us. And that's his full-time job. And it won't be just us. It'll be so many people that do the same thing. But we have some very close friends here who help us navigate things, but it's forever changing and forever confusing, even for them.

FRANCESCA: And even outside of friends, on the personal level, the two ophthalmologists and surgeons we work most closely with have been really supportive of our work and believing in what we do. They try to create awareness, obviously by referring patients, but they've always really believed in what we're doing, and I think our morals align as well. So it's been really nice to have that support. We're definitely on the same page with them, for sure.

NELLY: We work with two amazing female doctors that work at one of the main public hospitals in Kenya also, and they are both involved in a program where they have midwives do follow-ups with babies to check for retinoblastoma. In the last seven years, I think, they started doing that when a child comes in for a six-month checkup, if they come in for a six-month checkup. But sometimes a patient will live very far away, or they won't be able to afford to come in for a checkup, whether it's transport or the appointment. So I think it's a little bit of the health-care system and a little bit of affordability and accessibility. A lot of the hospitals have good doctors. It's just whether a patient can get to them for whatever reason.

FRANCESCA: There might not be the specialist doctors in rural areas, and people need to travel to Nairobi or Mombasa to get that specialist treatment.

NELLY: And as Francesca was saying, a lot of fly-in, fly-out doctors—doctors who come from the UK and the States. They'll come in and do a clinic of two weeks, and they'll bang out a whole lot of surgeries and then leave again. So, yeah, it's scattered, I would say. Especially during COVID.

FRANCESCA: That was a big eye-opener. All of the sudden, the ocularists from America or wherever were no longer coming.

NELLY: That was one of the reasons we thought it was probably good that we hang around for a few years. There was one maxillofacial prosthetist who used to come and work with a woman at a rural eye hospital here. He'd come once a year, and he'd drop off a whole lot of materials and do a clinic. And then during COVID, because he couldn't come and donate materials, that clinic closed down because it relied on those donations.

FRANCESCA: And we were also realizing how hard it would be for people within Kenya to become ocularists. I mean, it was hard for us to get into ocularistry, not being born into a family of ocularists. We asked around a lot before we found someone willing to take us on as apprentices. But then you add the costs for someone from

within Kenya if they wanted to go get training outside of Kenya and bring it back. We'd like to train more people. It's obviously a big undertaking. It's a long time, a big commitment. But we absolutely want to.

NELLY: We get asked quite a lot to go to Mombasa. It's the other main hub on the other side of Kenya. It would be great to train someone there because for patients to come to us, it's a big cost. For us to go to the patients, it's also a bit of a cost. Our clinic is mobile, so we could do it. But it would be good to have somebody based there to be able to service that area.

<p style="text-align:center">* * *</p>

NELLY: Kenya runs on a WhatsApp system. Everything is done through WhatsApp, including all of your appointments. And it's our own personal numbers that we give. So even if we've seen a patient once or twice, a lot of people still message and say, "Hey, how are you? Just seeing if you're okay. Happy Christmas!" We have this nice, quite friendly follow-up system. I think the difference between our appointments and those we had when we worked in the UK and Australia is the time. People here don't have the freedom to have off so much time from work because time is money. When we see a patient, we have an initial appointment, which is about an hour, and then we have a collection appointment. We don't have that appointment time of sitting and painting like we did when we worked in the UK, when we could just sit and look at someone's eye and paint. We paint a lot from photos and from memory. And we take color references of sample eyes that we have. We don't have as much time with the patient, but we're both very emotional, sensitive people, and we do like to talk and chat a lot. It's not just the eye, right? It's the rehab for someone to feel whole again, and that is such a special moment to share. So we always try to chat and make people as comfortable as possible. We cry often in our clinic, with happy tears.

<p style="text-align:center">* * *</p>

NELLY: We trained to do the alginate impression. But we were also taught one method, right at the end of our training. Our mentor was like, "Just in case you need it, try this." So we've got a lot of eye templates. We've got a huge amount of prosthetic eyes. So our method is to try in a shape, find what fits best, and then copy that shape.

FRANCESCA: Add wax, adjust it.

NELLY: And we just find that it works a lot better for our patients because one thing that we really need to be aware of is how the eyelids move. Often people have not had a prosthesis before, or they've been wearing a stock shell that's way too big, and the eyelids are stretched.

FRANCESCA: Or they had a surgery years ago.

NELLY: It's really crucial that we see how the eyelids move to get a good balance. We realized, too, how important it is for the patients to be able to see what it will look like, just in case there is a language barrier or something. It's easier to explain how it will

feel when there's a temporary prosthesis in situ, and to reach that step, because time's a luxury, so we just need to make it a little bit quicker. We sometimes do an alginate impression if it's required. But we have to be aware of being able to get things in and out quickly.

FRANCESCA: If there's a lot of volume deficit, we can take an impression and see that it's going to be quite large and heavy, and can the lids support that?

NELLY: We have a lot of live eyes, a lot of sort of quick-stitch jobs. There's a lot of trauma that we see. But if somebody has had an enucleation or an evisceration, it's not a given that they have an implant. It's not standard. Sometimes it depends on the price. When you get priced for a surgery at the hospital, everything is itemized. So if somebody can't afford the implant, you remove that from the plans and just go ahead and do what can be done. Even postoperative conformers are not always used. Basically, the way it was working before was, after the patient has the surgery—because they do not want to be seen without something—in place of a postoperative conformer, they'd sometimes put in a stock eye that would come usually from India. They are often not cosmetically acceptable. And sometimes they'll have surgery on a child, but they'll only have adult size, but they'll put it in anyway.

FRANCESCA: They'll use the same for the left and the right socket.

NELLY: So we're working on something at the moment that's kind of a hybrid of the two. It's like a postoperative conformer and stock shell. We're trying to figure out a way to make it as efficiently and affordably as possible.

FRANCESCA: It'll be made out of better-quality materials, the right sizes, the right colors. With us being the end of the referral chain, for us to then have to say to a parent that their child is going to need another surgery, it's tough.

NELLY: One of the doctors we work with said the main hospital used to have a bunch of stock eyes. They've just slowly depleted. She said they can't replace them because the hospital won't pay for them. If doctors want to get stock eyes, they will pay for them themselves. So we do see them every now and then as a stopgap for someone who can't afford or can't get a custom-made eye.

FRANCESCA: The quality varies as well. I've seen some from India that are decent, but there's some that the edges are really thick and rough. And they degrade very easily. A lot of the ones we see here are delaminating. They go well beyond their intended lifespan.

* * *

NELLY: We follow a lot of ocularists from the States, and there's this movement toward people having fun eyes, with glitter or anime or other things. And here, there is no way. There is no way somebody would draw attention to something like that. That is just not even a thought yet. We really feel the contrast here so much when we see the fun eyes. We're like, "That's awesome; I love that you're raising money for a second or third fun eye." But here somebody really needs one regular eye to feel a part of their community, to be able to feel whole. So sometimes it's a bit disjointed.

FRANCESCA: We've even had patients who are like, "I can look for a husband now." Yes, *disjointed* is a good word.

NELLY: We do plan to stay here, if they'll have us. It wouldn't feel fair or right to leave. As much as it can be really stressful sometimes, just life, and the money thing can be really stressful. The biggest thing for us is the sustainability of our clinic. We charge the least amount that we can that keeps us sustainable. We charge 300 US dollars. It's the same quality that you would get in the States. It's the same technique that you would get in the UK. It's top-top end. But 300 US dollars for most people in Kenya is quite unaffordable. That is our biggest challenge. We have made pledges to NHIF and a few other insurance companies. If somebody has private insurance, they might be able to get something back. But then we have to explain to the insurance companies, because this is such a new service, that an eye needs to be replaced every five years, or whatever, or that the patient needs to come to an appointment every year for maintenance.

FRANCESCA: It's always a battle to justify its importance.

NELLY: We're very lucky. We've had a few people that have heard about us that have donated, so that some of our patients can be seen and provided with a prosthesis. And I think without that we would not have a running clinic. Materials and things are supereasy to get. We try to buy as much as we can locally, but we still source things from overseas.

FRANCESCA: Getting things into the country is a challenge.

NELLY: Nobody has a mailbox. There are only private post office boxes. So to get things in, you have to find an address, and you say, "Hey, I live near this police station, down the road on the right."

FRANCESCA: If you don't do that, it will get held at the port, and then the longer it's held at the port, there's more time for you to receive a call with someone trying to get you to pay extra taxes on top of things.

NELLY: Getting the word out about our services has also been a little bit more long-winded than we anticipated. You don't email. You go to visit doctors. You show them: "This is what we make. So if you have patients that need a prosthesis, send them to us." It has to be word of mouth. We were also recommended to put an advert in the newspaper as the best marketing you can do to get word out that this service is available now. Or use classifieds online. We're trying to get the word out to ophthalmologists and the public. The service wasn't available before, so even that referral step from ophthalmologists didn't exist, though we are starting to see that change now. Before, if a patient needed an eye removed, it would be removed. It's now that next step of the doctor saying: "You're coming up for your surgery. After six weeks, go and see these people." We've had to elbow in there and say, "Think about us." We've met so many patients that would Google "ocularists" and find nothing locally, so they would fly to India. It's a quick and cheap flight, and it's a very common flight. So we're trying to intercept that and say, "Hey, you can do this here." We get a lot of patients coming from Ethiopia, Tanzania, Rwanda, South Sudan. The word seems to be spreading outside of Kenya.

FRANCESCA: There are now only two clinics in Kenya: us and the two people we trained. We do have plans to expand, but for a long time, especially with the

pandemic, we've been treading water. We're definitely a lot more stable now, but for a while it was just trying to keep things sustainable. And it's still a struggle, but it really does mean a lot to be noticed from afar. Sometimes it just feels like we're constantly trying to do everything, and we lose track of the small achievements. We're very tucked in here. Our big goal is to establish ourselves as a charity going forward. That would open us up to grants and help with our sustainability. But for now it's just the four of us for 50 million people.

7

Closer

A man in Arkansas working for a power-line company in 2021 was nearly killed when he came into contact with a live high-voltage wire. He ultimately lost his left arm. Reconstructive surgeries couldn't repair the damage to his face, including his missing lips and nose. His right eye was okay, but his left eye hurt so much that it had to be removed. Two years later, in 2023, he was at New York University's Langone Health, where doctors gave him a new face— only the nineteenth face transplant ever to be performed in the United States. And they added something. They took a full eye from a donor—not just a cornea, as is common—and transplanted it into the man's empty socket. They spliced together the length of optic nerve still attached to the donated eye with what was left of the patient's optic nerve, then injected stem cells from the donor to encourage healing. It was the world's first transplant of an entire human eye.

Doctors were prepared to see the eye "quickly shrivel like a raisin." After six months, however, "the donated hazel-colored eye was as plump and full of fluid as [the man's] own blue eye" and showed no signs of being rejected. That cosmetic success was ground-breaking. "We're not claiming that we are going to restore sight," said Dr. Eduardo Rodriguez, NYU's plastic-surgery chief, who led the transplant. "But there's no doubt in my mind we are one step closer."[1]

The transplantation of eyes so that they function fully—like transplanted kidneys or hearts—would rock ocularistry. So would a steady supply of available eyes grown in labs as we already know how to grow bladders and windpipes and blood. An eye is an enormously more complex undertaking. Still, at least one of the knottier challenges is being chipped away at. A research team at the University of Wisconsin, Madison, figured out how to reprogram stem cells derived from human skin into rods and cones and retinal ganglion cells, among other types of retinal cells. They then demonstrated that these cultured cells could be transplanted into an existing eye and "plug into, or shake hands

with, other retinal cell types in order to communicate"—that is, conduct the synaptic connections essential for vision.[2] Medical advancements in dealing with lost eyes are thus on the near horizon.

Closer, though, and perhaps more immediately consequential for ocularistry are engineering advancements: specifically, artificial intelligence (AI) and 3D printing. These combined technologies could bring about the biggest change to the fabrication of ocular prosthetics since the invention of acrylic eyes in the 1940s.

Andrew Etheridge thinks so. He's a clinical anaplastologist. He makes prosthetic body parts for real people, including eyes but also pretty much anything else: jaws, breasts, cheeks, orbital sockets, fingers, toes, feet, hands. He's a faculty member in the Department of Art as Applied to Medicine at Johns Hopkins University, and he teaches in the recently established graduate program in clinical anaplastology, which is now one of the few places in the world where students can learn to make eyes through a university program. He has studied with a number of ocularists and anaplastologists who specialize in eyes, and by the time he and I talked, he had nearly completed the five-year curriculum of the ASO's College of Ocularistry.

Etheridge knew 3D printing well from his anaplastology work. In 2019, he got a grant to research the 3D printing of eyes. Similar research was ongoing elsewhere, most notably at Moorfields Eye Hospital in London, which had the goal of modernizing the eye-making process so that it would be noninvasive (no need to make a physical impression) and fully digital, an "end to end 'no touch' process."[3] Moorfields got a lot of publicity in late 2021 when it announced that one of its patients was "the first person in the world to be supplied solely with a fully digital 3-D printed prosthetic eye."[4] That patient was a man in his forties who'd worn a traditionally made acrylic eye for twenty years. "They had the most money and time and resources," Etheridge said of Moorfields. "And so they got there pretty quick."

But "there" is not *there*, Etheridge implied. Meaning that although a 3D-printed eye is what Etheridge called "an acceptable outcome," there are some shortcomings that need to be eliminated through more trials and more data collection. That's the phase ocularistry is beginning to enter.

The basic steps for making a 3D-printed eye are:

- Scan the empty eye socket to get a digital representation of its topography, which will provide the dimensions for the back of the prosthetic.
- Scan the companion eye, the natural one, to get the dimensions and the colors for the front of the prosthetic. You'll have data for the surface structures of that real eye as well as the iris topography and color.

- Feed those two scans into modeling software, where the images are married together. However, there will be some data missing because the scanner captures only about 60 percent of the space the prosthetic needs to fill—excluding, for instance, the corners of the sockets.
- Use AI machine learning and statistical shape modeling to fill in the other 40 percent or so.
- Print.

There are many finer steps to the process, including the manipulation of the digital models on your computer screen and the postprocessing, such as the polishing and other aspects of fit and comfort. Etheridge said, "I think in time—which doesn't mean a lot of time—it's just a matter of how much input you can collect. If it's AI machine learning, it's all about input. The more patients that get seen, the more of that data gets put in, the more corrections get added, and the more modifications we get, it's just going to get better and better."

He added: "Obviously, it's brilliant. But it's kind of semi-custom-stock fitting. I mean, really nice, like a modified impression stock fitting. And it could serve the world's population, could be ideal for humanitarian efforts, though some populations might have a higher standard, especially with the internet, where people can look up anything they want."

We spent a minute or two sharing concerns over what it could mean to rely on a "no touch" process. Because pairs of eyes are rarely symmetrical, for example, I wondered about assuming that the anterior curvature of the companion eye will be exactly what the prosthetic eye needs to hold its own lid in the right place or for the gaze to be perfect? Those are the small details an ocularist obsesses over.

"Yeah, I'm going to add a little bit more there, scrape away a little bit there," Etheridge said, obviously having done those kinds of final adjustments. He had concern, he said, about "cutting out that really important process where there's an individual who's really dedicated to the field and the craft and being with the patient."

Still, Etheridge is enthusiastic about and committed to the possibilities for the digital fabrication of eyes. In his research, he looked at two approaches to how the technology might be employed. One approach would be reasonably affordable for private ocularistry clinics and provide plenty of opportunity to maintain the personal nature of the profession. The other wouldn't be.

For the affordable approach, an ocularist would need only to invest in an economical scanner and printer. Software that does a very adequate job is available free online. The key to a realistic use of these tools is that an

ocularist's adoption of digital technology could be hybrid. Scanning and printing could complement rather than supplant traditional fabrication methods.

"You can print diagnostic fitting models with biocompatible material and try them in and modify them," Etheridge explained. "Grind them down and add wax to them. That's a great way to implement technology into your current practice. I find that stuff really fun because I get to use technology, but I can also use my hand skills. I love doing things like that. I love mixing it. In anaplastology, you have to do that all the time. So I'll take a scan or an impression and scan the impression, work digitally a little bit, print something, see how it functions, how it works, do a prototyping, modify it, maybe even go back digitally and print something else, and then most things are finished traditionally, by hand. So I can play in these two worlds and go back and forth in space. I think that's a really good way to work."

Another bonus: "You can have your scans or have your impressions digitized, and you have a library that you can manipulate all you want. You're not confined by real space. You're in virtual space. So you can just design all kinds of interesting things, whatever you want to do."

The costlier approach that Etheridge investigated will probably result in a more dramatic revolution to ocularistry as a whole. This method involves pricey printers that can print multiple types of material and multiple types of colors in one shot. The most sophisticated printer can build layers of photopolymers as thin as 0.00063 inch and use resins that are cured by light into both rigid and smooth end products, with high definition of the intricate features—such as the irises and veins in the case of eyes. One of these printers can cost up to six figures. The scanning, ideally, is done with an Optical Coherence Tomography scanner, which can cost another six figures, though smaller and less expensive models have been coming on the market. With this route, fabrication time can be cut in half.

"The only thing that concerns me about this system," Etheridge said, "is: Does it have the potential to eliminate the whole industry of ocularists? What happens if anyone can scan, print, and mail you the finished product?"

I asked: "So it's possible some ocularistry Jeff Bezos comes in and has his expensive machinery and starts selling eyes cheaply, and all little guys are out of luck?"

"Yeah, yeah, exactly," he said.

It's easy to be romantic about ocularistry, I admitted to him. My relationship with my own ocularist had always been—and continues to be—one of relaxation and trust, an intimacy I get from no other professional whose services I employ. After I got my first eye, I swore that Michael and Michelle Strauss had suddenly risen into the top tier of the most important people in

my life. What am I going to find if in five or ten years I do another exploration of the culture of prosthetic-eye making? Will I be looking only online? Will people who need prosthetic eyes bemoan the disappearance of ocularists in the way people have bemoaned the disappearances of so many independent bookstores? Or will 3D-printed eyes from some distant company, if they exist in large numbers, be equivalent to stock eyes today, the ones produced in factories in India and China and used when custom-made prosthetics simply aren't available?

The difference between Etheridge and me, I suspected, is that I am merely a wearer in ocularistry, and he is a maker. I have a very personal stake in wanting my ocularist to be someone whose office I can drive to once a year for a polishing and with whom I can talk at length about how the eye is working in my life or when it's time to get a new eye.

But I have ordered eyeglasses online. They were so cheap that I ordered several pair at once, and they're all okay. Perfectly fine. But I've also bought glasses from the independent optical shop down the street, where the owner, Teresa, leads me to frames I wouldn't have noticed on my own, knowledgeably and generously evaluates how any particular pair works with my face and my hair and my eyes and my personality (she reads people well), and fits and adjusts and cleans whatever I end up getting so that they are ten times better than anything I have bought online. They cost quite a bit more, of course.

Etheridge is naturally interested in efficiency at the same time that he's committed to the highest quality. He knows, as I do, that greater efficiency is sometimes the difference between being able to stay in business and having to close shop or can simply mean being able to make more money. He's fascinated by—and skilled at—the digital technology that can be a true help in making eyes, even, or especially, for the ocularist who wants to continue at least partly with traditional methods of fabrication and doesn't want to sacrifice the human connections that can come from the long hours ocularists and patients so often spend together.

"I do fear that the more things go in this tech revolution, the colder it gets," he said. "And I want to make sure it can retain some of that warmth that the industry has. But it doesn't mean the technology is going to be a bad thing. I fell in love with this field and prosthetics in general because I can take my creativity and my hand skills and my knowledge of building things and put it into an industry and, hopefully, grow it. So, yeah, I'm passionate about making things, and I'm very romantic about the field, too, but you can take some of those same passions and put it into crafting something digitally. I never thought I would. Looking back even maybe ten years, I was like, 'Nah, I'm not going to do it that way.' And then...."

"It becomes its own kind of creativity," I said. "Some things lost, some things gained, no doubt." But I also remembered when my kids took shop class in school and made very intricate clocks with laser cutting. Did they really learn how to work with wood, I wondered, or did they just learn how to program a laser cutter? Why does it matter?

"We thought about that, too, with our graduate program at Hopkins," Etheridge said. "We do have some heavy curriculum in 3D technology, but all the students start off with a lump of clay. Back to basics. You've got to be able to sculpt something before we go digital."

And the timeline? I asked. If changes of one sort or another are coming, how soon?

"It's really on the cusp," Etheridge said without hesitation. "It's teetering, I think. Once certain printers become more affordable, or the entry point is lower, or maybe, like you said, a company says, 'Now you have to go through me to provide eyes because I've been approved by the FDA [Food and Drug Administration], and I'm the one that has this machine, and I'm the one that sells the scanners, and all the ophthalmologists are buying the scanners.' And you're going to buy the scanner for $100,000? No, I don't think so. So how are you going to make this work? That could be an issue."

I asked whether ocularists should be worried.

"I don't want to scare anyone, and I don't think it should be scary," he said. "People should just be aware that a lot of people are invested in making it happen, and it likely will happen at some point. Also, it just makes sense in how everything is going this way. And AI is a huge variable when it comes to almost anything. Take, for example, illustration. Now almost anyone can text to generate image. How many illustrators are not freaking out right now? And writers, too. Of course, automation and AI machine learning are going to change many things. It just takes individuals to collect the data, and then you're going to have things that are a little more streamlined for manufacturing and things like that. It's an inevitable evolution at this point. It doesn't seem like things are going to go backwards. So that's the reason I'm like, 'Well, might as well invest some time and energy!' I'm not saying one method's better than the other or even one digital method's better than the other. Or one traditional method's better than another. Just continue to learn. It's lifelong learning. Take it in. Maybe you can do something faster and better and cheaper in your own labs with technology that maybe you never thought you could."

I was ready for a new eye right about the time I talked with Etheridge. I was not interested in a 3D-printed one even if someone could print me a really great one. I thought about my preferences and my previous experiences when I was on my way to Rochester on a late fall morning in 2023 and as I stopped

again at the Montezuma National Wildlife Refuge and walked the Seneca Trail. Clouds hung low, and because it was closer to noon than to sunrise, most birds seemed to have gone back to bed. The trail begins near a starkly charismatic sculpture of two herons, swooping feathers crafted in silvery metal, in and above a nest of oxidized iron. Around the trail's first bend is a tower, thirty or forty feet high. From its upper platform, I gained a look at the refuge's wide vista. An expanse of grasses and marshes and ponds. Stands of trees in red and orange a half mile or more away. At the far horizon, silent in its distance, the New York Thruway, with tiny eighteen-wheelers sliding east and west. Farther along the trail, milkweed stalks were laden with pods, both opened and still shut in their bulbous pointiness. Red honeysuckle berries clustered amid green leaves edged in yellow. Deeper in a stand of woods, thick moss was emerald on the leaning trunk of an ash. On the Erie Canal, which runs through the refuge and the trail skirts, a lone gull bobbed.

I'd had my initial prosthetic for fourteen years, and I wanted to feel the quiet and the autumn richness of the refuge as preparation for replacing it. Michael Strauss and I had been talking about a new eye during my past few annual polishings. The old one—"Old Faithful" Michael would call it when I got to his office—was still as shiny and solid as it had always been. It could last years longer. But the landscape of my socket had changed. The deterioration wasn't a glaring one. In fact, sometimes I would look in the mirror and see nothing much different. More often, though, especially in the morning, the eye would be hunched down in its seat like a student who doesn't want to be called on.

I'd heard stories of people keeping the same eye for twice as long as I had mine, but those were rare exceptions and, according to the ocularists who described those cases, not always the most considered choice. The typical time between plastic eyes is five to seven years. I'd had a run of good fortune.

To be honest, I didn't need perfection. But I also didn't want to let the eye get to the point where it was slipping in the socket like a transmission with 200,000 miles on it. And I had the unfounded fear that if I waited too long, Michael and Michelle would take an early retirement or become computer programmers or move to Costa Rica. I had twenty years on each of them but also a selfish interest in their continued good health and that of their business. Getting a new eye was no emergency, and it wouldn't provide anything like the jump from my bad eye to my first prosthetic, but it would set me up for, I hoped, another decade and a half.

In that familiar parking spot outside Strauss Eye Prosthetics, I confirmed my decision in the rearview mirror. Whether what I saw was only what I was looking for to convince myself the trip was necessary or the change in appearance was truly there, I was going in. And I was only partly assured of my choice when I was in Michael's exam room and he told me about an exchange

he'd just had with Michelle. I had said hi to her on the way in, and then Michael had gone to check with her on the timeframe for the painting, which I would come back for in a week or so. "She was like, 'Yeah, Dan looks absolutely amazing,'" he said, "and I was, 'He does, but I think he can look *way* better.' So, we're looking for way better, not slightly better or close enough. We're looking for as close to perfection as one can get."

"That sounds like a good goal," I said, contradicting what I'd said to myself in the car.

"That's what I'm going for," Michael said. "I think it's obtainable."

The day's process was as familiar as that parking spot. The major difference was that Michael no longer used alginate to get an impression. When he oozed some goopy material into my empty socket to capture the initial shape for a mold, it was vinylpolysiloxane, or VPS. He had been using it for several years and called it "revolutionary to the things I do." Alginate is moisture based. VPS is not and so doesn't draw moisture off the conjunctival tissue or the cornea, which is what can create the stinging sensation patients sometimes feel with alginate, he explained. Alginate requires mixing together two components: get the ratios wrong, and you can end up with a different consistency and hence a different mold. VPS always comes out exactly the same, and a mold made from it retains its shape for much, much longer—perhaps years. An alginate impression would shrink to half its size or less within a week if left out of a wetting solution such as distilled water. Using VPS, Michael said, he could do an impression on a child who's under anesthesia in an operating room in Buffalo or Syracuse and then on the drive back to Rochester "can do the speed limit and not worry about whether the impression is going to be degraded an hour later."

VPS "is about eight or ten times the cost of alginate, for sure," he said, "but if it were twenty times more, I'd still use it."

When the VPS had hardened—more quickly than alginate—he eased it out of my socket. It looked like solidified Silly Putty. The concave interior, which had been against the socket's tissue, was shiny, and the convex top was covered by a dozen or more short, cylindrical, flat-topped nubs evenly spaced, where the VPS had oozed through holes in the impression tray. It was periwinkle. It was 1.5 millimeters thicker than Old Faithful.

"The mold doesn't lie," Michael said. "You definitely have more orbital volume."

He left for a while to make a wax mold. He inserted an iris button onto the front of that, then spent half an hour or so trying it in my socket, taking it out to shape with his little knives and his torch, evaluating and tinkering.

"The main focus for me right now is position and volume," he said. But he also had me look up, down, left, and right. "Way better movement," he concluded.

Then I drove home, the old eye back in place for its last stint before being put in a drawer or attached to a chain for a necklace or placed under my pillow for the Eye Fairy to take and leave me all the money that my insurance company—more tight-fisted than many insurance companies—was not going to pay for its successor.

I went back to Strauss Eye Prosthetics to meet Michelle on a Monday morning.

"They say you should never take your car in for repairs on Monday morning," I said. "Mechanics are not in a groove yet."

"That doesn't apply to eye painting," she said. "The first appointment is the freshest. I'm all ready."

First, though, an announcement of one big difference since our long afternoon together all those years earlier. Michelle no longer painted with the patient in the room. The COVID-19 pandemic had seen to that, at least temporarily, and she hadn't gone back to the old ways. During the worst of the pandemic, she decided not to wear a mask while painting for fear it would absorb too many of the volatile organic compounds given off by the paints, even with a good ventilation system. "It would be like soaking a sponge and then putting it over your face," Michael explained to me later. So Michelle began painting alone, then masking and meeting with the patient in a different room to check her progress every thirty or forty-five minutes, then going back to painting alone, unmasked. This approach worked in large part, she said, because camera phones had gotten so good that she no longer had to worry about colors being off in pictures she used to get printed at the local drugstore.

And, she discovered, it allowed her to concentrate better. As Michael would tell me later, some patients who liked the one-on-one could also slow down appointments too much by saying things like, "Did you see my Facebook page? Look what I was doing last weekend." And Michelle would think: "Well, if you want to hang out, why don't we book a time on Friday night or Saturday? We'll go to a restaurant or a bar. But if you want me to work, you have to give me the time to do it."

I liked the one-on-one, to kind of hang out. When I admitted my disappointment about not exactly repeating the therapeutic experience I had the first time, Michelle said that no one else had told her that.

"Mostly people really don't like the long eye contact," she said.

But she also did compliment me on being easy to work with, which made me feel less saddened.

"Usually that's the part that's difficult, the person, not the eye," she said.

"Because they're anxious?" I asked.

"That, or they're uncooperative," she said. "I don't think it's intentional, though sometimes it is. But mostly it's just like a tension, a squeezing down so I can't get the eye in, especially with children. Yeah, I guess anxiety would cause that. For some people, I think it's a reflex. A lot of people won't look at me. They will not make eye contact, and that makes it hard. And some people don't like their picture taken, either. Other people are really sensitive. I put the eye in, and then their eye immediately starts watering, and they're crying, and they can't look up, they can't open their eye."

I was perfectly good when she took my picture, when she stared closely at my old eye, saying out loud that she thought the sclera might need a little more gold on the nasal side, that the pupil might need to be smaller, that the center field probably needed to be lighter. I was cooperative when she asked me whether I wanted a patch and some tape for when I sat in the waiting room because she would need to take my eye with her, and she didn't want to keep putting it in and taking it out, anyway, because that could irritate the tissue and swell it a little, and then Michael would be fitting the new eye to swollen tissue. I declined. I'd sit in the reception area unpatched.

Michelle called me back two or three times for progress checks. Each time we chatted casually and without rush. She explained everything she was doing. We talked about where to eat lunch in Rochester. She told me this new eye was going to be so much better, that she wanted it to be perfect. I forgave her.

"What colors are you using?" I asked. I was remembering what she'd said with my first eye, that blue is not blue but an impression of lots of other colors. That, she said, hadn't changed.

"I'm using gray, raw umber, black, white, yellow—three different yellows—orange, possibly a little bit of marine blue," she said. "Even though I'm sure you say you have blue eyes, and you do, there's very little blue in a blue eye. Almost none. It's the weirdest thing. I use more blue in the white of people's eyes than in the blue of a blue eye. It's a highlight, but it's not a base. I used to float blue over the top when I was done, and even that's too blue, usually. So now it's more just highlights. The blue, I feel like it's more of a reflection than it is a pigment. I don't know all the anatomy of it. But I know that I don't use very much of it in terms of paint, which when people did watch me paint used to make them very upset. They were like, 'You're not using any blue! Why aren't you putting any blue in my eye?' I was like, 'It doesn't work that way.'"

"What changed?" I asked about the new eye during her final check, just before I would go get some lunch while Michael processed the eye, which would take a couple of hours.

"Not much," Michelle said. "They do look very similar. I would say it's the fit, not so much the color. I think the limbus is a little softer. The pupils are the

same size. And I know I said that your sclera needs a little bit more color, which I'm going to do. But I thought the other eye looked good. When Michael said we were repainting your eye, I was like, 'What? Why are we doing that?' Because I saw you when you were here last week, and I was like, 'You look really good! What are you doing?' But in terms of the fit, I do see it."

"It probably feels fuller," Michael said when he put in the nearly finished eye to let it settle while he wrapped up Old Faithful and gathered a bottle of lubricating drops and a new suction cup for when I wanted to remove the eye, though even after fourteen years I still never took the eye out because the idea of looking at my socket in the mirror would go completely against my very deep wish for the eye not to call any attention to its fakeness. I'm happy to continue to be fooled by the eye, to live within my comfortable illusion. But this one did feel fuller, and when Michael gave me a mirror, it looked better, too.

We lingered, talked about how busy he'd gotten lately because during the pandemic many of his longtime patients, ones who had been putting off replacements or just polishings, noticed their eyes more because that's what really stood out when they were masked.

"And they go, 'Wow, my eye doesn't look as good as it did,'" Michael said. "So people started to say, 'I have to do something with that prosthesis that I had made ten years ago or five years ago.'"

As we were winding down, I understood that the experience of getting this second eye had to be more muted than the experience of getting the first. I was no longer undergoing the same kind of transition, had not just recovered from drastic surgery, was somewhat removed (though never completely) from an unrelenting self-consciousness. This was more of a continuation, a maintenance. It was certainly more significant than, say, replacing a stove or a favorite pair of jeans that had worn through because this was an eye, the small object that determined—in a radically different direction than had my bad eye—the shape of so many moments in each of my days. I still felt grateful for the eye's ability to do that, and I didn't take it for granted. Yet Michael gave me a helpful reminder when he told me, as we were walking down the hall to the front desk where I could pay my bill, about a recent patient, a woman who got a scleral shell and went from initially saying such things as "This can't work" and "Life is horrible" to walking out of his office "in a way that you would never say that they're the same person," as he put it. "It's amazing to me," he said. "It's unbelievable. It's the best part of what I do, to see that transformation."

8

Care

The four or five artificial eyes a dentist made for Tracey Morgan-Harris throughout her childhood looked "okay," at about the level of a $10 haircut. She wore them from preschool up through middle school and well into high school, each replacement eye bigger because her whole body was growing. The dentist, skilled with teeth, was winging it outside of that domain. Because he wasn't an artist, he didn't create fake eyes that matched Tracey's real eye but instead aimed for what he thought an eye *should* look like. He did go well beyond simple cartoon eyes, a circle of solid black surrounded by a ring of one-dimensional color, something even a kid could paint. But he never captured the complexities of Tracey's natural eye, with its iris's variegated swirl of intersecting and overlaying colors—an impressionist's mix that wasn't hazel but added up to that—and with its depth and moistness, its *soulfulness*.

Tracey had lost her real eye, the left one, early on in her life. When she was only four-and-half months old, retinoblastoma, a tumor, showed up on the schedule of a baby tooth. Doctors and her parents opted for an enucleation, the quick removal of the eye so as to keep its trouble limited to within its own boundaries. To fill the new emptiness: a prosthetic. Tracey's sequence of prosthetics allowed her to avoid growing up with an unoccupied socket shading every one of her social interactions. As an adult now looking back on those youthful years, and now as the doctor she has become—a pediatrician and neonatologist—she appreciates the dentist's efforts, imperfect though his results were.

"He was trying his best with the unfortunate patient that was in front of him," she told me.

She remembered, too, that the dentist knew his limits as an eye maker. "If there's someone else," he would often say to Tracey and her parents, "I will send you to them because this isn't my area of expertise."

A prosthetic eye too loose in the socket can dislodge as easily as a button popping out of a stretched-out buttonhole. For a few months when she was

four, Tracey went to a Montessori preschool staffed partly by Filipino nuns. Her eye would fall out, or she would take it out on purpose, but she wasn't old enough to know how to put it back in. The nuns didn't want to either, so they would call Tracey's mom and say, "Tracey, eye out." At that stage, Tracey had no self-consciousness about her removeable body part or about how she looked without it, and the other preschoolers didn't care, either, any more than they noticed each other's runny noses or untied shoelaces.

Soon enough, though, self-consciousness burgeoned, and a fake eye added complexity to a kid's place among her peers. Tracey realized that her party trick—being able to make her eye fall out simply by looking off to the side— was "both good and bad" for her social life.

There was, for instance, a mortifyingly clichéd moment in the school cafeteria in fourth or fifth grade. Her eye plopped into her plate of spaghetti and meatballs. It happened just as all the kids, those who'd brought their lunches and those who'd gotten the school meal, were settling around the long table and checking out what everyone else was eating. Tracey dissolved into tears. Kids sitting near her screamed. Her mother came to pick her up and told her she could stay home the rest of the week until the dentist could make a new eye that fit better.

When Tracey was midway through high school—a forbearing teenager, though not without what she remembers as "a good deal of bitterness and grumpiness"—she finally told her parents, who agreed with her, that "this dentist thing wasn't working out." She was tired of her mother telling her to stop letting her hair hang over half her face. ("No one can see you!" her mother said, and Tracey thought: "That's the point.") They searched farther afield for a true ocularist. There was one, they'd heard, in Atlanta, a four-hour drive away. They'd known about him for a while, but the trip hadn't been feasible, not when they would have to make it every time Tracey needed a new eye or an eye polished or an adjustment. (The other hard fact of Tracey's early childhood was that her identical twin sister also had retinoblastoma in both eyes, was treated with radiation rather than with the removal of her eyes, and died at nine from a secondary brain tumor. She had been the family's medical priority.) But Tracey's parents understood the quality possible from someone trained and experienced in the art and not just the rudiments of artificial eyes. Tracey's very first eyes, when she was one and two and three years old, had been made by an ocularist. The family had been living in Hawaii then, and there had been one ocularist in that state. They had saved those old eyes like souvenirs.

The Atlanta ocularist made her an eye that, like those from her early childhood, was subtle in its artfulness, intricate in its coloring, as close a replica of

her real eye as she'd ever had. But like a professional carpenter hired to do renovations on a house built and previously repaired in haphazard and amateurish ways, the ocularist told Tracey there was some neglected work she'd need to catch up on before he could make her an even better-fitting and more comfortable eye. She would need to have her implant replaced.

Tracey's implant was glass, a baby-sized marble installed when she was a baby. It sat cuddled in her socket tissue. But as she grew, the implant stayed where it was, producing less and less of a convex geography for the prosthetic to rest on, like a rock slowly disappearing under a heavy snow. The dentist hadn't realized the implant ought to be replaced with a bigger one. Instead, as her socket grew, he simply made each successive acrylic eye bigger. Bigger meant heavier. Heavier meant it was harder for Tracey's eyelids to hold the prosthetic in place. Hence the falling out. And, hence, an unnatural stretching out of her eyelids—another problem that would need to be surgically repaired later.

So she had the right-sized implant installed. It was made of coral. Once she healed, the ocularist made her another eye.

"That was very nice for a teenager," she recalled about going from having a "superobvious" fake eye to having only that small looseness in her eyelids.

That eye got her through college. A year or two into medical school, she was probably due for another replacement but had no time to get it done. The implicit message for med students, she said, was "You can go and do whatever you need to do as long as you don't."

Then, however, she matched for a residency in pediatrics at the University of Iowa Hospitals and Clinics and discovered that the small college town of Iowa City is to ocularists what Key West is to bartenders. There was an abundance of them—strange for a town of 70,000, half a day's drive from Chicago, St. Louis, and Minneapolis and in the middle of what feels like infinite corn and soybean fields. But Iowa City happens to have been the longtime home and workplace of Lee Allen, once called "the greatest ocularist in the history of the profession."[1] As the original staff ocularist at the university hospital for forty years, he had been a center of gravity in the profession, taking on apprentices and spinning them off as well-trained ocularists. Some stayed local. When Allen retired from the hospital in 1976, one of his former apprentices joined him in opening Iowa Eye Prosthetics, Inc., which is still going today, though Allen died in 2006, and which has the slogan "We specialize in special eyes." The other ocularistry lab in town, Yeager Ocular Prosthetics, was started by another of Allen's former apprentices.

"There's like seven or eight, which is insane," Tracey said, numbers comparable to those of New York City and Los Angeles. "It's like going from

'There's one within four hours if you're lucky' to 'Eight! And they're right next to your house!'"

Faced with so many options, and as busy in her residency as she had been in med school, Tracey chose Iowa Eye because it was on her drive from home to the hospital, and it had an appointment available earlier. Of the three ocularists on staff there, Tracey ended up working with the youngest, a woman who had been making eyes for a bit more than a decade and whose path to that initial meeting with Tracey was nearly as circuitous as the one Tracey had taken.

Lindsay Pronk grew up in Iowa City. Her mother had for a time been married to Lee Allen's business partner, the man who'd started Iowa Eye with him. Nonetheless, like many young people who don't pay much attention to the specifics of what adults do for livings, Lindsay had only a hazy familiarity with eye making. Her own early artistic bent leaned not in the direction of eyes but of food. She liked creating things in the kitchen. At nineteen, she went to Florida to attend culinary school. She earned degrees in international baking and pastry as well as food and beverage management. She worked in a cute French bakery there, making breads and rolls and tarts and ornate desserts for all the tourists. She got married. Eventually, though, Florida lost some of its appeal. She longed to be closer to her family. She and her husband moved back to Iowa, but she found that for all its cultural riches as a college town—the bookstores, the music scene, the decent number of good restaurants, the theater and performing arts—Iowa City at the time did not have a bakery that could put Lindsay's pastry skills to best use.

"The bakeries that they did have," she told me, "it was all frozen. So you just pull it out of a box and throw it in the oven, and, boom, you have artisan bread. It just wasn't what I was looking for."

Nor did she want to decorate cakes at the Hy-Vee grocery store. For a few months, she barely survived the boredom of an office job. Then she began thinking about eyes and about the work her mother's exhusband did. She asked him if she could come to the office and observe. He said, "Sure." As she watched the fitting and the molding and the painting, one of her first thoughts, she said, was, "Oh, yeah, okay, so this is similar but different." Here was intriguing work, full of interesting potential she never really had reason to consider. She signed on as an apprentice. She completed workshops offered at the ASOs' annual conventions. She passed an exam and was named a board-certified diplomate.

"When someone asks me, 'Do you have a science background?,'" Lindsay said, "it's like, 'No! I did baking and pastry!' But when you're fitting an eye,

it's sculpting. Sure, you have to understand the mechanics of how things work, and there are some rules about fitting and making sure you don't do any damage, but it's essentially an art. With baking, you have to be very technical with your recipe or things don't turn out right. But once you get the recipe down, you can make it look however you want. It's kind of the same with eyes. Mostly it's 'Do whatever you need to do to get what you want your final product to look like.' I'm still creating something, and it's different and it's beautiful. It just happens to be out of plastic instead of food. And creating an eyeball is the same satisfaction I get making a beautiful cake. Because it's like, 'I did that, look how nice it is.' And also helping people, which is nice."

The first eye Lindsay made for Tracey was designed to address the looseness in Tracey's upper eyelid. Until Tracey had enough time in her schedule to get the outpatient surgery that would tighten the lid permanently, it needed help staying up. So Lindsay sculpted an eye with a "ptosis shelf." *Ptosis* is the medical term for a heavy or droopy upper eyelid.

If you look at a typical prosthetic eye from the side, the front of it is rounded like a real eyeball. "But when we do the ptosis shape," Lindsay explained, "we actually cut into the upper half of the eye so that lid basically has a spot to sit on."

The person can still blink mostly normally, but when the lids are open, the shelf serves as a little crutch. (A ptosis shelf is also often called a *ptosis crutch*.) If the eyelid's droopiness becomes more pronounced, the ocularist can make the shelf wider by making the eye thicker. There's a limit to that approach, though, because too much thickness would make it difficult or impossible to blink. The prosthetic eye would become as irritatingly dry as would a real eye.

Just before Tracey did eventually have the lid surgery, Lindsay removed the excess material from the front of the eye and filled in the shelf with more plastic. The side view of the prosthetic was then the normal little hillock of a natural eye. The surgeon could adjust the eyelid to rest at the same level on the prosthetic eye as Tracey's other upper eyelid was resting on her real eye. Symmetry.

Lindsay moved on from Iowa Eye in 2016, not long after beginning to work with Tracey. She became the staff ocularist at the University of Iowa Hospital, Lee Allen's old position. The hospital gave Lindsay a new lab in the Pomerantz Family Pavilion. She amused the money people, she said, with her budget for start-up costs and yearly operating expenses. Everything she needed— alginate, veining thread, eye jars, monomers, wax, mixing bowls, paints, paint brushes, molds, felt buffers, suction cups, and dozens of other items—cost a

fraction of the price of, say, one slit-lamp ophthalmoscope. The lab happened to be almost directly below the neonatal intensive-care unit where Tracey was working. And because Tracey was on the night shift and the hospital air was kept unnaturally dry, her eye began to feel ragged more quickly than it might have in other conditions. She could pop down for a polish every three months or so instead of the usual six or twelve months most eye wearers wait.

It takes twenty minutes to polish an eye. Because Tracey and Lindsay, as they both admitted, liked spending time chatting, they sometimes had to remind each other that other patients were coming in for their own appointments.

But if Lindsay were making an eye for Tracey, they had the hours that slow and deliberate work requires: the molding, the shaping, the painting. Tracey described those visits as "like going to an artist's studio, and I'm just going to relax and talk while they do their work." Lindsay called them "more just like hanging out with a friend for two days, while being productive at the same time." This kind of companionability is common among ocularists and patients, though of course it's not inevitable. Some people aren't looking for or don't need more than a direct transaction. "And so the two days of eye making kind of come and go," Lindsay said of such instances, "and I do my part, and they're happy, and they go home happy, and that's great, but that will just be the relationship. And that's fine."

But the slow nature of ocularistry often does lend itself to opportunities for conversations that transcend the superficial—in part because of the necessary and extensive eye-to-eye contact. As other ocularists in addition to Lindsay have told me, many of them feel that an essential aspect of their work is to recognize the experience of a loss that can go to the core of self-identity. Whatever led a patient to be in need of an ocularist's talents was probably agonizing and harrowing: a failed suicide attempt, a drunk-driving accident, a battering from an abusive partner, a mugging, a hockey puck, a fistfight, diabetes, a golf ball (don't look up when someone yells, "Fore!"), the long needle of a rosebush, a pop-bottle rocket, the clichéd but still dangerous BB gun. I heard of one woman who was leaving the house to go for a drive and asked her dad to toss her the keys. It was a gentle toss, but she missed the catch. I heard of a guy gored by a steer; of another who yanked a poster off a wall and had a thumbtack hit him in the eye; of a kid who was running with a candy cane and fell forward on it; of a plumber who was drilling a hole through a low brick wall and leaned over the wall to check on his progress, only to drill out his own eye.

Emotional damage for someone who has lost an eye is usually raw and unhealed. Even in the most straightforward cases—an eye removed surgically because of cancer or, as in my own instance, an eye I willingly sacrificed—the

experience for the patient is frightening and uncertain, one more step in what has often already been anything from simply distressing to horrific.

Combine any of those circumstances with the long hours an ocularist and a patient spend in each other's presence, and opportunities for openness range from the casual to the heartrending. Also, in the most successful instances, when some small or large emotional and psychological healing comes directly from the making and presentation of a handsome and realistic artificial eye, ocularistry becomes a profession defined by a rapport like the one that grew between Lindsay and Tracey.

"When you spend that much time with a person in that close of quarters, you just really get to know each other," Lindsay said.

She told me of a similar closeness with another patient. A young girl born with microphthalmia was two weeks old when Lindsay began working with her. There were appointments every few weeks for months and then less frequently but consistently as the girl grew. Even after the family moved a thousand miles away when the girl was five, and even though there are ocularists closer to that family's new home, Lindsay remains their ocularist. The family makes the long trip back as needed.

"I FaceTime with them all the time," Lindsay said, "because you're kind of going through it with them. When a person loses an eye, or if the parent of a child that I'm working with, it's a process. So, sure, I'm making them an eyeball, but sometimes there's just a lot of therapy that happens at the same time. I've been doing this a long time, but the people I work with, this is all new to them. They don't know anything. So I have a long-term perspective as far as it's going to be okay, and I can tell them stories or anecdotes of other patients and how they handled things or how they went through it and just try to be kind of understanding, but when it's that intense, too, you can't help but remain connected."

When I'm in Michael Strauss's office, we talk about all kinds of things, from sports to being fathers to the impact of his work on my life. But here's my experience as a patient in that office, whether for a polishing or a much more extensive eye making: I come out feeling more cared for, more seen, more healed (each time, amazingly) than I've ever felt after a visit to any doctor, after any hospital stay. This is not to dismiss the exceptional care I've been fortunate enough to have gotten elsewhere when I've needed it: the surgeries, the physicals, the vaccinations, the drugs to ease the pain of kidney stones, the stitches and prescriptions, the cleaning out of impacted ear wax. Nor is it to diminish the sincere concern and attentiveness my primary-care physician has shown during the twenty years I've been seeing her. I'm lucky that every

lump and tightness and weird patch of skin I've asked her to diagnose has been innocuous, that I've so far dodged the catastrophes, that my visits have been mostly routine. But she's beholden to the pinball-like demands of her field, attending to one patient after another from morning until evening, treating whatever condition or disease or accident or worry someone brings through the door, caring for all parts of the body and mind, and referring patients to specialists when they need more extensive care. That reality probably lands the duration of my times with her pretty close to the eighteen minutes that research shows primary-care physicians in the United States spend on average with each patient.[2]

Here's a story Michael told me about how the making of eyes can transcend the technical and simple providing of a product. He was in a store buying a lantern before the arrival of a big storm predicted to bring power outages. The man who waited on him had an eye that was shrunken and barely visible. Michael knew he risked offending the man by calling attention to his eye, but he spoke anyway.

"I think I can help you," he told the man.

"You think you can help me?"

"With your eye. I don't mean to pry or anything, and if you're not interested, just tell me, and I'll just go another direction. But I can help you."

Michael gave him his card, explained what he did for a living—that he makes not only prosthetic eyes that replace eyes that have been removed but also scleral shells, which are thinner and fit over shrunken eyes and don't require surgery.

"Are you serious?" the man asked. He said he had never heard of anything Michael was describing.

Michael told him they did free consultations. He offered to pick him up if he needed a ride.

"And we sat in the aisle and probably talked for I bet twenty minutes or a half hour," Michael told me, "about how he was divorced, fifty-two years old, been in and out of jobs, trying to hold a job, always in the back of his head thinking when he met somebody: 'Are they looking at my eye, or are they looking at me? When I go for an interview, am I not getting the job because of the eye? Am I divorced because of the eye?' It was so emotional right there in the aisle, and I'm shocked that it ever went down that way. I said, 'Come to the office. I can show you what I can do, and we can go down that road if you want. I'm willing to work fourteen hours just on you to show you that we can do what I'm telling you we can do.'"

The man did come to the office. Michael made him a scleral shell that matched his good eye, gave a balance to his face the man hadn't had since

he'd injured his eye when he was three years old. He became a regular, returning for polishes, for a replacement as needed.

"Every time I see him," Michael said, "it is right back to being in that aisle talking. For fifty years, he'd lived his life knowing that's just it, that's the way it is. He'd said, 'You know, I've accepted who I am and what I look like.' But he also couldn't help feeling embarrassed for his family members or for the woman he was dating and eventually married. He said, 'I knew she loved me, and I knew it had nothing to do with the eye, but whenever we went to a restaurant, I always wanted to be the best I could be for her. And here I am with a damaged eye, and they're looking at my eye, and I'm always questioning whether they're thinking, "Wow, she could do better with somebody else. Why is she with somebody with a damaged eye?"' After he got the scleral shell, his oldest daughter was getting married, and he said, 'You know what? In pictures it's always been "This is my eye, and this is the way that it is." But now when my daughter gets married and we have pictures, I don't have to worry about people going, "Why does your dad's eye look like that?"'"

And here's a story that Jim Strauss, Michael's father, told me. A woman had recently undergone one of the most dreadful months imaginable: her son was shot and killed in a store robbery; two weeks later, her husband died of a heart attack; and right after that, she was hit by a car while she was going to church and lost her eye.

"All within a month," Jim said. "Okay, she comes into my office, and she needs an eye. And the first thing out of her mouth is, 'You know, I don't know why I'm here.' She says, 'The last thing I need is this stupid eye.' She said, 'I don't care about an eye. The doctor told me to come here, and why am I doing this? Because I've seen people that have [prosthetic] eyes, and they look like freaks.'"

Jim told her, "Let me make you an eye. Let me show you what I can do." He said he was thinking two things: that God needed to help him come up with something to say because he wasn't a psychiatrist and that he had to make this woman a really good eye.

"And all the time we're making the eye, she's angry," Jim said. "She's very angry, and she's letting me have it, right? Right and left. She just kept it up. She kept saying, 'You don't know what I'm going through.'"

He agreed every time.

He worked to get the fit as perfect as it could be, the painting meticulous. He listened. Near the end of the process, the woman spit out her accusation for the eighth or tenth time. Jim was hesitant about turning any attention on himself or appearing to claim even the smallest bit of equivalency with her trauma, but it seemed to help when he told her that he'd become an oculartist

because a family member had lost an eye as a teenager and had struggled with finding a prosthetic that looked at all natural. Jim had seen the doubt, the difficulties, and the disappointments closely enough with someone he loved. But over and over with his many patients, he had seen the healing power of a good artificial eye.

"I'm not denying that your problems are pretty severe," he said to her. "I just hope that what I've done for you, giving you this eye, will help."

He told me: "Okay, she's crying, and I'm crying, and we're hugging each other. That was pretty emotional for me. She wrote me a letter about two or three years later. Beautiful letter. I'm getting a tear in my eye just thinking about this. She said she was doing social work in a hospital, and at the very bottom she goes, 'p.s., I want to thank you for saving my life.' And I'm like, '*Wow.*' I have never been told that. So, it's a little piece of plastic," he said about an artificial eye, "but, boy, it brings out a lot more in people that they just don't realize is there."

As a doctor within a medical universe of immense complexity (specialties, subspecialties, sub-subspecialties), Tracey Morgan-Harris was primed to notice what she called "the ancillary things that are absolutely a hundred percent necessary if not even more necessary than the doctors and the nurses." This awareness resulted gradually, she said, from having been to a lot of eye-making sessions in her life. Her initial understanding of ocularistry, even after she completed med school and was in her residency, was still elementary, maybe similar to what a person who goes for yearly vaccinations knows about immunology. She'd always been a typical patient, subjecting herself without much questioning to the work of someone who seemed an authority, even when that authority was tenuous. What she did know from personal experience was that "there were people who were ocularists who made eyes. And you wanted to get ocularists; you did not want to go to someone else because it just wasn't as good." Once she became Lindsay's patient, she was primed to better see and appreciate ocularistry's existence as a vital little ancillary solar system on the edge of that infinite medical universe. She was more capable, too, of understanding the quality of Lindsay's work, which she described as having a level of perfectionism that's "a little scary."

"There was one time she was doing an eye, and I thought she was done," she recalled. "It looked really good. I thought it looked great. And she was like, 'No, I don't like it.' I remember she made me come back. And I'm like, 'Okay, I'm not going to tell an artist that she cannot do whatever she wants.'"

Lindsay laughed when I repeated that to her, but she also copped to that fussiness.

"I always joke that it does come to a point where it is no longer about what the patient wants," she said. "It is about what I want. You have to leave with this, and I have to be happy with you leaving with it. And I will say, 'I just need to do one more thing.' I've been known to say 'one more thing' for an hour. Just *one* more thing. Just *one* more thing. If I don't care, or if I care just enough, then I can finish the eye two hours earlier than maybe I should."

Care is a word that comes up often in conversations with ocularists, as it does in all medical arenas. Ocularists often use the word as Lindsay did: the act of giving full attention to the quality of their work. They just as often mean caring for the person who has come to them for help. Anyone who has been caught up in the immensity of a sprawling medical system—with its bureaucracy, paperwork, number of patients, the mere eighteen minutes per visit—probably understands how care is always at risk of becoming merely functional and impersonal. During the past few decades, the response to those dangers has been a move toward patient-centered care in which "providers treat patients not only from a clinical perspective, but also from an emotional, spiritual, social, and financial perspective."[3] The American Association of Colleges of Nursing prefers the term *person-centered care* and describes it as "more holistic and inclusive of family, significant others, context, prevention, promotion, and preferences."[4] In both versions, the patient is seen not simply as a passive receiver of whatever treatment someone else decides is right to provide but also as an empowered and respected participant in the process.

Ocularists are not clinicians. They don't diagnose and treat disease. Yet the field is almost naturally and necessarily patient centered and person centered. The work is individualized because it is extensively one-on-one. It's a profession that seems undergirded by what moral philosophers call an "ethics of care." At the heart of this theory is a belief in the moral significance of relationships. (In contrast, other common moral theories prioritize justice.) The philosopher Nel Noddings, who was one of the first to articulate an ethics of care in the 1980s, proposed that "care" should be thought of in two forms: "caring for" and "caring about." The first is the tangible work: for an ocularist, making an eye. The second, according to Noddings, "must be seen as instrumental in establishing the conditions under which caring-for can flourish. Although the preferred form of caring is cared-for, caring-about can help in establishing, maintaining, and enhancing it. Those who care about others in the justice sense must keep in mind that the objective is to ensure that caring actually occurs. Caring-about is empty if it does not culminate in caring relations."[5]

Adhering to an ethics of care can require a caregiver to, say, talk with a patient for thirty minutes before starting any treatment, to hear what needs

the patient is expressing. But an ethics of care can be in stark conflict with demands for efficiency.

Ocularists do not get formal training in moral philosophy. It could be, then, that ocularists simply tend to be nice people who are naturally empathetic and kind. Perhaps the work itself invites its practitioners to be that way.

"But you do have to care," Lindsay told me. "You have to genuinely care about the person and be patient because not everyone reacts the same way to eye loss. There are some people that are, 'Great, let's move on, I'm ready to get going.' And then I have people that it was just very traumatic for them, emotionally. They weren't ready to lose the eye, and they're never really going to be happy because the prosthetic is not their eye, and they weren't ready. There is a grieving process. Kids, they're resilient, they're fine. But patients in their seventies, eighties, nineties, it changes their entire life simply because it can affect their balance and how they move around in the world. But I can say to them: 'Be patient with yourself. It takes time, everything is time.'"

For her, this kind of care is not endlessly and unrelentingly polite. Care also sometimes means bluntness. "Now, after a couple of years," Lindsay added, "if they're still coming in and, you know, 'Woe is me, my life is so hard,' then we have a little bit of a 'come to Jesus' talk about things."

Jim Strauss adopted that same kind of frankness when he told his patient she was going to have to get through the many troubles that had been loaded on her.

"Just care as much—and authentically care—as much you can," Lindsay concluded, "and be understanding to how everyone journeys through the process—whether they're skipping ahead and they're happy or whether it's really, really tough."

Midway through Tracey's residency, Lindsay did make her that new eye she was so finicky about. The color of Tracey's real eye had changed slightly, the white getting a little more yellow. That happens to everyone but isn't usually noticeable if both eyes are changing together. And the tissue in Tracey's socket had resettled again. Tracey would arrive for her eye-making appointment in the morning after a graveyard shift and fall asleep on the sofa whenever Lindsay was doing something else that didn't require Tracey's sitting upright. Lindsay would wake her up as needed.

Then Tracey's residency at the University of Iowa Hospital ended. She was faced with the possibility of moving to a place far from Lindsay and maybe far from any other ocularist. It wasn't likely she would have the same surprising luck she had when she moved to Iowa City. Any move, no matter to where, would force her to consider her loyalty to Lindsay—not a business-type

loyalty based on money but her own psychological commitment to being Lindsay's patient because of the comfort, because of the care, because of her knowledge about the quality of Lindsay's work, because of the relationship the two of them had formed.

I have talked with many eye wearers who swear to that kind of commitment to their ocularist, often because the initial experience of having someone make their first eye was the start of a healing on so many levels. Eye wearers tend to stick with the same ocularist for decades, even when that might not be the most convenient choice. These relationships veer toward the deep and long-lasting, not least because there are great expanses of the world where no ocularists exist.

It's possible, of course, to switch ocularists, just as people switch doctors and hairdressers and yoga teachers. Even in a field as small as ocularistry, skills and satisfactions vary. With the internet, it's easy to shop around. I've come to trust, through my talks with many ocularists, that there are plenty of extremely talented ones out there. A "scary" level of perfectionism is not atypical. Nonetheless, I'm glad the odds are that I won't need to search elsewhere.

Nevertheless, questions of allegiance arise, as it did for Tracey in a big way, as it did for the young girl with microphthalmia and her family and as it did, in a small but surprisingly powerful way, for me recently. I was in North Carolina interviewing the ocularist Anna Boyd Jefferson. She and I talked for two hours at a coffee shop, a lively and interesting chat that had made me feel the same way I'd felt after so many talks I'd had with other ocularists: envious of their enthusiasm for and love of their work. She then took me to her business a few blocks away and gave me a tour of the exam rooms, the fabrication lab, the children's room. She introduced me to everyone else who worked there. She gave me a sample-sized bottle of an artificial-eye lubricant I hadn't tried. She showed me a painting done by one of her patients, which was hanging on the wall in a hallway. It was of a nude figure, shown from the back and from the waist up, with a long, curved neck, the head dominated by one blue eye as big as a trout, stretching from ear to ear and from the bridge of the nose to the upper forehead. Upper eyelashes swooped in long arcs into the air above the head. A single tear was about to drop from the bottom of the eye. The figure held a bouquet of seven eyeballs. I had no idea what the painting meant, but it was inviting and oddly celebratory. I found myself feeling immensely happy while looking at it. Then Anna asked me how long it had been since I'd had my eye polished. I told her it had been the previous summer, so about seven months.

"We can polish it for you, if you'd like," she said. She wasn't seeing any patients that day and was in the office only to talk with me.

I had never received such an offer, and I was flustered. For her, who had done thousands of eye polishings, it was a simple and innocuous task, like an off-duty chef offering to make you a tuna fish sandwich. For me, it was a moment of weird uncertainty and nervousness. In the years I'd had my artificial eye, no one except Michael and Michelle Strauss had ever taken it out. I didn't even take it out. When I'd gotten the eye, I'd felt an immediate and unrelenting possessiveness and protectiveness of it. Even when I do go each summer to have it checked and polished, I inevitably feel like Hulga, the character in Flannery O'Connor's short story "Good Country People," who has an artificial leg she cares for "as someone else would his soul, in private and almost with her own eyes turned away." The story's final scene is in the loft of a barn, where a con man who has been posing as a Bible salesman sweet-talks Hulga into removing the leg as proof of her love for him, and then he sets it just out of her reach. She gives "a little cry of alarm." I think of that cry whenever Michael removes my eye with a small suction cup—a casual and practiced move on his part, like a magician taking someone's watch or a parent brushing food off a kid's face—and when he steps back, the eye in his closed hand, I feel the absence. When the Bible salesman refuses to put Hulga's leg back on—"Leave it off for a while. You got me instead," he says—she feels "entirely dependent on him. Her brain seem[s] to have stopped thinking altogether and to be about some other function that it was not very good at." That's how I feel without the eye I've become used to, dependent on. While Michael is across the hall polishing it, I remain very still, don't read the magazine I've carried in from the waiting room, think of almost nothing. I sit as if a battery has been removed. I always get a chill when I read what the con man says to Hulga as he's leaving: "I've gotten a lot of interesting things. One time I got a woman's glass eye this way."[6]

This sudden offer of a polishing by someone I'd met only that morning, then, was not an easy yes. But I was there, in North Carolina, and everything about the previous few hours had made me trust this ocularist who was volunteering this small and generous act. She'd been working with eyes for twenty years. I'd thoroughly enjoyed our talk, and I was impressed with everything she'd told me about her career. And I thought, too, this was a moment to seize, a chance to learn something from ocularists in a way besides by simply talking with them. I did say yes.

She had me sit in the chair in her exam room. I told her she'd be the only person ever to take my eye out besides my own ocularist.

"How's your anxiety level right now?" she asked, smiling.

"Actually, pretty high," I said.

But she was professional, assured. She nimbly lifted out the eye, and though I felt the same absence as always, it was an excitingly comfortable one. More than that, it was a surprisingly intimate experience for me. I feel this all the time with Michael—every visit to his office colored still by the gratitude that had overwhelmed me when he and Michelle first made my eye, by being restored in some way I'd never been before, brought into a vision of myself that had always been simply a dream. There's something about allowing another person to touch and handle your eye. It doesn't matter to me that the eye is a piece of plastic because it creates the impression of reality, and even I am often fooled by that impression when I look in the mirror. Perhaps this weird tenderness goes away if you have several eyes made over the years. Perhaps the process becomes as mundane as getting their hair cut is for most people. It hasn't for me.

"Be back," Anna said. When she returned and slid the eye back in, it was smooth and clean. She told me how beautiful it was, how wonderfully it had been painted. And that made me feel even more moved, her recognition of the treasure I'd been given.

The next day I was telling a fellow eye wearer about that experience. His name is Dave Oberhart, and we were having lunch at a Mexican restaurant in Durham, North Carolina, me eating fajitas and him working his way through a chicken El Volcanito. Prior to that part of our conversation, I was thinking about how it seemed Oberhart was looking right at me across the table, as if he *saw* me. Yet he is completely blind and wears two prosthetic eyes. Both eyes have a fair amount of motility, and Oberhart said he still has a good idea of where to focus, still turns his head in the direction he would if he were seeing, from once having had vision. He got his prosthetics when he was a teenager in the 1970s, the first to replace his left eye when he was in sixth grade, the other a swap for his right eye when he was a sophomore in high school. He'd been diagnosed with glaucoma at two months old, then spent his childhood in and out of the hospital for treatments of pain, retinal detachments, and various infections. By the time he was seventeen, he'd had twenty-nine eye surgeries.

I was getting his story, which was especially interesting not only because of the two fake eyes but also because of his accomplishments since then. He has a third-degree black belt in Tae Kwon Do. He's parachuted out of a plane. He'd been a college teacher for eleven years. He'd spent the previous eight years as a sales associate at an Apple store, where customers almost never suspected he was blind. (Occasionally he would get an ophthalmic surgeon, he said, someone who worked at the nearby Duke University Hospital, who'd

look long at him and say, "I have questions." Oberhart would happily respond, "Okay, I have answers.") He'd been a contestant on *Jeopardy!*[7] What I found out as we ate was also that of all the eye wearers I've met or heard about, Oberhart may have the most unrelenting and absolute loyalty to his ocularists. I began to understand this when I did tell him, halfway through our lunch and still feeling a lingering exhilaration, about Jefferson polishing my eye the previous day. Oberhart's response was blunt.

"I would not have let her polish my eyes," he said with no hesitation, shaking his head with vigor. "Nope. Because if something had happened, I would have to explain that. If she had done something just a little bit wrong, then I would have to explain why, and I would feel like I had betrayed them."

By "them" he meant his own ocularists, Dan and Hillary Yeager, a father-and-daughter team who run Yeager Ocular Prosthetics in Iowa City. Though Oberhart had lived in North Carolina since 1989, he'd grown up in Bettendorf, Iowa, a sixty-mile straight shot east of Iowa City on I-80. That was how he'd come to be a patient of the Yeagers. The hospital he'd been in and out of in his early years was the one at the University of Iowa, where Dan Yeager was the ocularist on staff after Lee Allen had left and a couple decades before Lindsay took that job. Even after Oberhart left the state, he never looked for a new ocularist, never considered doing do. He returns to Iowa once a year for polishings and once every five or six years for a new set of eyes.

"I won't let anyone else work on my eyes," he told me as he ate.

He attributed that loyalty first to the superiority of the work the Yeagers do for him, and his observations in that regard were resonant with what Tracey said about Lindsay's perfectionism. "Dan won't let me out the door unless it's right," Oberhart said. "He's not going to let *anybody* out the door who doesn't look the best they could look, given what he has to work with. His standards are equal to nobody's."

But at least as important, it seemed, if not more, is that the Yeagers have long been family for him. Oberhart knew Dan Yeager and his wife, Jeanine, before they were married. He knew their children from the time they were little. When their daughter Hillary grew up and decided, after earning an associate's degree in applied science dental assisting at the local community college, to join her father in the family business, Oberhart eventually became her patient. He'd hung around long enough to see firsthand the kind of generational continuity so common in the ocularistry world.

"I don't have the words to say what that family has done for me. I don't," Oberhart said.

I had no reason to doubt his sincerity, in part because that was not the first time I'd heard him speak so emotionally about the magnitude of the Yeagers'

impact on his life. I'd met him once before, at the Yeager's office back in Iowa City. I'd been interviewing Hillary and Dan, and I'd heard Oberhart in the next room, telling jokes and making people laugh. Hillary had asked me whether I wanted to talk with a patient who'd been with them since before she was born. I did.

When we joined Oberhart in the exam room—he was finished with that day's polishing and seemed in no rush to leave—he first confirmed what Hillary had quickly told me about him: the parachuting, the appearance on *Jeopardy!*, the black belt. He said a few things about his decades as Dan's patient, but then, because just he and Hillary and I were there, he spoke about how glad he was that Hillary had become an ocularist and that she was now his primary eye maker. ("Hillary did about 98 percent of my most recent set," he said. "Dan did a little bit of painting. He just wanted to sign his name." Hillary laughed and said: "He wasn't ready to let you go yet, Dave.")

"I admire her a lot," he told me about Hillary, "because I don't know that I would have been able to do what she did: working in an apprenticeship for five or six or seven years and being apprenticed to your father. Dan and I have known each other for a long, long time, and he wouldn't let her do it if she couldn't. And I knew that. He's not going to let somebody who doesn't know her stuff do what she's doing. Because his level of expertise and his level of perfection is so high that it's not something that you can just say, 'Well, that'll be all right.' That's just not the way he is. And he has for the longest time wanted to leave something behind; that's his legacy. There she is."

He turned his eyes to point directly at her, as if he were seeing her standing there. "He won't sacrifice the quality of the work that goes on in this building. And I'm just as proud of her as he is."

"Thank you," Hillary said quietly.

"The level of respect and admiration and love I have for these people," he continued, "I can't even describe."

"Mutual," Hillary said.

"Stop it," Oberhart replied.

They laughed.

At the end of her residency in Iowa City, Tracey took a job as a neonatologist at a hospital in North Dakota. Once again, therefore, as in her years in South Carolina, she found herself in a landscape mostly empty of ocularists. There is one in the Twin Cities, and he travels sometimes to Fargo and Sioux Falls and maybe Bismark. But Tracey, like Oberhart and like Lindsay's young patient with microphthalmia and her family, has so far continued to return to Iowa City.

The visits are not easy. It's an eleven-hour drive. Winters are nasty. So she's on more of an annual polishing schedule or on a six- or eight-month schedule, if she's lucky. Tracey does what she can to keep up "the fun part" of seeing Lindsay in person, of feeling the tangible care that complements the mechanics of keeping the eye in good shape. In a worst-case scenario, though, if travel is impossible and the eye is overdue for a polish because even taking it out and running it under some soapy water doesn't make it as comfortable as it needs to be, Lindsay offers Tracey an old-school option, a throwback to the days before custom-made eyes, when you could, for instance, order an eye from the back of a magazine. Just mail her the eye, Lindsay says. She'll polish it and mail it back.

Dan Roche, Eye Wearer

In the early weeks after I'd gotten my prosthetic, a cashier at the supermarket told me I had beautiful blue eyes—a normal kindness between two strangers facing each other briefly. I thanked her and immediately asked if she could tell which one wasn't real. She was as confused as if I'd offered to present my eyes to her on a plate, a St. Lucy appearing in line to buy the week's groceries. Tapping my eye with my fingernail didn't help. She chuckled awkwardly. I don't know what story she might have told to her friends that night.

Other revelations went better. I was in a conversation about eye colors with three people I'd just met, and one of them described mine as "smoky." There was no obligation to divulge the actuality of what she was seeing. Color was color, whether a pigmented iris or layers of paint. Yet I so wanted to share, even while suspecting my own motives. To brag? To startle? Maybe—the purest impulse, if I could elevate it—to commune over something extraordinary outside all of us? I tread more softly than I had with the cashier in case the talk didn't want to go that way. But they perked up like those people who cornered Michelle Strauss at parties. "No way! No way!" they said repeatedly. They laughed at having been tricked, stifled screams when I tapped my eye. I stopped before turning myself into a circus act.

The eye fell out once, also early on. I was, illogically for someone with a single good eye, training in karate. Way back in college, I'd earned a black belt, but a thirty-year break meant beginning again at white belt. During warmups at a 6:00 a.m. class, I was, with other white belts, in the back row, feet spread wide, bending forward to grasp my left ankle, stretching the hamstrings and the lats. I had sleep in my right eye and dug it out with a fingernail. The eye came too, falling two feet to the wood floor and bouncing once before I scooped it up like a jack. I bowed myself out and went to the locker room, inserted the eye for the first time by myself. When I returned, no one asked.

I had never known how to be looked at. I'd spent a life wanting not to be looked at—or, rather, wanting to be seen but not wanting to make myself seen. When I was my mid-twenties, the first time I met with a therapist, which is a request to be seen in all of one's imperfections, I explained for twenty

minutes why I was there: a failing relationship, depression, disconnection. "I think it's all because of this," I said, waving my hand vaguely toward my bad eye. He didn't know what I meant, and when I told him, he said, "I hadn't even noticed." (That therapy didn't go much further.)

Soon after I got my new eye, I was on the carpeted floor of the kids' room in the church I go to. A half-dozen four- and five-year-olds were on their hands and knees around me or sitting crisscross applesauce. I'd been asked to substitute for a Sunday school teacher who had another commitment. Because I had my own young kids at the time, I must have seemed to be someone who could be in close contact with other such humans and like it. In fact, I had wanted to say no, but I'd been asked right at the conclusion of church the previous week, and the words "Go into the world in peace to love and serve others" had been hanging in the air.

The kids didn't even look at me. Or they glanced if I said something or if they wanted to tell me something and then went back to their coloring or their toys. For an hour I sat among them. It was not unlike sitting on a meditation cushion in an ashram (I imagine), the silence and the breathing and the gentle voice of a yogi guiding me into a release of the mind at work, into a liberation from the physical and psychic self. Each moment a child did not ask me what was wrong with my eye, each experience of eye contact that did not cause perplexity in a curious child's face, was an unburdening, a reinvention.

There were two fresh realities in my life with my new eye. The first: that the eye truly looked realistic and beautiful. People who knew it was fake or people whom I told it was fake (no one ever seemed to suspect on their own) complimented it with apparent sincerity and even awe. When they claimed that they could not tell even after I invited them to lean in and inspect it closely, I believed them because sometimes when I was looking in the mirror, even I forgot which eye was which. One night when I was putting my son to bed—he was six at the time—and leaning over to give him a kiss, he grabbed my shoulders and looked back and forth at both eyes. "Which is your real one?" he asked.

Second: I began to let myself be beheld.

I mean something of but not quite exactly what the disability scholar Rosemarie Garland-Thomson means by that word. To behold, she says, is to stare at another person not with selfish voyeurism but as a "way to bring visual presence" to that person. To be beheld is not to present yourself passively as a novelty to be stared at (she is considering prominent examples of disfigurement or disability: the person in the wheelchair whose body is twisted from a muscle-wasting disease, the burn victim, the amputee) but to tell the starer

how to see you. Starer and staree, each has a role in the act of seeing and being seen. For fifty years, I did not want to be stared at. Yet Garland-Thomson says the obvious, which I knew but had little capacity for allowing to happen or to help make happen: "To be held in the visual regard of another enables humans to flourish and forge a sturdy sense of self. Being seen by another person is key to our psychological well-being."[1]

There would be many opportunities over the coming years to be beheld: never easy, rarely smooth. The self-protection I'd learned remains rooted still in some room of my subconscious. I've often wondered about the flourishment Garland-Thompson notes. If I had known how to let myself be beheld earlier, or if I'd found my way to an ocularist much sooner, would the "wholeness" of my appearance have been a catalyst for a wholeness in friendships, academics, family, romance, mental health? Would my "moral torture," to use Auguste-Pierre Boissonneau's term, have been lessened or absent altogether? With the new eye, I've succeeded more often than before (although not always) at holding eye contact with friends, with people at work, with strangers, my kids, my wife. Muscle memory makes my head tilt downward or turn at an angle, and I almost have to push my chin up with my fingers. Still, to stare and to be stared at, which had before been almost always distressful, became distress eased by exhilaration.

I think of two moments when I consider what it means for me to have two matching eyes. They are not the only significant moments; there have been other encounters like the one with the cashier and other times of surprising ease of presence, as with the small kids at church, and they have happened with strangers and friends and family. But these two times in particular called up the imperfect complexities of my transformation's possibilities and limits. Each moment had its mysteries, its satisfactions, and its simultaneous reminders that the new eye, for all its power and wonder, changed much but not everything.

For the first, I was at a four-day writing retreat with a dozen of my colleagues. Though we had hours each day to work alone, this was a communal gathering, built around the goal of freshening and deepening our creative efforts through contemplative practices, led by a wisdom teacher named Bill Redfield. We did group meditations, had long and frank discussions about our work, about its connections to the rest of our lives, to our values, to our selves as individuals and as members of our communities. We nodded to each other in the mornings during silent breakfasts, then talked over good dinners and, later in the evening, over bottles of wine (against Bill's gentle suggestions that we get to bed early and maintain our contemplative bearings). I was in the

early stages of writing this book, and I read aloud to the group some draft passages about my bad eye. Before that, I had never talked with any of those people about my eye. Some of them had known me before I got my prosthetic, and some hadn't. Some knew I had a prosthetic, and some didn't. The passages I shared contained or hinted at, I think, anger over doctors not removing my cataract right away, resentment about not having been cared for as I wanted but didn't know how to request, shame, and self-consciousness. I was trying to lay some things out there.

Bill guided the retreat with tenderness, led us in exercises meant to deepen our experience of presence, which would come, he explained, through experiences of surrender, attention, and compassion, the last of which rests upon self-forgiveness. The sessions and the hours each of us spent alone thinking and writing (sometimes napping) felt increasingly safe and full of empathy. Much of the wisdom Bill offered to us or helped us to discover for ourselves grew from his previous work as a therapist and an Episcopal parish priest. He pointed to how Western culture prioritizes the intellectual and encourages us to define things by differentiation, separation, division and then suggested the alternate possibilities of considering everything as integral, ourselves as integrated. He encouraged us to be open-hearted, to break out of our self-protective shells, to strive for an authenticity of being that transcended liking or disliking and instead simply recognized. I was moved and persuaded by his ideas, by the ways the group was opening within and beyond itself, by the urge to leave behind every judgment I'd made or imagined being made about my old eye. Yet it was never lost on me that I'd had to rid myself of that authentic thing and replace it with a trick, a disguise, in order to consider the possibilities Bill talked about as attainable for myself.

On our final morning together, after meditation—we would end the retreat at noon—Bill told the group, "Before we part, I would like to look into your eyes. I will go around the room, stand in front of each of you, hold your hands, and we will look into each other's eyes for fifteen or twenty seconds. No words."

There was nervous laughter. One person clapped her hands in excitement. Others groaned but accepted the inevitable, like kids submitting to a kiss from an aunt they barely know. I was taken by surprise, felt the old anxiety and yet also an excitement of capability. Several people glanced my way. I'd described what looking into someone's eyes was like for me and how little I still did it, even with my new eye.

We stood in a circle. Bill faced the first person, took his hands, looked into his eyes. There was a slight smile on Bill's face, relaxed, generous. The

person looked back. Without a nod or a word, Bill gently released the person's hands and moved to the next person.

I was fourth in line.

I gave him my hands. I dropped my shoulders. Breathed. Bill's eyes were blue. He was about seventy, but his youthfulness was vibrant, his calmness full.

What surprised me most was that Bill's gaze did not seem to be focused on any one part of me. It felt wide, all-encompassing, not diffused into seeing discrete parts but taking me in as an entirety. And though the exchange was brief, the twenty seconds it took was long enough for me to relax some into the same kind of generous looking. That kind of looking required, I understood even as it was happening, that I look at *him*, not at *him looking at me*. When he let go of my hands, I felt elevated.

Months later when I saw Bill again, I asked him why he did that, why he chose that series of eye contacts.

"I find," he said, "that in terms of grounding myself in a group of people and just connecting with them, it's a very powerful way. I mean, a hug is also. This is just a different kind of intensity from a hug. And it's reciprocal. That's what I love about it." He'd gotten to the point in his life when, he continued, "I just long to connect. That's the purpose of my life. I long to connect. And when I can do that, when I can look into somebody's eyes, . . . I mean, in ordinary conversation we look into each other's eyes. But in a sustained way, there's something that's spoken through that kind of intentionality, that says: 'I am here, I am meeting you here.'"

The other moment was years earlier. It was, in fact, a month after I'd gotten my first new eye. Even now I don't know for sure if the moment was really what it felt to me.

Just before my evisceration, my father, after eighty years of vigorous health, had had a stroke, rising from bed one morning, dropping to the floor, never again able to walk or speak more than "no," "damn it," and my mother's name, "Bonnie." He was in Ohio in a nursing home, and I was in New York. For months, our separate medical urgencies had kept the miles between us.

He'd had engaging eyes. They were green, lively, an accolade magnet, social currency. They weren't his only charm. He'd had an easy laugh, good looks, the ability to tell a joke (if not a wide repertoire), self-confidence that served him well as he rose through a career in the air force, the young airmen who worked under him and sometimes showed up at our house to have a few beers and some burgers from the grill seeming to respect and love him. It was

his eyes, though, that determined so much about our relationship, even more than the biggies: politics, religion, personalities (his mostly gregarious, mine often sullen). It's possible that the importance of his eyes and my eye never occurred to him. We never had a talk about it. My bad eye was just there, unspoken about except when someone else mentioned it, and my dad would default to an anecdote he seemed unable to keep himself from telling over and over, about when I was two and the doctors had patched my good eye so the bad one would have no choice (they hoped) but to pick up the slack, and I continually ran into walls and furniture. The story amused only him.

I'd made assumptions: that he couldn't imagine what it might be like to have his own best physical attribute diminished, that the flaw in my eye scared him, embarrassed him, made him feel guilty. And then I gave up.

At the nursing home, he was in bed, propped up on two pillows. He'd been moaning and trying to move around, and people had been telling him to relax, lie still. It was hard to tell whether he noticed that I had walked in. I hung back. There was a routine there, established over the months by my mom, who sat bedside most hours of every day, and the aides and my sisters. I hadn't been present for the earlier hospital visits, the search for a nursing home, the physical therapy that wasn't really working, the learning of how to get him in and out of bed, the months now when, if he answered questions, it was just with those few words, occasionally strung together into his only sentence: "No, damn it, Bonnie." Sometimes, if he were feeling all right, he said it with happiness; sometimes he said it as if the entire world were stupid. I didn't want to burst in as if I'd brought any solution.

Nevertheless, my mother announced me: "Dan's here! Look, he got a new eye. Show him your new eye!"

I walked to the bed and leaned over my father, as I would do soon after, in fact, with my son.

"I got a new eye," I said.

I could feel the other people still in the room, but almost immediately everything narrowed down to my father's face. He quit moaning, stopped moving. As I would come to know during the next week as I visited, he had little control over what his face did, but his eyes were as expressive as ever. And in that moment, as I was eighteen inches above him and his eyes darted back and forth, I thought I saw either wonderment or befuddlement, either of them signifying that there was suddenly one more thing to make sense of in his already altered world. It was thirty seconds, maybe sixty, maybe ninety. I didn't pull away, and he was going nowhere. If he could have moved his arms, he might have grasped my shoulders as my son would. But he stared at me in a way he hadn't for so long that I had no memory of his ever having done so.

The moment was pure and confusing at the same time. Our relationship had long been a power struggle, a quiet criticism of each other's choices—though, again, maybe that was just my perspective. What I didn't know in that nursing-home room and don't know any better now is whether the indulgence and contentment of that experience, the liberation of it, was more the result of my being in full control—making him look at me, making him see that I had rid myself of the flaw that had determined so much about who I was with respect to him—or the result of relinquishing myself to his stare.

Acknowledgments

My many thanks to all of the following and undoubtedly lots more:

Karl Stukenberg and Phil Terman, whose friendship and support I've relied on once again while writing this book.

Aaron Sprague, who spent many Fridays "coworking" at my kitchen table, him doing his IT stuff and me writing, after which we'd play ping-pong.

Lainie LaRonde and Stephanie Belanger, who expertly translated articles from French for me.

AC Muench, who transcribed hours of interviews and did so with speed, accuracy, and an animated curiosity about the stories they were hearing, which helped remind me there may be other people as interested in this topic as I am.

Sarah Strauss, who shared with me her expertise on Chicago style and helped me wrassle the endnotes into proper shape.

Mike Brophy, astute proprietor of Doyle's Books, who during his regular visits to antiquarian book fairs always looked for anything that might be helpful in my research and called me immediately when he made a discovery.

Kari Zhe-Heimerman of Le Moyne College Library, who helped me track down all kinds of relevant articles and books.

Reagan Brumagen, Gail Bardhan, and Katie Monsell of the Juliette K. and Leonard S. Rakow Research Library at the Corning Museum of Glass, who did the same.

Jessica Murphy of the Center for the History of Medicine at the Francis A. Countway Library of Medicine, Harvard Medical School, who provided gracious help with archival research.

Dr. Katherine Ott of the Division of Medicine and Science at the Smithsonian's National Museum of American History, who let me into the museum's back rooms to look at the eyes there.

Le Moyne College's Research and Development Committee and Harriet O'Leary Committee, which generously gave me money for research and travel every time I asked.

The Adirondack Center for Writers, which gave me two weeks of vital time and space at a critical point in the writing process. My productivity at the Twitchell Lake Retreat Center was so much the result of the encouragement, wisdom, and artistic smarts of the other writers there with me, who quickly become dear friends: Leah Hampton, Annie Stolte, Fay Dilday, Ashanti Jackson, Steven Potter, and Nathalie Thill.

Jane Dystel and Miriam Goderich, who have been perseverant literary agents: knowledgeable, dedicated, savvy, patient, and caring.

Bob Prior, executive editor of biomedical science, neuroscience, and trade science at MIT Press, who saw something he liked in the proposal for this book and was always smart, kind, funny, and tactfully insightful.

Janice Audet, who stepped in upon Bob's retirement and gave me kind and excellent suggestions for toning and tightening the manuscript.

The many others at MIT Press who have cared about and cared for this book. What a privilege to be a beneficiary of their expertise and professionalism.

Kim Waale, who created the book's drawings and taught me how to see prosthetic eyes as material objects in ways I never had. Her artistic vision and talent were eye-opening for me.

Roy Behrens, an eye wearer whose generous conversation was inspiring at a critical time.

Cassie Kircher, who has been a longtime friend of this project and who first workshopped an early chapter in her undergraduate nonfiction writing course (the students' insights mercifully led me to throw away much of that chapter) and later invited me to read more polished sections at Elon University.

My older sister, Kathy Roche, who has enthusiastically primed her expansive world for this book by telling her many friends and colleagues it's coming. May her PR continue.

My mom, Bonnie Roche, for her close reading of the manuscript.

So many ocularists and apprentices who with absolutely unfailing kindness helped me better understand their work, whether in long interviews or brief encounters. In addition to those whose voices are explicitly in these pages, I owe a big debt to Fred Harwin, Steve Sanders, Michael Hughes, Tom Dean, Marie-France Clermont, Randy Light, David Gougleman, Jim Willis, David Le Grand, Eric Jahrling, Kurt Jahrling, Kuldeep Raizada, and Sachin Gupta.

And above all, my kids, Maeve Brady and Fergus Brady, and my wife, Maura Brady, who have always beheld me as I have needed to be beheld.

Notes

Chapter 1

1. John Scudder, "Artificial Enamel Human Eyes" (advertisement), *New-York American* 10, no. 2029 (July 7, 1829): 1.

2. T. J. Davis, *A Treatise on Artificial Human Eyes: Made from a New Material, on an Improved Principle / Discovered and Introduced by T. J. Davis, . . . , Together with Some General Remarks on Their Adaptability and Employment* (New York: T. J. Davis, 1863), 1.

3. Emile Debout, "On the Mechanical Restoration of the Apparatus of Vision," *Dublin Quarterly Journal of Medical Science* 36, no. 1 (1863): 88–89.

4. Scudder, "Artificial Enamel Human Eyes," 1.

5. A-P. Boissonneau, *General Observations on Artificial Eyes: Their Adaptation, Employment and the Means of Procuring Them* (Paris: At the Author's Residence, 1862), 5–6.

6. Isaac Newton, *Opticks: Or, A Treatise of the Reflections, Refractions, Inflexions and Colours of Light. The Second Edition, with Additions* (London, 1718), 363.

7. "'Repulsive' Side to Light Force Could Control Nanodevices," *ScienceDaily*, July 13, 2009, https://www.sciencedaily.com/releases/2009/07/090713131556.htm.

8. Quoted in *Oxford English Dictionary*, s.v. "repulsive (*adj.*), sense 3," accessed August 6, 2024, https://www.oed.com/dictionary/repulsive_adj?tl=true.

9. Katherine Ott, "Hard Wear and Soft Tissue: Craft and Commerce in Artificial Eyes," in *Artificial Parts, Practical Lives: Modern Histories of Prosthetics*, ed. Katherine Ott, David Serlin, and Stephen Mihm (New York: New York University Press, 2002), 152–153.

10. John J. Kelley, "History of Ocular Prostheses," in *Oculoplastic Surgery and Prosthetics*, ed. Gerard M. Shannon and Francis Connelly (Boston: Little, Brown, 1970), 713.

11. Friedrich A. Müller and Albert C. Müller, *Das Künstliche Auge* (Wiesbaden, Germany: J. F. Bergmann, 1910), 4–5.

12. "Artificial Eyes at the Paris Exhibition of 1855," *The Lancet*, September 13, 1856, 315.

13. Charles Dickens, *The Life and Adventures of Nicholas Nickleby* (New York: Oxford University Press, 1987), 30.

14. Anthony Trollope, *The Bertrams* (London: William Clowes & Sons, 1905), 408–418.

15. Freud, "The Uncanny," in *The Standard Edition of the Complete Psychological Works of Sigmund Freud, Volume 17, 1917–1919, An Infantile Neurosis and Other Works* (London: Hogarth, 1955), 244.

16. Sarah F. Rose, *No Right to Be Idle: The Invention of Disability, 1840s–1930s* (Chapel Hill: University of North Carolina Press, 2017), 112.

17. Rose, *No Right to Be Idle*, 1–2.

18. Rose, *No Right to Be Idle*, 2.

19. "Basketball Player Pops Eye Out on the Court!," *The Doctors*, February 17, 2017, YouTube, https://www.youtube.com/watch?v=GYq-E04Nngk.

20. Madeline Farber, "Mom Feels like 'Walking Dead' Extra after Losing Part of Eye in Freak Accident, She Says," FOX News, October 16, 2019, https://www.foxnews.com/health/mom-feels-like-walking-dead-extra-after-losing-part-of-eye-in-freak-accident-she-says.

21. Edgar Allan Poe, "The Tell-Tale Heart," in *Great Tales and Poems of Edgar Allan Poe* (New York: Simon & Schuster, 2007), 3.

22. Daniel M. Kirby, *Surgery of Cataract* (Philadelphia: J. B. Lippincott, 1950), 183, 182.

Chapter 2

1. "Enucleation of the Eye and Its Substitutes," in *The American Encyclopedia and Dictionary of Ophthalmology*, ed. Casey Wood (Chicago: Cleveland Press, 1915), 4384.

2. Ott, "Hard Wear and Soft Tissue," 150–151.

3. "Enucleation of the Eye and Its Substitutes," 4392.

4. George Bartisch, *Ophthalmodouleia*, trans. Donald L. Blanchard (Ostend, Belgium: J.-P. Wayenborgh, 1996), 220.

5. David R. Jordan, "Anophthalmic Orbital Implants," *Ophthalmology Clinics of North America* 13, no. 4 (December 2000): 587.

6. "Enucleation of the Eye and Its Substitutes," 4392.

7. Ott, "Hard Wear and Soft Tissue," 149.

8. Cyril M. Luce, "A Short History of Enucleation," in "Oculoplastic Surgery and Prosthetics," ed. Gerard M. Shannon and Francis J. Connelly, special issue, *International Ophthalmology Clinics* 10, no. 4 (Winter 1970): 682.

9. B. Joy Jeffries, *Enucleation of the Eyeball: One of the Select Papers Read before the Mass. Medical Society, June 2d, 1868* (Boston: Clapp & Son, 1868), 281, 285–286.

10. "Enucleation of the Eye and Its Substitutes," 4395.

11. J. Fernando Arevalo et al., "Update on Sympathetic Ophthalmia," *Middle Eastern African Journal of Ophthalmology*, 19, no. 1 (January–March 2012): 1.

12. Lesley Brown, ed., *The New Shorter Oxford English Dictionary* (Oxford: Oxford University Press, 1993), s.v. "eviscerate."

13. Luce, "A Short History of Enucleation," 684.

14. Philip Mules, "Evisceration of the Globe with Artificial Vitreous," *Transcriptions Ophthalmologic Society UK* 5 (1884–1895): 200–206, reprinted in *Advances in Ophthalmic Plastic and Reconstructive Surgery* 8 (1990): quote on 70.

15. "Enucleation of the Eye and Its Substitutes," 4387.

16. Mules, "Evisceration of the Globe with Artificial Vitreous," 71.

17. Mules, "Evisceration of the Globe with Artificial Vitreous," 69.

18. Mules, "Evisceration of the Globe with Artificial Vitreous," 69.

19. "Enucleation of the Eye and Its Substitutes," 4438–4439.

20. Mules, "Evisceration of the Globe with Artificial Vitreous," 70, emphasis in original.

21. Mules, "Evisceration of the Globe with Artificial Vitreous," 71.

22. W. Adams Frost, "What Is the Best Method of Dealing with a Lost Eye?," *British Medical Journal*, May 28, 1887, 1154.

23. Frost, "What Is the Best Method of Dealing with a Lost Eye?," 1154.

24. F. L. Henderson, "Enucleation or Evisceration?," *American Journal of Ophthalmology* 25, no. 1 (January 1908): 7–8.

25. Jack S. Guyton, M.D., "Enucleation and Allied Procedures, Part I: A Review," *American Journal of Ophthalmology* 32, no. 11 (November 1949): 1525.

26. Arevalo et al., "Update on Sympathetic Ophthalmia," 7.

27. Mules, "Evisceration of the Globe with Artificial Vitreous," 71.

28. Report from 1898 cited in Henry P. Gougelmann, "The Evolution of the Ocular Motility Implant," in "Oculoplastic Surgery and Prosthetics," ed. Gerard M. Shannon and Francis J. Connelly, special issue, *International Ophthalmology Clinics* 10, no. 4 (Winter 1970): 691.

29. "Enucleation of the Eye and Its Substitutes," 4447.

30. "Enucleation of the Eye and Its Substitutes," 4446.

31. Scudder, "Artificial Enamel Human Eyes," 1, emphasis in original.

32. Auguste-Pierre Boissonneau, ad for artificial eyes, *Lancet General Advertiser*, October 17, 1863, n.p.

33. Henry Mayhew, "The Doll's-Eye Maker," in *London Labour and the London Poor*, vol. 3 (London: Frank Cass, 1861–1862), 232.

34. Gougelmann, "The Evolution of the Ocular Motility Implant," 691.

35. "Implanted Port," Cleveland Clinic, last reviewed October 30, 2024, https://my.cleveland clinic.org/health/treatments/21701-implanted-port.

36. Gougelmann, "The Evolution of the Ocular Motility Implant," 702.

37. Arthur C. Perry, Device for Orbital Implant, U.S. Patent Number 4,976,731, filed October 19, 1987, issued December 11, 1990.

38. C. W. Lin and S. L. Liao, "Long-Term Complications of Different Porous Orbital Implants: A 21-Year Review," *British Journal of Ophthalmology* 101, no. 5 (May 2017): 681–685.

39. M. S. Sagoo and G. E. Rose, "Mechanisms and Treatment of Extruding Intraconal Implants: Socket Aging and Tissue Restitution (the 'Cactus Syndrome')," *Archives of Ophthalmology* 125, no. 12 (2007): 1616–1620.

Chapter 3

1. "14,000 Artificial Eyes Seized by Customs Men," *Brooklyn Daily Eagle*, November 5, 1911, 11.

2. United States vs. 2,659 Glass Eyes, 904 F.3d 319 (1912).

3. "Want a Good Glass Eye? Officer Has 2,659 to Sell," *Atlanta Georgian and News*, October 2, 1912, 3.

4. Ethelbert Stewart, "The Making of Glass Eyes," *National Glass Budget*, November 23, 1912, 3.

5. John Pinkerton, *A General Collection of the Best and Most Interesting Voyages and Travels in All Parts of the World*, vol. 4 (Philadelphia: Kimber and Conrad, 1811), 154.

6. T. Peacock, ad for artificial eyes and other products, *Auckland Star*, January 9, 1900, 8; Seattle Optical Company, ad for eye and ear prosthetics, *Seattle Union Record*, February 4, 1921, 2; Pettie & Whitelaw, ad for medical supplies, including eye and ear prosthetics, Dundee Directory: Advertisements, 1905–1906, 137.

7. Ott, "Hard Wear and Soft Tissue," 158.

8. W. T. Levitt, "Modern Aladdins," *Bulletin of the American Ceramic Society* 13, no. 11 (November 1934): 312.

9. "The Manufacture of Artificial Eyes," *Glass Industry* 3 (1922): 138.

10. "A Glass Eye Famine," *New York Times*, October 6, 1914, 4.

11. Office of Medical History, US Army, "Artificial Eye Program," in *Medical Supply in World War II*, ed. Charles M. Wiltse (Washington, DC: Office of the Surgeon General, Department of the Army, 1968), 87.

12. Office of Medical History, "Artificial Eye Program," 88.

13. Office of Medical History, "Artificial Eye Program," 88.

14. Stanley F. Erpf, Milton S. Wirtz, and Victor H. Dietz, "Plastic Artificial-Eye Program, U.S. Army," *American Journal of Ophthalmology* 29 (1946): 986.

15. Lee Allen, "Modified Impression Fitting," in "Oculoplastic Surgery and Prosthetics," ed. Gerard M. Shannon and Francis J. Connelly, special issue, *International Ophthalmology Clinics* 10, no. 4 (Winter 1970): 747.

16. Diana L. Tomb, "A Better Look," *Rochester Democrat and Chronicle*, April 24, 1994, 47.

17. "The Development of Acrylic Eye Prosthesis at the National Naval Medical Center," *Journal of the American Dental Association* 32, no. 19 (October 1945): 1227.

18. Phelps J. Murphey and Leon Schlossberg, "Eye Replacement by Acrylic Maxillofacial Prosthesis," *U.S. Naval Medical Bulletin* 48, no. 6 (December 1944): 1085.

19. Allen, "Modified Impression Fitting," 751.

Chapter 4

1. Martin Gayford, *Man with a Blue Scarf: On Sitting for a Portrait by Lucian Freud* (London: Thames & Hudson, 2013), 64.

2. Beck's photography project *Both Sides Of* is covered in Laura Stampler, "Here's What Faces Would Look Like If They Were Perfectly Symmetrical," *Time*, June 9, 2014, https://time.com/2848303/heres-what-faces-would-look-like-if-they-were-perfectly-symmetrical/.

3. K. R. Pine et al., "Towards Improving the Biocompatibility of Prosthetic Eyes," *Heliyon* 7, no. 2 (February 2021): art. e06234, https://doi.org/10.1016/j.heliyon.2021.e06234.

4. In the California Code of Regulations, see "Prohibited Hazardous Substances/Use of Products," 16 CCR §989.

5. Gayford, *Man with a Blue Scarf*, 65.

6. Fredrick Schleipman et al., Dilating Ocular Prosthesis, U.S. Patent Number 6,139,577, filed March 4, 1999, issued October 31, 2000.

7. "Artificial Eyes," *Boston Courier*, February 18, 1830, n.p.

Chapter 5

1. Alexander C. Rokohl et al., "Concerns of Anophthalmic Patients—a Comparison between Cryolite Glass and Polymethyl Methacrylate Prosthetic Eye Wearers," *Graefe's Archive for Clinical and Experimental Ophthalmology* 256 (2018): 1203–1208.

2. "The Eyes Have It!," *Glass*, September 1989, 360.

3. Augenprothetik Lauscha, "Glass vs. Plastic" (in English), accessed June 14, 2023, https://augenprothetik-lauscha.de/why-glass/?lang=en.

4. Alexander C. Rokohl et al., "Risk of Breakage of Cryolite Glass Prosthetic Eyes," *Graefe's Archive for Clinical and Experimental Ophthalmology* 257 (2019): 437–438.

Chapter 6

1. Office of Medical History, "Artificial Eye Program," 88.

2. Raymond Jahrling, "The Maturing of the ASO," 2007, transcript provided by Jahrling to the author.

3. NEBO, "About Us," accessed November 20, 2024, https://neboboard.org/about-us.

4. Steven Leibowitz, MD, website home page, accessed November 14, 2024, https://www.drste venleibowitz.com/home.html.

5. Katherine Schaeffer and Shradha Dinesh, "32% of Americans Have a Tattoo, Including 22% Who Have More Than One," Pew Research Center, August 15, 2023, https://www.pewresearch .org/short-reads/2023/08/15/32-of-americans-have-a-tattoo-including-22-who-have-more-than -one.

6. Dan Gudgel, "Eyeball Tattoos Are Even Worse Than They Sound," *American Academy of Ophthalmology: EyeSmart*, May 15, 2019, https://www.aao.org/eye-health/tips-prevention /eyeball-tattoos-are-even-worse-than-they.sound.

7. Quoted in Meirav Devash, "The Dangerous Risks of Eye Tattoos, according to Body Modifi- cation Artist Who Invented Them," *Allure*, January 21, 2021, https://www.allure.com/story/eye -tattoo-risk-and-dangers.

Chapter 7

1. "Arkansas Man Receives the World's First Whole Eye Transplant Plus a New Face," Associ- ated Press, November 10, 2023, https://www.npr.org/2023/11/10/1212067302/arkansas-man -receives-the-worlds-first-whole-eye-transplant-plus-a-new-face.

2. Sharon Reynolds. "Lab-Grown Eye Cells Form New Neural Connections," *NIH Research Matters*, January 24, 2023, https://www.nih.gov/news-events/nih-research-matters/lab-grown -eye-cells-form-new-neural-connections.

3. Mandeep Sagoo, "3-D Printing in Eye Tumour Treatment," TEDx Talks, January 11, 2023, https://www.youtube.com/watch?v=SBOmc_kO2VQ&t=531s.

4. "Moorfields Patient Receives World's First 3-D Printed Eye," November 25, 2021, https:// www.moorfields.nhs.uk/news/moorfields-patient-receives-world-s-first-3-D-printed-eye.

Chapter 8

1. Walter Tillman, *An Eye for an Eye: A Guide for the Artificial Eye Wearer* (N.p.: self- published, 1987), dedication.

2. H. T. Neprash et al., "Association of Primary Care Visit Length with Potentially Inappropri- ate Prescribing," *JAMA Health Forum* 4, no. 3 (2023): art. e230052, https://doi.org/10.1001 /jamahealthforum.2023.0052.

3. "What Is Patient-Centered Care?," *NEJM Catalyst*, January 1, 2017, https://catalyst.nejm.org /doi/full/10.1056/CAT.17.0559.

4. "Person-Centered Care," American Association of Colleges of Nursing, accessed September 28, 2023, https://www.aacnnursing.org/5b-tool-kit/themes/person-centered-care#:~:text=The %20Institute%20of%20Medicine%20describes,(IOM%2C%202001%2C%20pp.

5. Nel Noddings, *Starting at Home: Caring and Social Policy* (Berkeley: University of Califor- nia Press, 2002), 23–24.

6. Flannery O'Connor, "Good Country People," in *The Complete Stories* (New York: Farrar, Straus and Giroux, 1971), 288, 289, 291.

7. *Jeopardy!*, season 20, episode 74, directed by Kevin McCarthy, aired December 18, 2003.

Dan Roche, Eye Wearer

1. Rosemarie Garland-Thomson, "Beholding," in *The Disability Studies Reader*, 3rd ed., ed. Lennard J. Davis (New York: Routledge, 2010), 205.

Index